NAT GEO AMAZING!

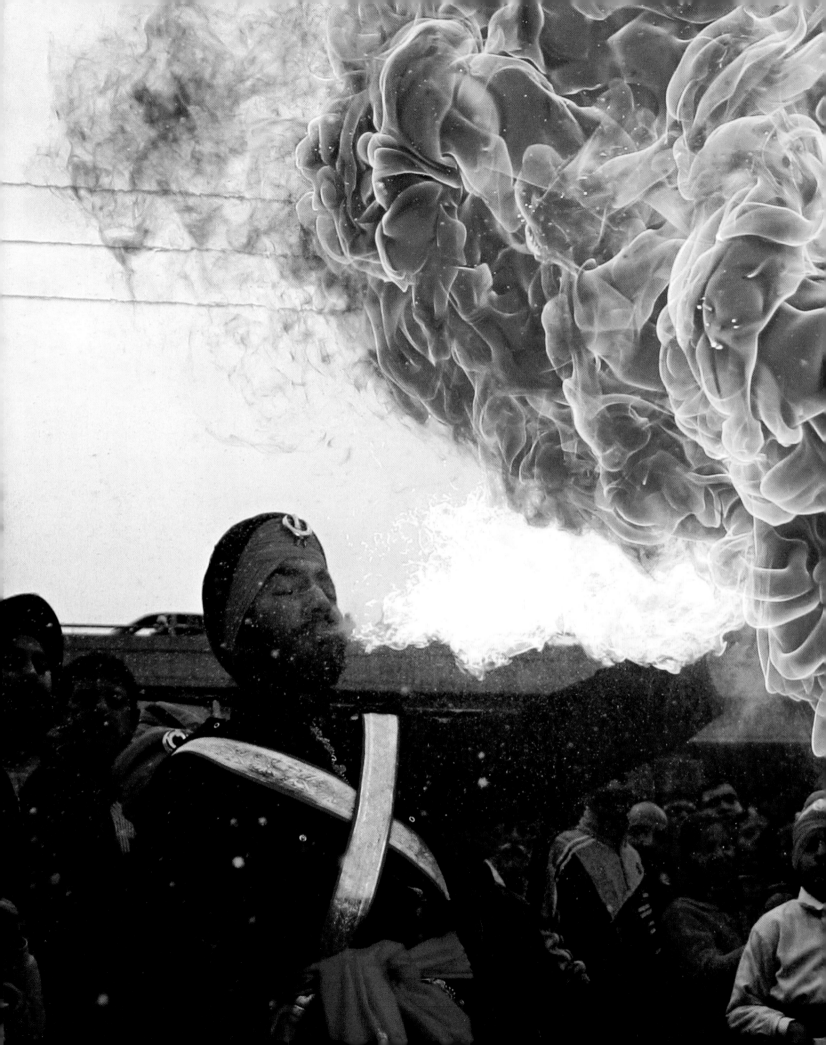

NAT GEO AMAZING!

100 PEOPLE, PLACES, AND THINGS THAT WILL WOW YOU

Melina Gerosa Bellows

NATIONAL GEOGRAPHIC

Washington, D.C.

CONTENTS

49

82

38

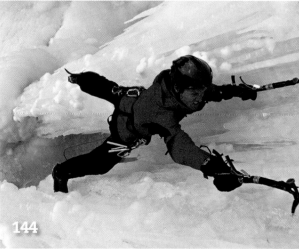

144

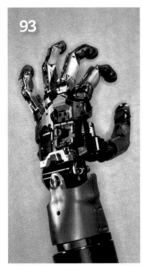

93

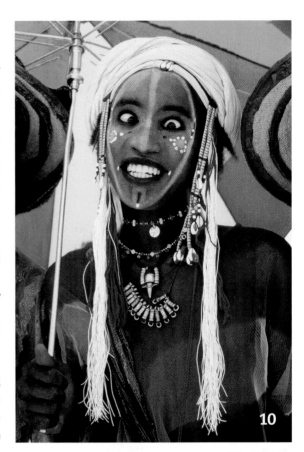

10

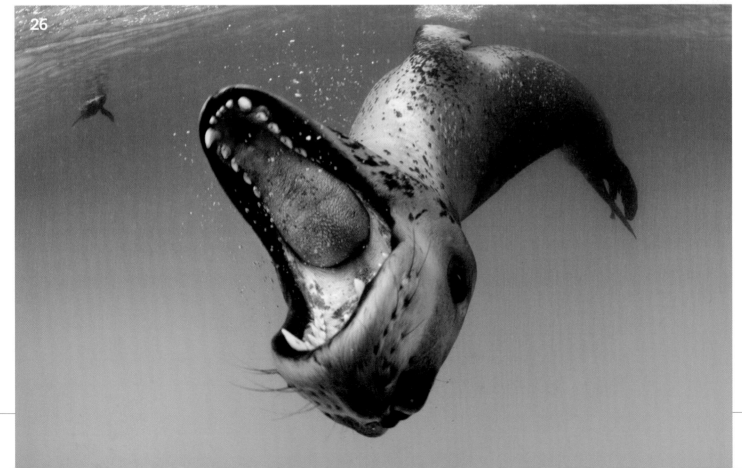

26

When I was a kid, the world came to me through my mailbox. My parents subscribed to magazines like *LIFE, Time,* and *National Geographic,* and the first chance I got, I would pilfer each issue from them so I could spend hours poring over the photographs, spellbound by the colors, the locations, and the people I saw. I fell in love with them, and the images burned into my brain forever.

Cut to me as a grown-up when, 15 years into a career in entertainment journalism, I switched gears to edit the National Geographic children's magazine. The job was an exquisite challenge: Everything I knew, loved, and learned the hard way about storytelling had to be sped up, shrunk down, and über-relevant to satisfy a younger audience with a shorter attention span. I learned that you had to get to the point, and fast, or you'd bore the reader.

This was actually very good preparation for the book you now have in your hands—a companion to a new National Geographic TV series launching this summer. *Nat Geo Amazing!* is National Geographic as you've never seen it before. I took my love for unforgettable images and unbelievable stories and traveled the globe, scoured our archives, and cut through the cyberclutter to present you with 100 people, places, and things that will totally wow you.

We've got bizarre Guinness World Record holders, daring explorers, weird but true facts, exotic cultures on the edge, and more—all presented with the photographic excellence you'd expect from National Geographic. We hope the book is like a roller coaster ride for your brain, one that satisfies your curiosity by bringing you the stories you may not even know exist—whether it's puppies who reform criminals, the striking visions of blind photographers, or cuddly miniature tigers.

Our goal is to inspire you the way I was awaiting the mailman—with each turn of a page burning an unforgettable image on your brain. Even more, we'd like to hear from you. Visit us at **natgeoamazing.com,** or email us at **natgeoamazing@nationalgeographic.com** and tell us what amazes you. Wow us with your stories and photos! It's a conversation that could yield an amazing sequel, filled with even more people, places, and things that wow us about the world.

FOREWORD

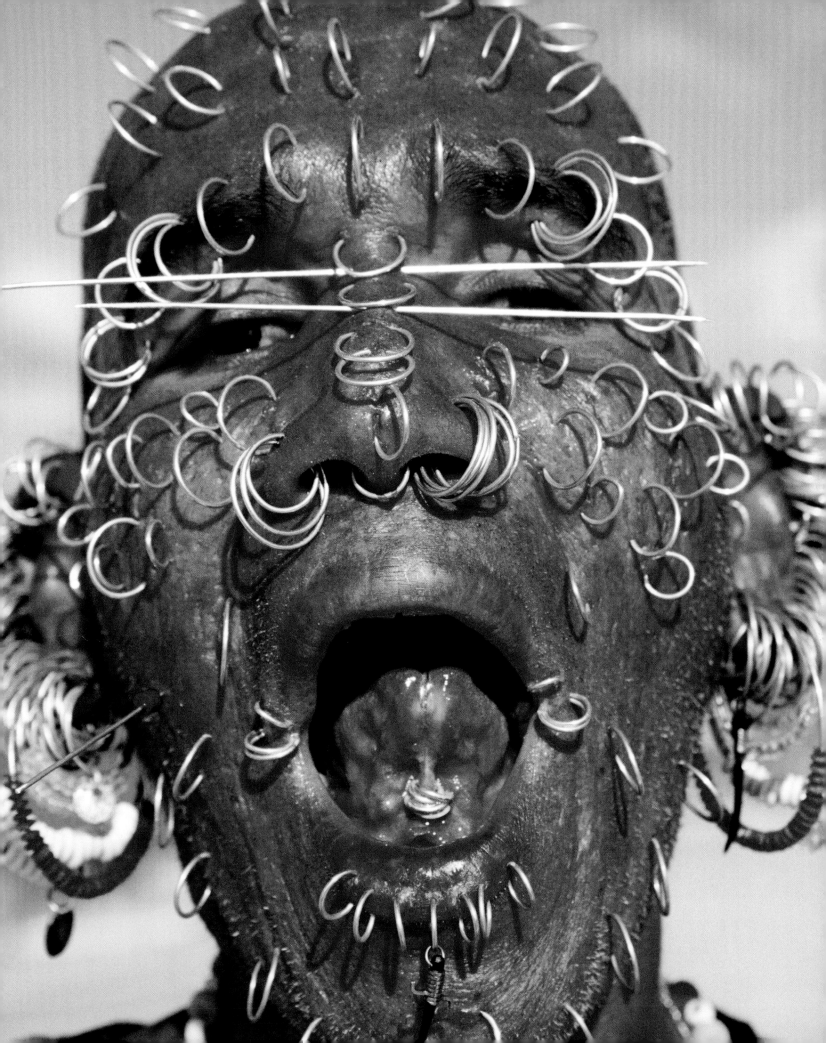

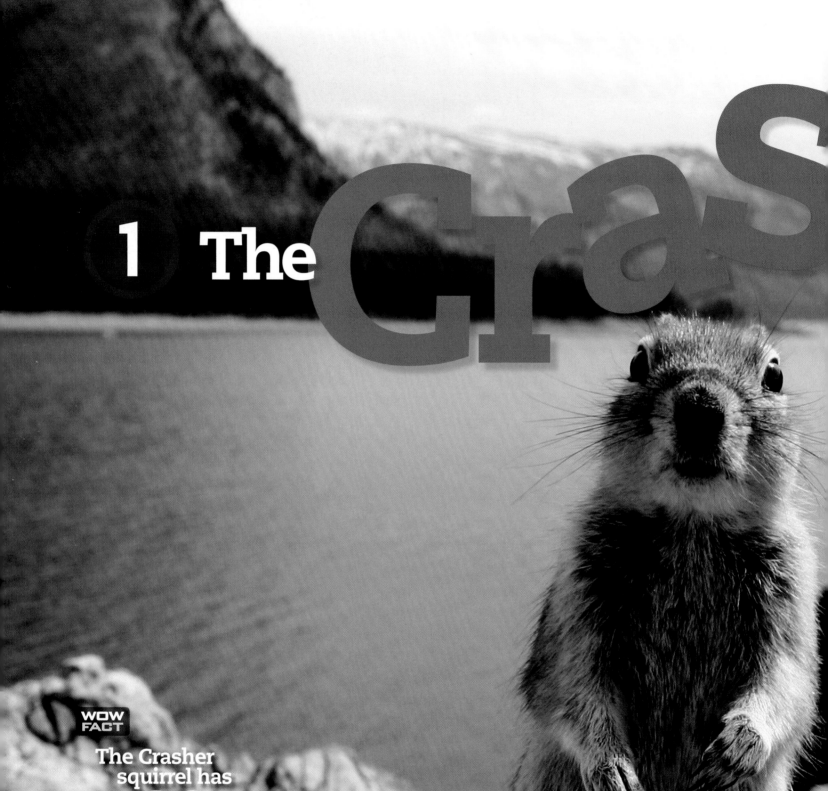

1 The Cras

WOW FACT

The Crasher
squirrel has

**6,854
friends**
on Facebook.

her

"**H**ad I known what was going to happen, I wouldn't have been wearing a two-dollar maternity T-shirt," says Melissa Brandts, who thought she was taking a personal snapshot of herself and her husband, Jackson, in Canada's Banff National Park.

Then, along came the squirrel. Soon after Melissa sent the picture to National Geographic's "Your Shot" Web site and it was posted, her husband got a call from a friend in North Korea, saying he had been emailed a photograph in which the couple looked a lot like the Brandtses. The popularity of the squirrel, who had become known as the Crasher, continued to grow around the viral world, urged on by a computer programmer who created the "Squirrelizer," which allowed people to upload the squirrel and drop him into any photograph. The critter was soon pictured with Abe Lincoln, Hollywood celebrities on the red carpet, and a lunar lander on the moon .

How does Brandts explain the mania? "It was the height of the unemployment rate and the bank crisis, and I think this was just lighthearted," she says. "Unlike the other stuff, this was fun to talk about."

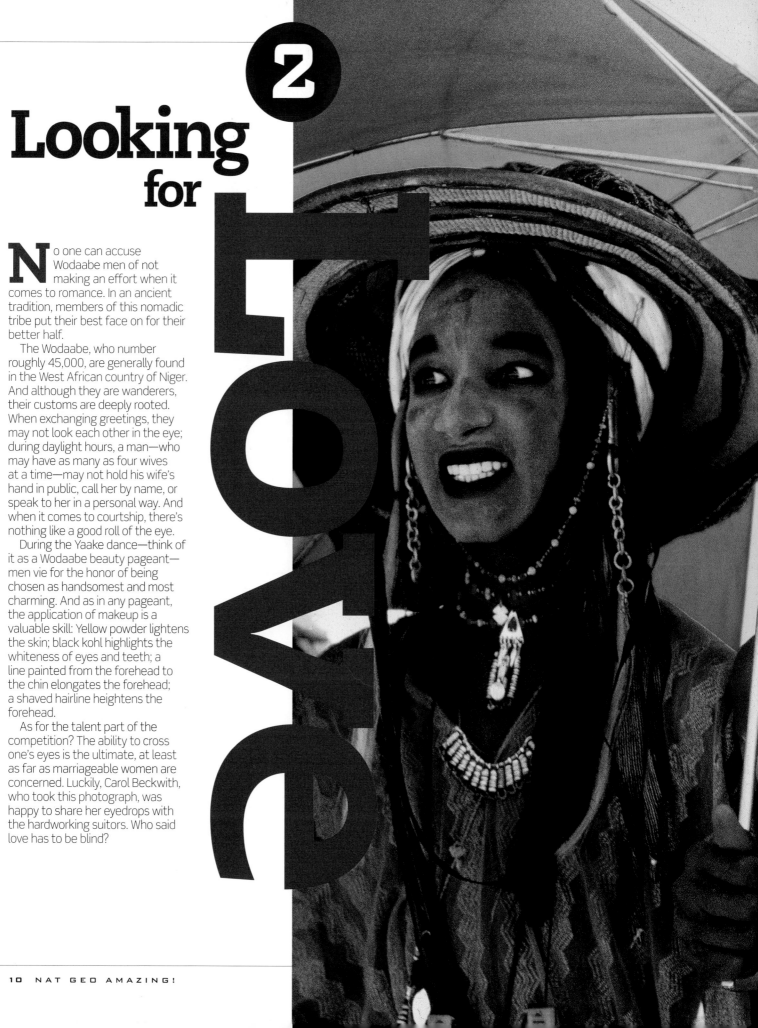

Looking for

2

Love

No one can accuse Wodaabe men of not making an effort when it comes to romance. In an ancient tradition, members of this nomadic tribe put their best face on for their better half.

The Wodaabe, who number roughly 45,000, are generally found in the West African country of Niger. And although they are wanderers, their customs are deeply rooted. When exchanging greetings, they may not look each other in the eye; during daylight hours, a man—who may have as many as four wives at a time—may not hold his wife's hand in public, call her by name, or speak to her in a personal way. And when it comes to courtship, there's nothing like a good roll of the eye.

During the Yaake dance—think of it as a Wodaabe beauty pageant— men vie for the honor of being chosen as handsomest and most charming. And as in any pageant, the application of makeup is a valuable skill: Yellow powder lightens the skin; black kohl highlights the whiteness of eyes and teeth; a line painted from the forehead to the chin elongates the forehead; a shaved hairline heightens the forehead.

As for the talent part of the competition? The ability to cross one's eyes is the ultimate, at least as far as marriageable women are concerned. Luckily, Carol Beckwith, who took this photograph, was happy to share her eyedrops with the hardworking suitors. Who said love has to be blind?

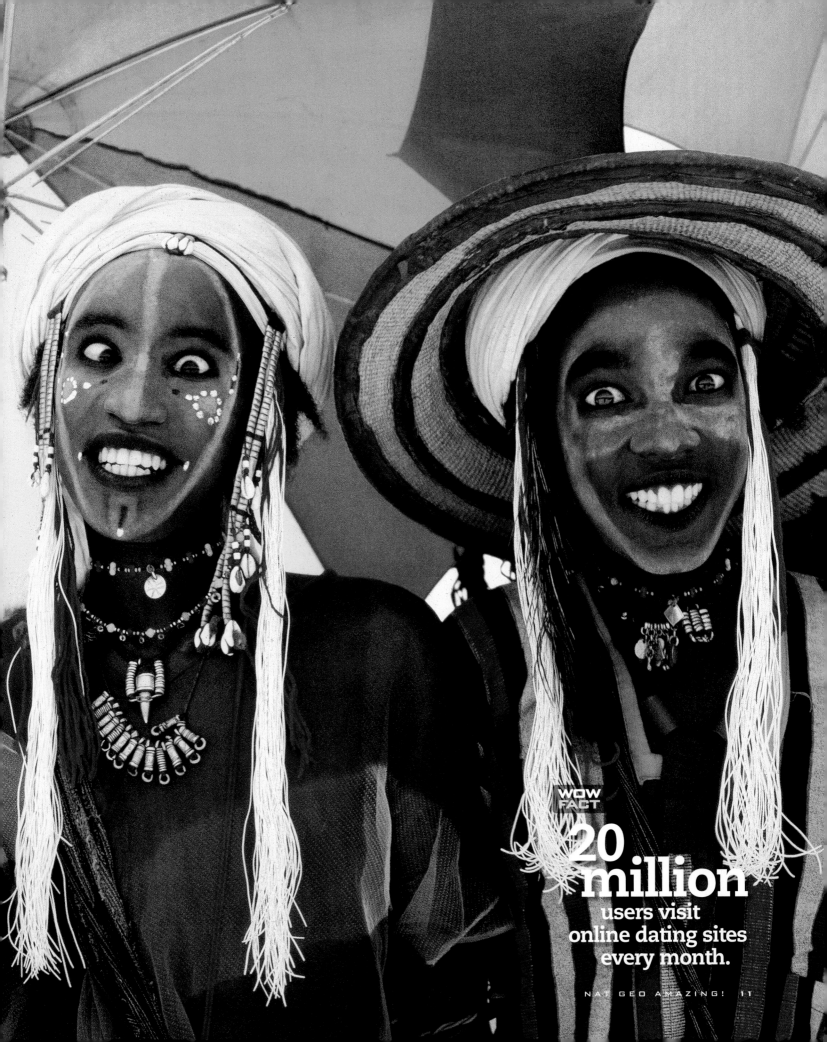

20 million users visit online dating sites every month.

3 IN SICKNESS

Palau

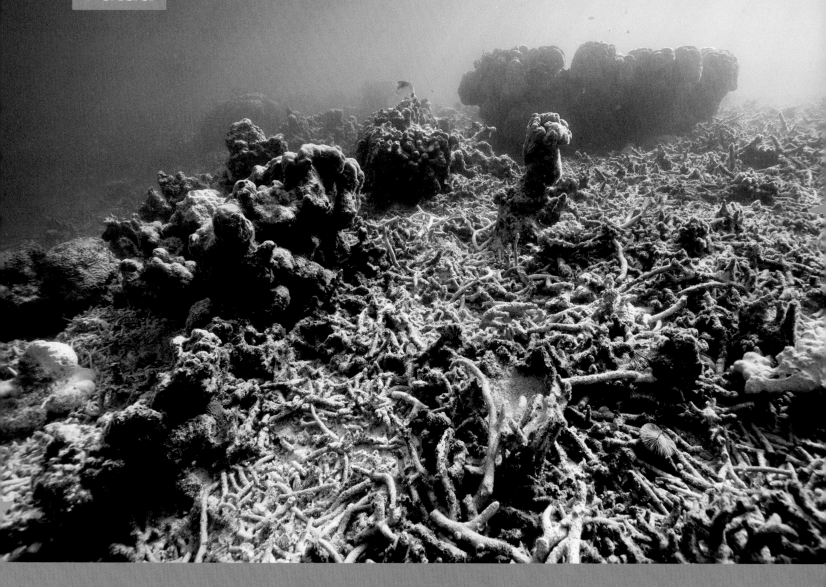

The color says it all: proof of the destruction afflicting our oceans' reefs; in this case, El Niño's devastation of a reef off the coast of Palau.

Coral are actually small animals, which grow limestone skeletons that house microscopic algae; the coral and algae live in a symbiotic relationship, with the algae providing the coral sugar in exchange for recycling their output. When water temperatures rise, as they did during El Niño, a chemical response causes the coral to expel the algae. Because the algae also provide the coral

with their color, the result, as seen here, is a reef that is bleached and monochromatic. The coral can't live without the algae, and die; the fish can't live without the reef, and move to higher latitudes in search of cooler climates.

Now compare the dead reef on the left with the bright one on the right. Kingman Reef, located off a remote Pacific Ocean atoll, remains as nature intended. The signs of Kingman's health are manifest in the brilliant colors of the coral, the clarity of the water, and the abundance of fish. A healthy reef supports a wide variety of species,

WOW FACT

70% OF THE WORLD'S CORAL WILL BE DEAD BY 2050 IF DESTRUCTION CONTINUES.

AND IN HEALTH

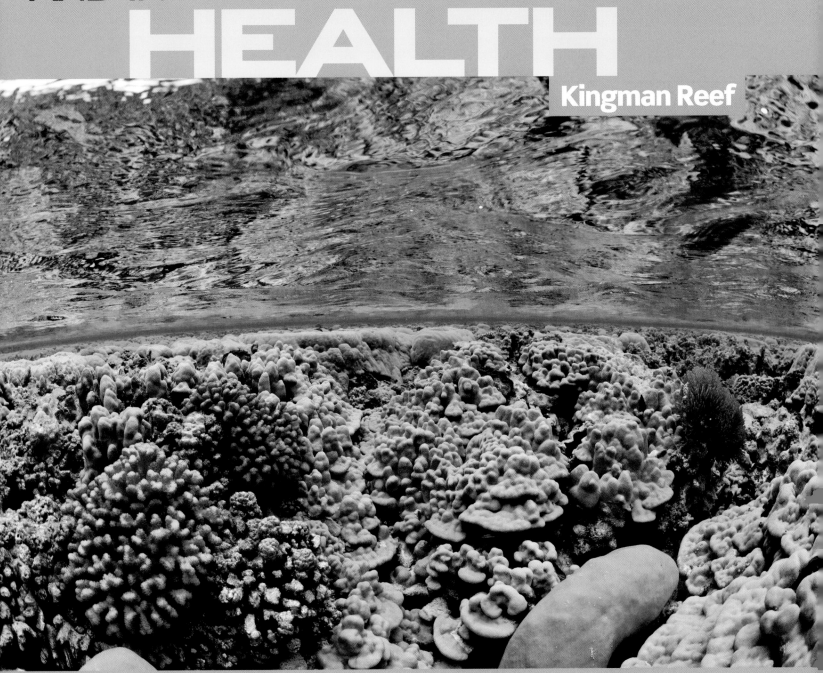

Kingman Reef

including a higher population of the top predators, such as sharks.

"It's one of the last pristine places," says marine ecologist Enric Sala, a National Geographic Fellow. "Less than one percent of the world's reefs still look like this." Sala has led expeditions to the 30-mile coral triangle to help scientists better understand what they *should* see in such an ecosystem. Studying only reefs in crisis, he explains, is like "being a car mechanic from Jupiter who arrives here and works in a junkyard. You have no idea that a car has wheels and actually drives.

This is one of the last marine car dealerships."

What can humans do to stop our underworld from turning barren? Cut back on greenhouse gases, which turn the oceans warmer and more acidic, and tread carefully on what's left. Continue to protect threatened areas and correct the devastation that has resulted from overfishing. Perhaps most important: Honor what we have. Kingman Reef has been designated a National Marine Monument, rendering it inaccessible to all but a few scientists and assuring it remains, forever, a lasting example of what is possible.

4 Nature's Alphabet

Counting the number of angels on the head of a pin may be impossible, but seeing letters of the alphabet on butterfly wings is not.

Photographer Kjell B. Sandved began his search to find a naturally occurring alphabet when he was a volunteer at the Smithsonian Institution. After noticing an *F* on a butterfly's wings, he decided to be the first person to find the entire series of letters on other specimens.

It was a journey that would take him a quarter of a century and span 30 countries, but he found all 26 letters. The result of the quest for his personal holy grail is captured in his popular book for children *The Butterfly Alphabet*, in which a poem reads, "On wings aloft across the skies / An Alphabet of butterflies / Each butterfly in secret brings / A letter hidden in its wings."

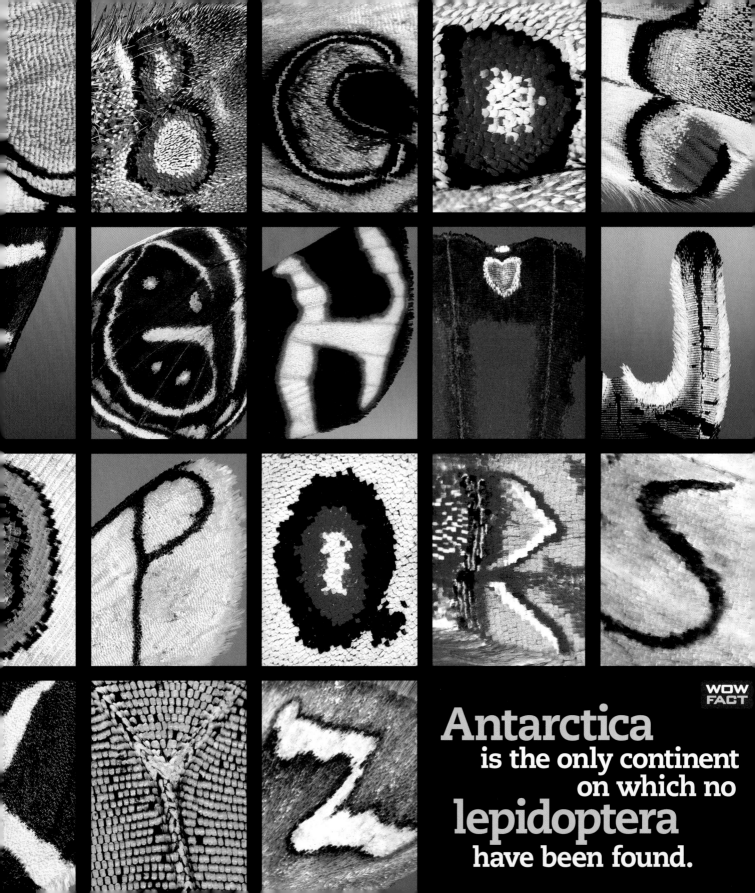

WOW FACT

Antarctica
is the only continent
on which no
lepidoptera
have been found.

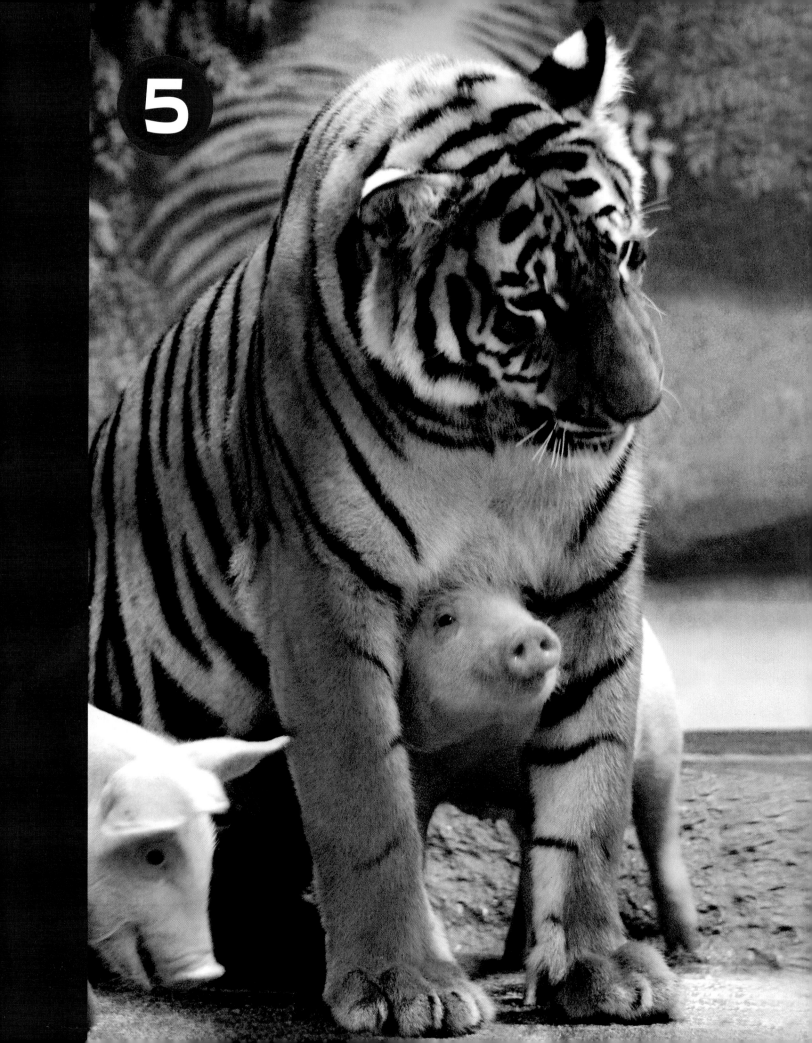

THE INCREDIBLE STORY OF THE TIGER THAT LOVED THE PIG....

...AND OTHER VERY WEIRD ANIMAL FRIENDSHIPS

6

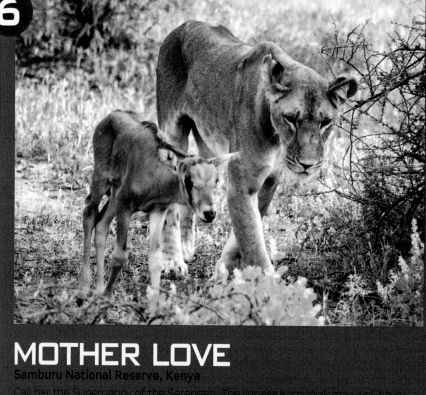

MOTHER LOVE
Samburu National Reserve, Kenya

Call her the Supernanny of the Serengeti. The lioness Kamuniak may well have had the best of intentions when she "adopted" these oryx antelope babies and fiercely guarded them from leopards and cheetahs. The antelopes' actual mother, however, didn't seem delighted to find herself with a full-time babysitter. Despite being chased away from her young, the mother oryx was finally reunited with two of her young when they managed to escape from under Kamuniak's watchful eye. Says lion expert Craig Packer, "Kamuniak is playful, but I think she gets carried away."

> ## "WE WANT TO SHOW THAT IF DIFFERENT KINDS OF ANIMALS CAN LIVE TOGETHER PEACEFULLY, WHY CAN'T HUMANS?"
> —JINTANA CHUMJINDA, SI RACHA TIGER ZOO

5

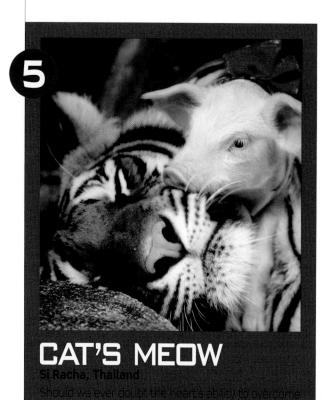

CAT'S MEOW
Si Racha, Thailand

Should we ever doubt the heart's ability to overcome our differences, let Saimai, who resides in Thailand's Si Racha Tiger Zoo, be a lesson to us. The noble Bengal, who has been raised playing with monkeys and dogs, generously shares her pen and affection with pigs in a realization of the zoo's mission to create a kinship among all kingdoms. "Saimai really is the piglets' friend," says the zoo's public relations manager, Jintana Chumjinda, "We want to show that if different kinds of animals can live together peacefully, why can't humans?"

MOUSE PAD ▶
Lucknow, India

7

Any port in a storm . . . or any lifeboat in a monsoon for this lucky mouse, which hitched a ride on the back of a frog when it found itself caught up in a severe summer flood. "Frogs are at home in the water, so they can easily weather these storms," says biology professor Jim Ryan (we assume with no pun intended). But since mice are meant for finer days, continues Ryan, "they'll use anything as a raft." Should we humbly be taking note of the rodent's crisis management abilities? Doubtful. "The mouse probably just grabbed the first thing that went by," says Ryan. "It was probably just a very tolerant frog, and a very lucky mouse."

SOMETHING FISHY ▶

Medford, Oregon

With their gently grasping mouth, thick insulating coat, and webbed paws, golden retrievers are bred to be of help to hunters, fetching wildfowl from ponds and woods. And as anyone who has ever lived with one knows—and there are many who do, since the breed is the fourth most popular in the world—these big-hearted beauties are enthusiastic about all water-based activities. (Well, with the exception of baths—then they suddenly turn into cats.)

But Chino, a golden that lives in Oregon, ups the ante when it comes to his passion for, and interest in, what lurks beneath the surface: He has a fascination with an orange-and-black carp named Falstaff that lives in a pond in his backyard. That isn't a complete surprise, given that retrievers are known for their fondness for all living creatures. But what is bizarre is that the carp, which isn't necessarily associated with warm, fuzzy feelings, seems to reciprocate with its own interest in the canine. Chino's owner, Dan Heath, says that the dog will run outside and peer into the pond, patiently waiting until Falstaff pops up. Afterward, the dog and the carp greet each other by touching noses. "Sometimes it looks as if Falstaff the carp is sucking on Chino's paws," says Heath.

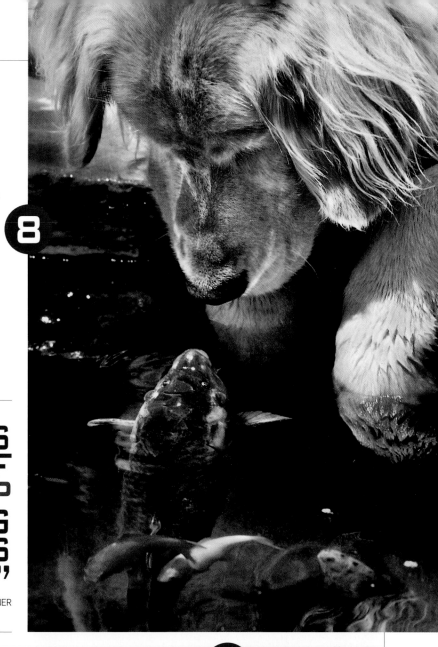

8

"SOMETIMES IT LOOKS AS IF FALSTAFF THE CARP IS SUCKING ON CHINO'S PAWS."

—DAN HEATH, PET OWNER

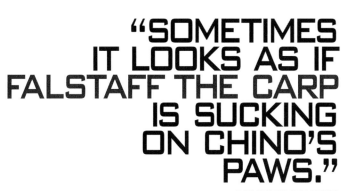

TSUNAMI CONNECTION **9**

Mombasa, Kenya

After a tsunami orphaned Owen, an African hippo, he apparently decided that life would be better savored at a slower pace. How else to explain his deep affection for Mzee, an Aldabran tortoise? The pair, who reside at the wildlife sanctuary Haller Park, are now inseparable. Despite hippos' penchant for clean ponds, Owen happily wallows in the mud alongside Mzee, while Mzee expresses his gratitude by placing his head in the hippo's mouth. Quite a demonstration, given that hippos are the largest mammals on Earth next to elephants and are known as fierce fighters. And while Mzee has been known to swat Owen away come mealtime, he graciously allows Owen to lick up the scraps—right off his face.

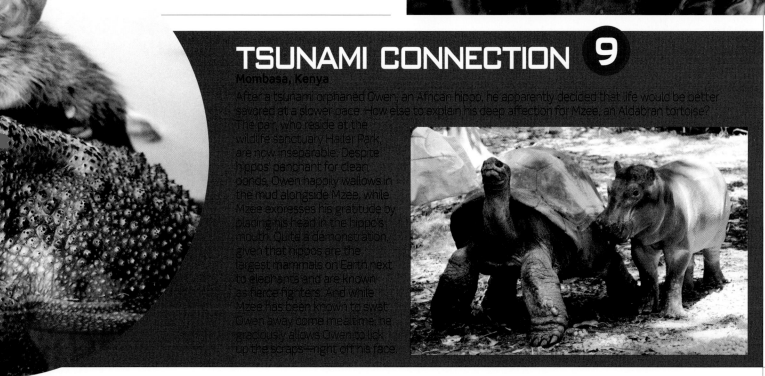

UNBALANCED

ost of us seek balance in our lives, but few of us have turned it into an art form. Eskil Ronningsbakken is the exception, perfecting it even over troubled waters . . . on a tightrope thousands of feet in the air. Sometimes he is on a bicycle, sometimes he is on his feet; often he is upside down. Occasionally he glides above solid ground, dangling from a hot air balloon.

"Other people might see this as stupid, but to me it's about being free and able to do what I want in my life," says the Norwegian, who has been performing for the past decade. Ronningsbakken is taking that message to the slums of Nairobi, Kenya, and the young Africans who live there. By teaching them acrobatics, he hopes to inspire lifelong confidence. "As a professional balancer," he explains, "you've got to be able to overcome fear. You've got to be at total peace with yourself."

"THAT'S THE BALANCE BETWEEN LIFE AND DEATH, AND THAT IS WHERE LIFE IS."

—ESKIL RONNINGSBAKKEN

11
Womb-mates

Babies **yawn** before they are **born.**

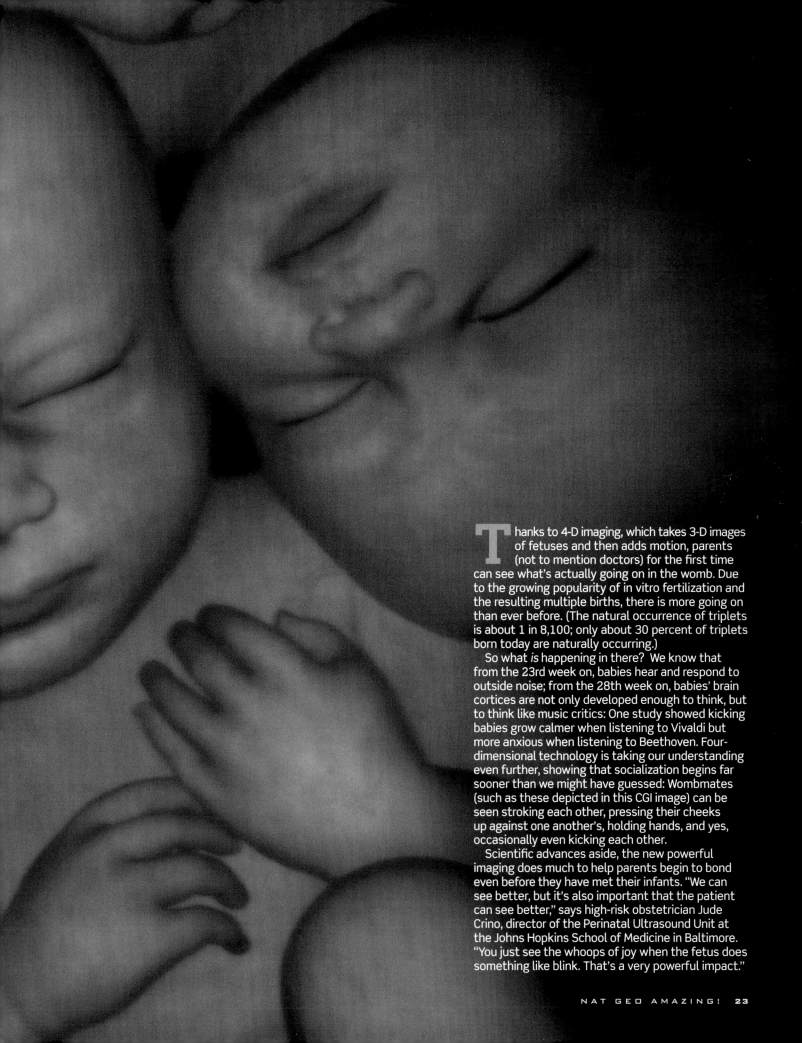

Thanks to 4-D imaging, which takes 3-D images of fetuses and then adds motion, parents (not to mention doctors) for the first time can see what's actually going on in the womb. Due to the growing popularity of in vitro fertilization and the resulting multiple births, there is more going on than ever before. (The natural occurrence of triplets is about 1 in 8,100; only about 30 percent of triplets born today are naturally occurring.)

So what *is* happening in there? We know that from the 23rd week on, babies hear and respond to outside noise; from the 28th week on, babies' brain cortices are not only developed enough to think, but to think like music critics: One study showed kicking babies grow calmer when listening to Vivaldi but more anxious when listening to Beethoven. Four-dimensional technology is taking our understanding even further, showing that socialization begins far sooner than we might have guessed: Wombmates (such as these depicted in this CGI image) can be seen stroking each other, pressing their cheeks up against one another's, holding hands, and yes, occasionally even kicking each other.

Scientific advances aside, the new powerful imaging does much to help parents begin to bond even before they have met their infants. "We can see better, but it's also important that the patient can see better," says high-risk obstetrician Jude Crino, director of the Perinatal Ultrasound Unit at the Johns Hopkins School of Medicine in Baltimore. "You just see the whoops of joy when the fetus does something like blink. That's a very powerful impact."

12 Junk
Food
Diet

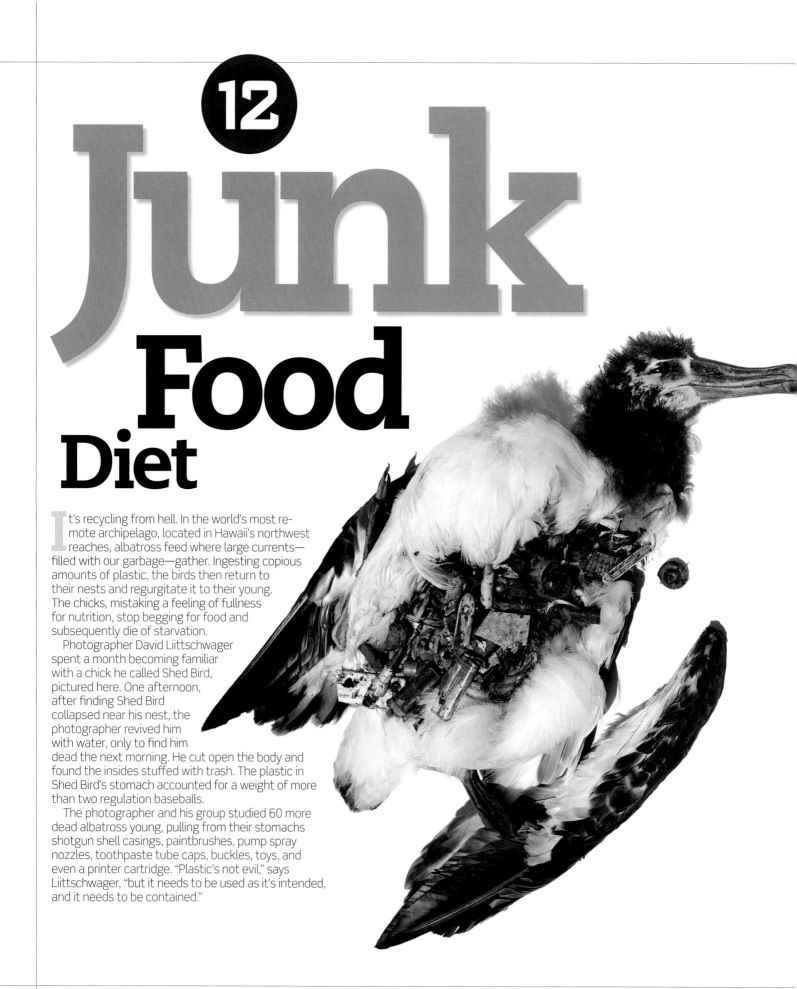

It's recycling from hell. In the world's most remote archipelago, located in Hawaii's northwest reaches, albatross feed where large currents—filled with our garbage—gather. Ingesting copious amounts of plastic, the birds then return to their nests and regurgitate it to their young. The chicks, mistaking a feeling of fullness for nutrition, stop begging for food and subsequently die of starvation.

Photographer David Liittschwager spent a month becoming familiar with a chick he called Shed Bird, pictured here. One afternoon, after finding Shed Bird collapsed near his nest, the photographer revived him with water, only to find him dead the next morning. He cut open the body and found the insides stuffed with trash. The plastic in Shed Bird's stomach accounted for a weight of more than two regulation baseballs.

The photographer and his group studied 60 more dead albatross young, pulling from their stomachs shotgun shell casings, paintbrushes, pump spray nozzles, toothpaste tube caps, buckles, toys, and even a printer cartridge. "Plastic's not evil," says Liittschwager, "but it needs to be used as it's intended, and it needs to be contained."

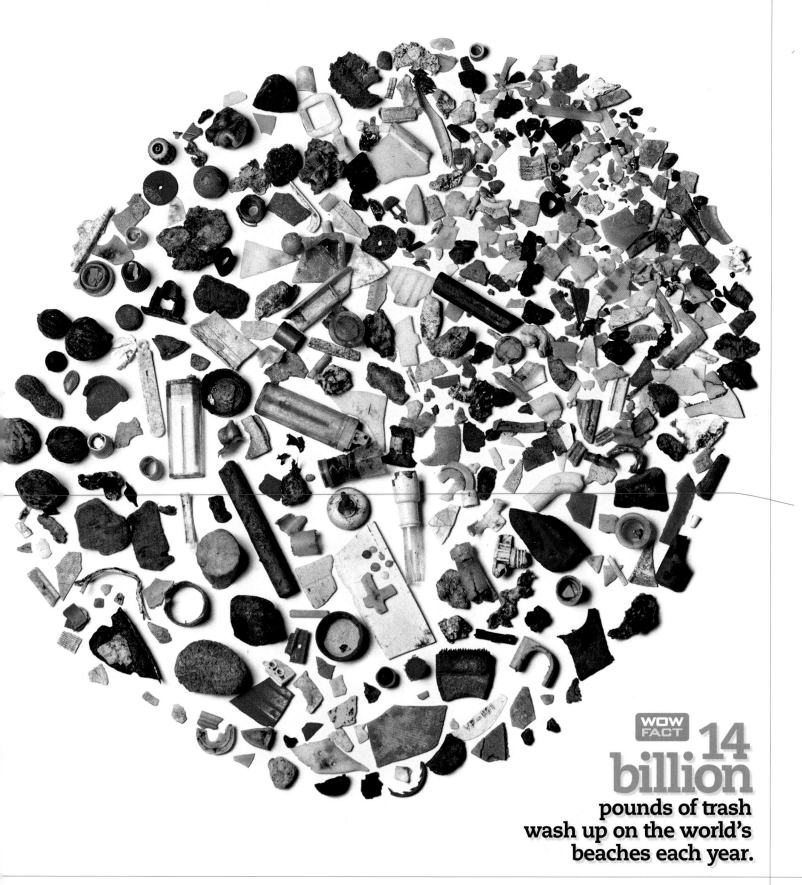

WOW FACT **14 billion** pounds of trash wash up on the world's beaches each year.

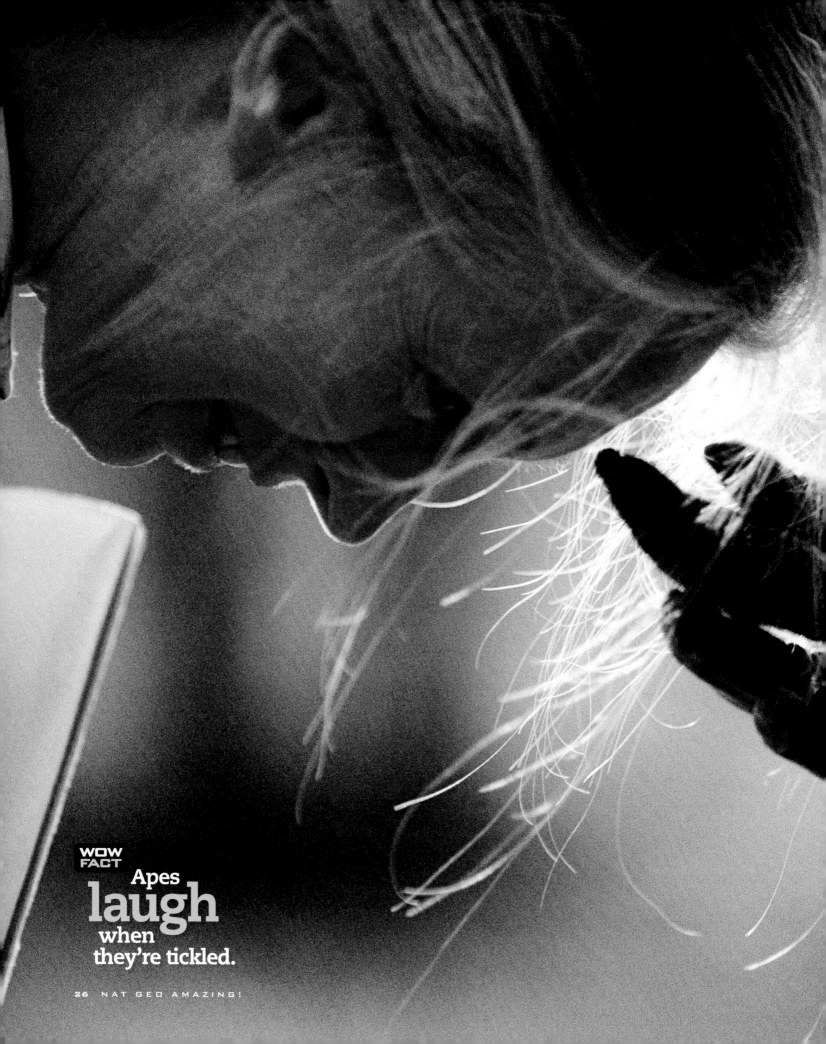

Apes
laugh
when
they're tickled.

Human Touch

An iconic moment, captured by photographer Michael "Nick" Nichols: Chimpanzee scholar, advocate, and activist Jane Goodall once again makes healing contact with a chimp wronged by humans—in this case Joe-Joe, who had spent years in solitary confinement at a Brazzaville, Congo, zoo.

Nichols, who has partnered with Goodall on two books, says the interaction was initially heart-stopping rather than heartwarming. After arriving at the zoo to visit with Gregoire, a chimp that had been caged since 1945 and was being rescued by actress turned animal rights activist Brigitte Bardot, Goodall spotted Joe-Joe, who appeared crazed from his years of isolation. As Goodall approached, remembers Nichols, "He started throwing feces at her, puffing up his chest, and acting crazy. I just started shooting, and hoping my film wouldn't run out. And then I was concerned because she was offering him her hair, which seemed just crazy because the chimp can just grab her hair, slam her head against the bars, and kill her. But she has so much empathy and understanding, she somehow knew he wasn't crazy, he was just acting crazy."

Gregoire managed to escape to a sanctuary, thanks to Bardot and Goodall's help. Nichols guesses that Joe-Joe died at the zoo, which became a killing field at the hands of guerrilla soldiers. Still, Nichols finds comfort in being able to educate the public with an image like this. "That's the magic of photography," he says. "Sometimes, there's one moment that's just perfect."

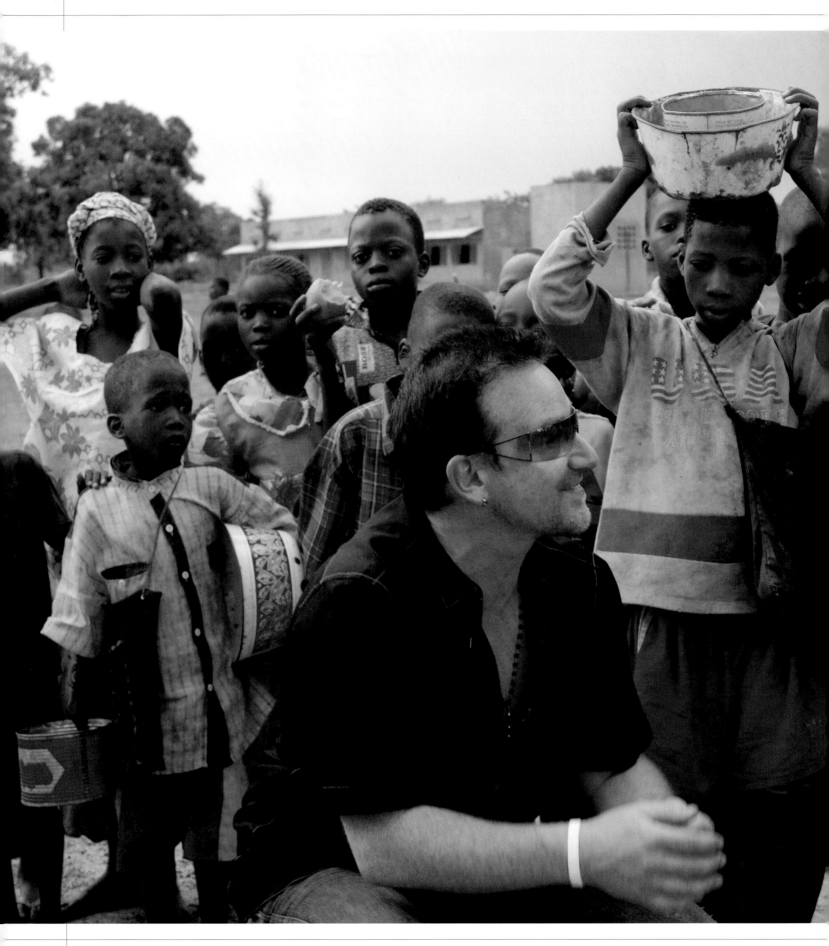

The Bono factor

14

> " Even a concert or public appearance can reach more people than anything a journalist can write in terms of raising awareness... "

First he sang about change. Then he started making it happen and asked others to follow suit. Bono, the lead singer of U2, led the charge of celebrities taking the stage and then taking on the world, demanding solutions to a myriad of problems, most specifically those plaguing Africa.

Angelina Jolie has campaigned for attention for displaced refugees, while George Clooney has raised awareness of the crisis in Darfur. Bono's emphasis, through his consciousness raising, his charities, and his meetings with decision-makers worldwide, has largely focused on long-term problem solving in the form of helping Africans help themselves. In 2002, he co-founded DATA (Debt, AIDS, Trade, Africa) to help eradicate poverty and HIV/AIDS on the continent. More recently, he has also focused on helping Africans shift from aid to trade so they might be less reliant on other countries.

His stand has earned him detractors, like any powerful politician. But few politicians can claim being three-time Nobel Peace Prize nominees who sing in a rock band. Paul Salopek, a journalist who has covered Africa for more than a decade and has contributed to *National Geographic*, says studies have shown there is a concrete benefit in terms of donations to African causes when a celebrity gets behind the cause. "Even a concert or public appearance can reach more people than anything a journalist can write in terms of raising awareness," he says. "And Bono's focus on debt relief is macro in a way that is even better and smarter than just getting people to open their wallets."

Indeed, debt relief, as opposed to attacking the myriad of problems in Africa one at a time, may offer the longest-lasting relief. As Salopek says, "You can take on something like female genital mutilation, but how far will you get? If you step back, as Bono has, and do something that might raise the standard of living for millions of people, who then might become educated, and then might change their views on female genital mutilation, you're at the top of the waterfall of the problem, rather than the bottom."

Bird's-eye View

15

Some believe they see images in nature or food, such as an image of the Virgin Mary or Jesus in patterns on tree bark or a grilled cheese sandwich. For photographer Bobby Haas that moment occurred when a large flock of pink flamingos, which he was photographing from a helicopter in the Mexican Yucatán, suddenly aligned themselves in the formation of a bird.

"The reaction to this photo has been remarkable. Some people have actually said that the image is divine intervention and proof that there is a God," he says. "It really was a very spiritual moment."

Haas, who specializes in aerial photography, has published two National Geographic books on the subject, *Through the Eyes of the Gods* about Africa and *Through the Eyes of the Condor* about Latin America. For this shot he had spent about half an hour flying above this flock, taking several hundred photographs. As the helicopter turned to leave, Haas looked over his shoulder one last time. That's when he noticed that the flock was moving into a shape resembling a flamingo. "I told the pilot to whip around but go in slowly, since if you startle the flock they will splinter," Haas remembers. The moment was so fleeting the photographer was able to take only five or six pictures of it with his digital camera; it wasn't until the photograph was published months later that he realized how magical the image was.

"It's the holy grail in photography when you capture an image you've never seen before and may never see again," he says.

There are more
PLASTIC
flamingos
than **REAL**
ONES.

NEW YORK,

1609

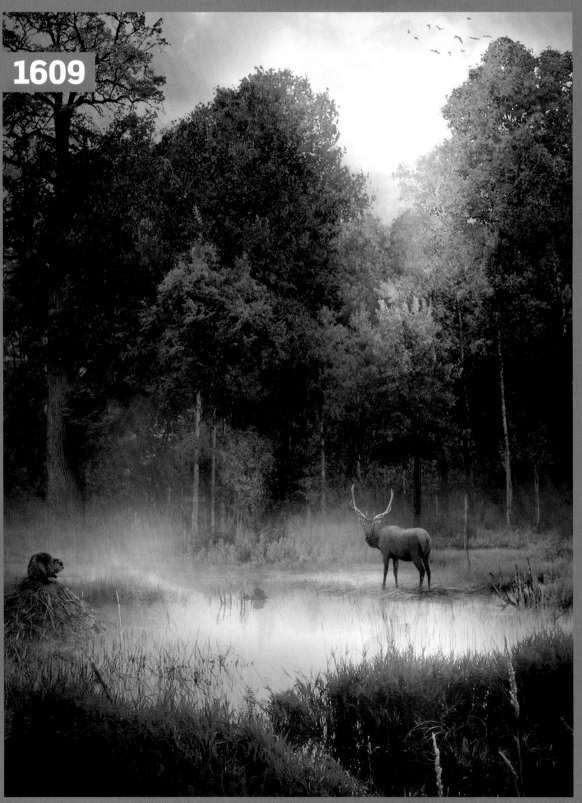

E nter a city like Manhattan from its outskirts, and it seems to arise as if it had always been a landscape of steel and bricks, lit from within. Few places on the island can compete with the "Look at me!" dazzle of Times Square, an intersection where Broadway and Seventh Avenue cross in a blaze of neon, where hotels and theaters and restaurants compete like nursery school children for attention. Photographer Robert Clark captures the energy of the area in the image at right, where speeding taxis become a blur and a pedestrian, inoculated to such stimulation, speaks nonchalantly on her cell phone.

Little wonder, then, that it can be so difficult to believe that at one time, not only were these streets silent, they weren't streets at all. Originally, Times Square was a red maple swamp, where two creeks joined to feed a beaver pond.

This is the goal of the Mannahatta Project, which is attempting to show what New York looked like in 1609—just before Henry Hudson and his crew arrived—in an effort to encourage conservation efforts. It was a time when Manhattan was a 13-mile-long wilderness, populated by towering chestnut, oak, and hickory tress, its salt marshes and grasslands filled not with rushing

NEW YORK

commuters but with wild turkey, grazing elk, and black bear.

Explains the project's leader, Wildlife Conservation Society ecologist Eric Sanderson, "I wanted people to fall in love with New York's original landscape, in a place that people normally don't think of having any nature at all." Sanderson's goal is to show what any spot in the city might have looked like 400 years ago, and to create a blueprint that can be used in wild places before they change. The project now includes more than 50 historians, archaeologists, geographers, botanists, zoologists, illustrators, and conservationists. "New York isn't just a place of fabulous art, music, culture, and communications," says Sanderson, "but also a place of amazing natural potential—even if you have to look a little harder here."

TODAY NEW YORK CITY IS HOME TO 8,363,710 PEOPLE.

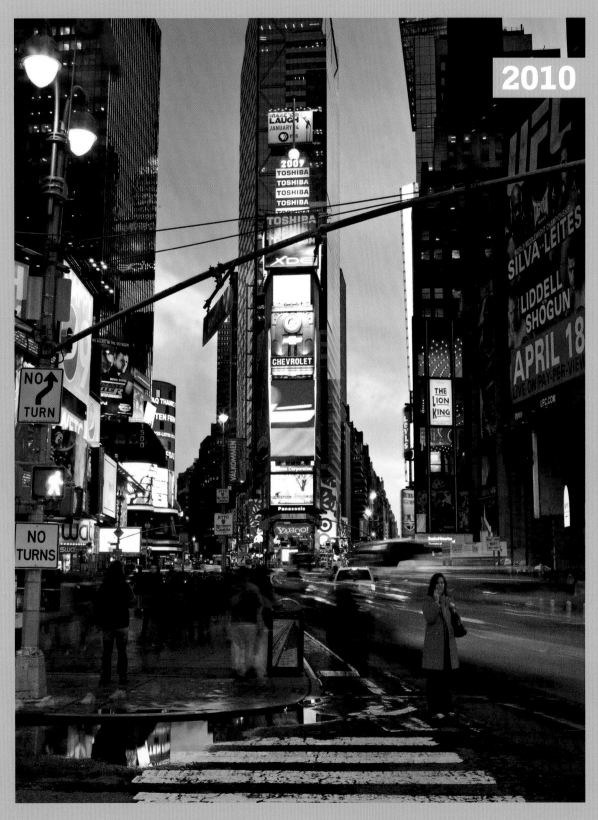

2010

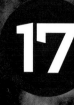

17

**WOW
FACT**

VERY FEW MEN STILL UNDERGO
SCARIFICATION,
NOT BECAUSE OF THE
PAIN INVOLVED,
BUT BECAUSE OF THE
EXPENSE.

IT COSTS A FEW HUNDRED DOLLARS AND SEVERAL PIGS
TO HIRE SOMEONE TO DO THE SCARIFICATION.

MANHOOD 101

Some cultures welcome adolescents into adulthood with parties. Others require rites of passage that test the mettle of the people about to leave childhood behind. For boys in New Guinea, becoming a man used to mean cannibalism, headhunting, and the ritual of scarification.

In 1929 Father Franz J. Kirschbaum photographed a boy undergoing a manhood initiation of scarification. The boy, thought to be a member of the Iatmul tribe, was held down by his uncles while one sliced hundreds of diamond-shaped slivers of skin from the boy's torso; ash was then rubbed into the wounds. Once the wounds healed, their scars would resemble the skin of a crocodile, an animal whose ferocious strength the boy would emulate as a man.

Headhunting and cannibalism have fallen out of favor as part of the ritual transition from boy to man, but the scarification rite is still practiced by members of the tribe. However, the practice is on the wane due to the high cost of having it performed. It can run a few hundred dollars and several pigs to hire someone to do it.

18 The Lady who Married the Eiffel Tower

Paris has inspired millions of lovers, but few in the same way it has Erika La Tour Eiffel, as she is now legally known. She considers herself the bride of the famous monument.

Eiffel is what is known as an objectum sexual, a person who forms deep, often erotic bonds to monuments and other objects. Talking about objectum sexuals, filmmaker Agnieszka Piotrowska, who shot, wrote, and directed the documentary *The Woman Who Married the Eiffel Tower*, explains, "They would say that they come from a tradition of animism, the Eastern philosophy that believes objects have a life and soul, and that they can tap into that energy and communicate with these objects through telepathy or something like that. I say that may well be the case, but even if it is, there's something particularly difficult about being in love with a steel bridge or tower, because it can't return an embrace."

Eiffel, a San Francisco native who wed the tower in a ceremony that took place in front of friends, is a former member of the military and a champion archer who also fell in love with her fighter plane and a bow named Lance.

Many objectum sexuals are omnisexual: Eiffel believes that the Eiffel Tower is a "she," the grande dame of Paris. During the wedding ceremony, says Piotrowska, "She said, 'I hereby take you as my wife.' " Nor do objectum sexuals necessarily practice monogamy: Eiffel also considers herself romantically attached to other monuments simultaneously, and she is aware that she "shares" these loves with other objectum sexuals—not to mention a public that considers them tourist attractions. She also has romantic connections with the Golden Gate Bridge and the Berlin Wall.

"She likes that the tower gives joy and happiness to other people," says Piotrowska. As far as sharing the Berlin Wall and the Golden Gate Bridge with other objectum sexuals who are also in "relationships" with these structures, "Sometimes it can become difficult," the filmmaker concedes. "But the wonderful thing about the Internet is there are support groups and chat rooms where about 40 people who have this passion are registered as users and can share with each other." Piotrowska says that, like many objectum sexuals, Eiffel claims to have suffered abuse as a child; many objectum sexuals have also been diagnosed with Asperger's syndrome, a mild form of autism (Eiffel has not). "If you asked the people in the film, they would be happy to say that some of them have Asperger's," says Piotrowska. "And they wouldn't have a problem saying many of them were abused sexually during their childhood, and that their relationships with objects are both loving and sexual. What they would not like," she continues, "but which I think is the truth, is that they have suffered a certain element of psychological damage, which is why they turn away from intimacy with people and towards autoerotic relationships."

For Piotrowska, the experience of making the documentary, which aired on British television's Channel 5, was no less than life altering: She soon returned to school part-time to earn her Ph.D. in psychology, which she hopes will inform her work as a filmmaker. As for the fate of Eiffel and others like her, Piotrowska stresses there is no need for concern on their behalf: "If you asked Erika, she would say she is happy with the way she is and her life. She has a lot of friends, but she can't relate to people sexually, and she doesn't want to."

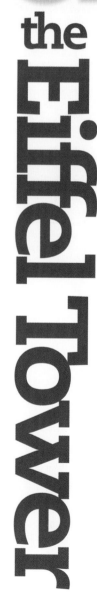

19 Nudi-Whats?

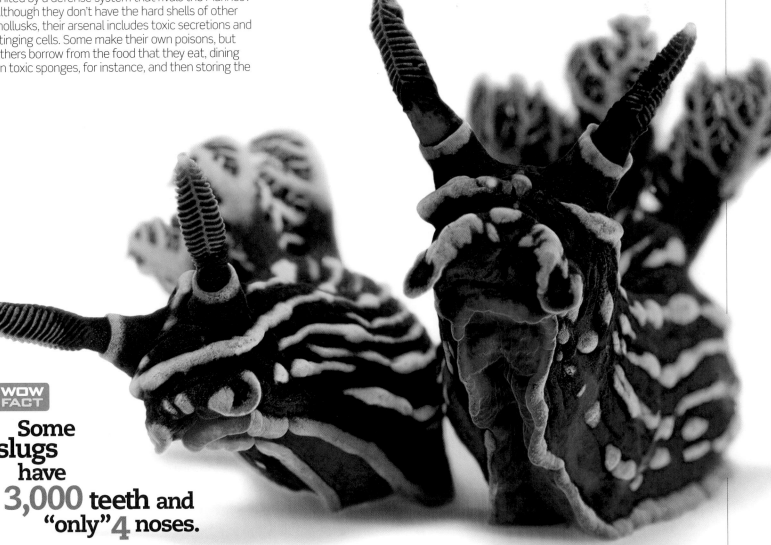

Bright blues, proud purples, garish greens—the colors of seabound nudibranchs (better known as sea slugs) are beautiful to the eye but deadly to the touch. Nudibranchs have nothing between their skin and the ocean—no protective shells or pointy spikes—to keep predators at bay. But their bold color scheme actually serves as a first line of defense; in the wild, a bright palette is often an indication of toxicity, so hunters often keep their distance from the colorful nudibranch, which means "naked gill."

There are 3,000 different species of nudibranchs, united by a defense system that rivals the Marines'. Although they don't have the hard shells of other mollusks, their arsenal includes toxic secretions and stinging cells. Some make their own poisons, but others borrow from the food that they eat, dining on toxic sponges, for instance, and then storing the irritating compounds to be released when they become agitated. Other nudibranchs ingest fire corals and anemones, to which they are immune, later letting those poisons loose.

This makes them less than appetizing on the plate, although sea spiders, turtles, and a few crabs can stomach them. Some people consume them, but only after removing the toxic organs. If nothing else, it must be acknowledged: This sea slug appears a worthy adversary.

WOW FACT

Some slugs have 3,000 teeth and "only" 4 noses.

GALAXY QUEST

20

QUEST 20

WOW
FACT

THE BRIGHTEST PHASE OF A
SUPERNOVA'S EXPLOSION

RADIATES AS MUCH ENERGY
IN A SINGLE DAY
AS THE SUN HAS IN THE PAST

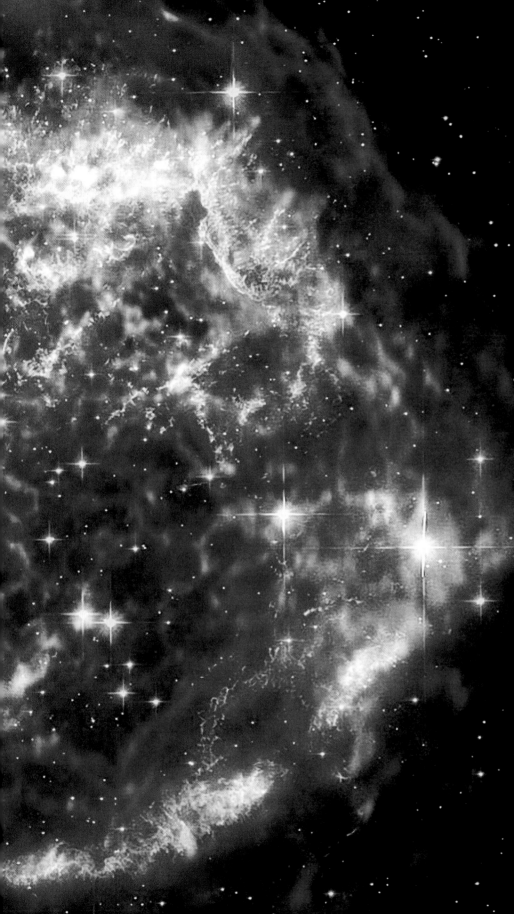

If only our personal flameouts contained half the beauty and majesty of Cassiopeia A, the supernova remnant of a star explosion in the Milky Way.

As captured by the Hubble Space Telescope, these wisps of interstellar gases make up the youngest known detritus of an explosion in our home galaxy. Located some 10,000 light-years from Earth, the star collapsed under its own weight more than three centuries ago, subsequently bursting into a flash of light composed of colored gases: green (oxygen), red and purple (sulfur), and blue (hydrogen and nitrogen). The gases and resulting light show remain on the move; comparisons of the Hubble images taken at different times from NASA's Chandra X-ray Observatory show some of the debris continuing to travel at up to 31 million miles (50 million kilometers) an hour. That's fast enough to make it from Earth to the moon in 30 seconds.

The astonishing recorder of these images weighs 24,500 pounds and was launched into orbit in 1990; it circles Earth above the atmosphere, which distorts and blocks the light that reaches our planet. The $1.5-billion telescope has captured hundreds of thousands of images and helped scientists determine the age of the universe (about 13.7 billion years, rather than the 10-billion-to-20-billion-year range previously thought) and the identity of quasars (quasi-stellar radio sources); it's also helped prove the existence of dark energy—not the one we're all too familiar with here on Earth, but a mysterious force that causes the expansion of the universe to accelerate. Even more astonishing, the Hubble accomplishes these things while moving at 17,500 miles an hour, completing an orbit in a stunning 97 minutes. Thankfully, one of its tasks isn't stopping to smell the roses.

3 MILLION YEARS.

A Wing and a Prayer

The secret of nature's most majestic migration.

One of my most inspirational experiences on assignment for National Geographic was to visit the winter home of migrating monarchs in Mexico.

My butterfly obsession began in yoga class. While my body was downward dogging but my mind was far, far away, in the Mexican states of México and Michoacán. North America's winters are too cold for the butterflies, so they migrate en masse to the area's boreal forests, which are the winter haven for more than 300 million monarchs.

After that yoga class, I started to notice butterflies everywhere. Fluttering down city streets in the winter, intricately tattooed on women's bodies, even appearing in my own children's artwork. The butterflies were speaking to me, so I decided to visit them.

r

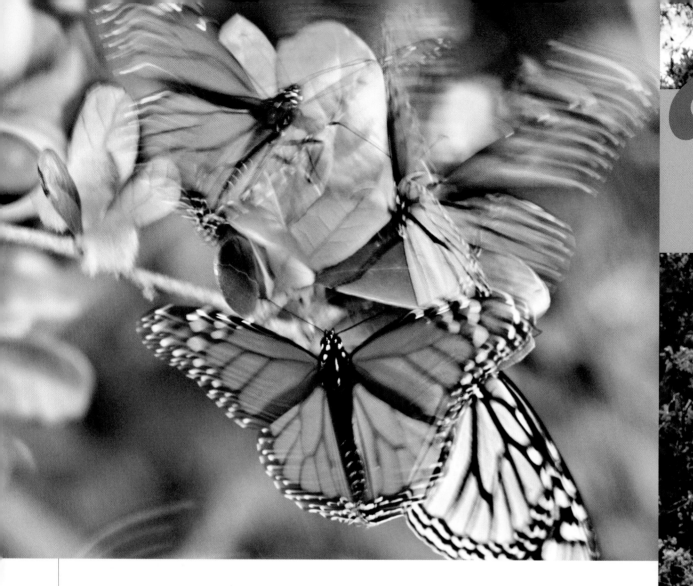

Gamely I set out to see the Kingdom of the Monarchs, a remote, 60-square-mile area in central Mexico's volcanic highlands.

How the monarchs reach this destination is nothing short of a miracle. They weigh no more than a fifth of a penny. Their wings are so delicate they would seem no match for the gusts of wind on which they surf. And though they have brains that are microscopic, they are somehow able to complete a trip they have never taken before—handed down through genetic code for at least 10,000 years—with pinpoint accuracy.

Once they reach their destination of warmer climes, they will stave off sexual maturity until spring arrives and the milkweed grows, creating a surface on which they'll lay their eggs. In the safe haven of these particular Mexican forests, they gather in groups that can number 150 million, hanging from pine trees that threaten to break under their cumulative weight.

I visit El Rosario Monarch Butterfly Sanctuary, 129 miles west of Mexico City, which requires an hourlong hike up into thin air. I pass other visitors who are on their way down.

"Worth it!" they call, jubilantly.

I continue to climb. It is like a walking meditation, the intensity of the experience is purifying, as if preparing the mind for the sacred experience to come.

I approach 10,000 feet, exhilarated but breathless, stripping off layers of clothing. I'm reminded of how a butterfly develops through four stages—from egg to caterpillar to chrysalis to the winged delight that flits around me. I arrive, and the show begins. One butterfly flutters by, and then another, and another. I watch as dozens float past, their shadows dancing like polka dots on the dry dirt. They are everywhere, hanging on the pine trees like flat Christmas ornaments, clumping like swollen beehives on the ends of branches. Some evergreens are so covered with butterflies that they resemble maples in the fall. I stand, surrounded by 150 million—million!—monarchs and take in the sound. Standing on the path, I am mesmerized. I listen. The whirring of their wings is soft, like rain. They say that this is the only place in the world that you can actually hear the sound of a butterfly's wings beating. I feel light, happy, as if I've been kissed by nature.

One of the most striking things about being in the sanctuary is not the monarchs themselves but the effect they have on the people here. Young, old, male, female, local, foreign—everyone is smiling, helpful, friendly. It's as if butterflies bring out the best in human nature. On the walk down, I'm befriended by a pack of female athletes on their annual visit here. Two of the four carry dogs in their backpacks: a white poodle with a pink bow named Bianca and a Chihuahua named Merlina with two puppies.

s the only place in the world that
CAN ACTUALLY HEAR THE SOUND
butterfly's wings beating. "

I ask these cosmopolitan women why they keep returning to this quiet place when Mexico has so many playgrounds for the young and beautiful. "It's a mystical place," says one of the women, Teresa. "It's healing for the spirit to come here."

As we walk down the path, back to civilization, Teresa's friend Josefina recites a poem in Spanish, which Teresa translates:

> Small volatile souls
> That let our imagination fly away
> That give us our strength
> And feel our vigor.

Yet for all of the butterflies' stunning survival skills, their migration and existence are becoming threatened by humans logging the forests in which they breed. In 2002, a single winter storm wiped out 70 percent of the overwintering population, leaving a two-foot-high pile of dead butterflies on the forest floor. I worry that my children may not know this experience, but I am heartened to learn the facts.

The state of Mexico is offering farmers incentives not to log the property where the butterflies gather, and killing even one butterfly leads to a fine of 500 pesos (about $39.00), enough to discourage most. In the past decade, Mexico has been able to triple its acreage of protected areas, with illegal logging dropping 48 percent since 2008. And UNESCO has declared Mexico's 139,019-acre Monarch Butterfly Biosphere Reserve a World Heritage site, helping ensure that these magical, mythical creatures may continue to fly away home. Good thing, considering the Aztec believe that when we die, our souls become butterflies.

After spending five days visiting the sanctuaries, I stop on the roadside to have a final experience with the butterflies, which are drinking the salt and minerals from the mud puddles. I watch as children in blue school uniforms crouch down to closely observe a populated puddle. A butterfly surprises one girl by hopping aboard her finger. Her friend snaps a picture with her cell phone, and the two girls giggle in wonder. Everyone around the kids smiles at their delight.

And that's when I realize the butterflies have given me a parting gift. I tuck into my heart the reminder that joy is contagious, we're all connected, and the proof of the healing, salubrious effect that Mother Nature has on human nature. ◢

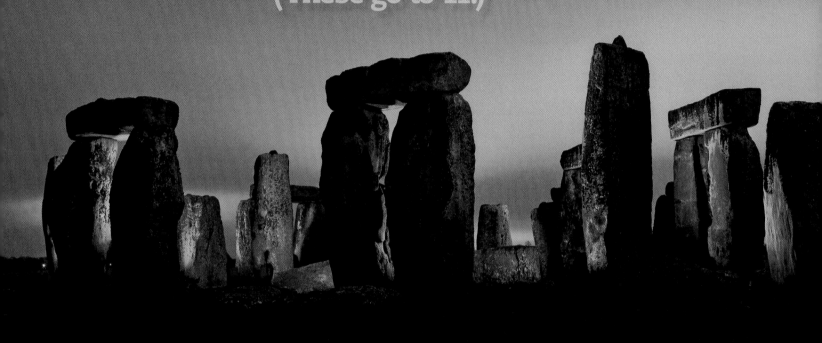

22 Secrets of Stonehenge

(These go to 11.)

Stonehenge: For some, the word brings to mind the famously funny concert scene from the movie *This Is Spinal Tap*. For others, it conjures up thoughts of ancient secrets and rituals. That Stonehenge still retains its mystery 4,500 years after its construction began is itself worthy of awe. How can we still not know what this majestic monument symbolizes, how people handled these massive sarsen stones—the largest of which weighs as much as 50 tons—and, most important, why they are there?

New research is shining light on the possible meaning of the circle, located on England's Salisbury Plain. Stonehenge is aligned on the axis of the summer solstice sunrise and the winter solstice sunset; discoveries at a former dwelling nearby called Durrington Walls, a Neolithic village that catches the winter solstice sunrise, lead archaeologist Mike Parker Pearson to believe that the village was used for lodging to celebrate the solstice, with a path between Durrington and Stonehenge.

One thing that is certain is that Stonehenge had been used as a burial site; 52 cremations and more burials have been found. With as many as 240 remains, it is the largest Neolithic cemetery in England. Parker Pearson's theory suggests seasonal processions led from Durrington to Stonehenge, the domain of the ancestral dead.

But scientists say there isn't yet enough evidence to stop asking questions about Stonehenge's purpose. Adds environmental archaeologist Michael Allen, "I see it being used as a cathedral, or Wembley Stadium. Some days it was used to hold solemn rituals, other days for more ordinary gatherings."

Whatever its ancient purpose might have been, today Stonehenge maintains a strong hold on the imagination. Thousands of people visit on the summer solstice to see the sun rise every year, continuing an ancient tradition. Others are content to listen to Spinal Tap's ode to the monument: "Stonehenge! 'Tis a magic place / Where the moon doth rise with a dragon's face / Where the virgins lie / And the prayers of devils fill the midnight sky."

WOW FACT

Stonehenge was dug 4,500 years ago with red deer antlers.

It's every armchair traveler's fantasy: a changing landscape without having to leave the comforts of one's home. Architect David Fisher has designed a 200-apartment building in Dubai where each of the 80 floors rotates individually, taking in the views of the city in a one-hour orbit.

The building is luxurious—a drive-in elevator allows owners of the apartments, which range in price from $3 million to $30 million, to park outside their doors—but it's also smart: Fisher's Dynamic Tower, as it is called, is the first 100 percent self-powered green building with the ability to generate electricity using horizontal wind turbines and solar panels. Those who wish to live here but suffer from motion sickness need not despair: A voice-activated control allows owners to instruct the floors when to take a spin.

TAKING A SPIN

23

WOW
FACT

MORE THAN
10 MILLION MILLIONAIRES
ARE ALIVE
TODAY.

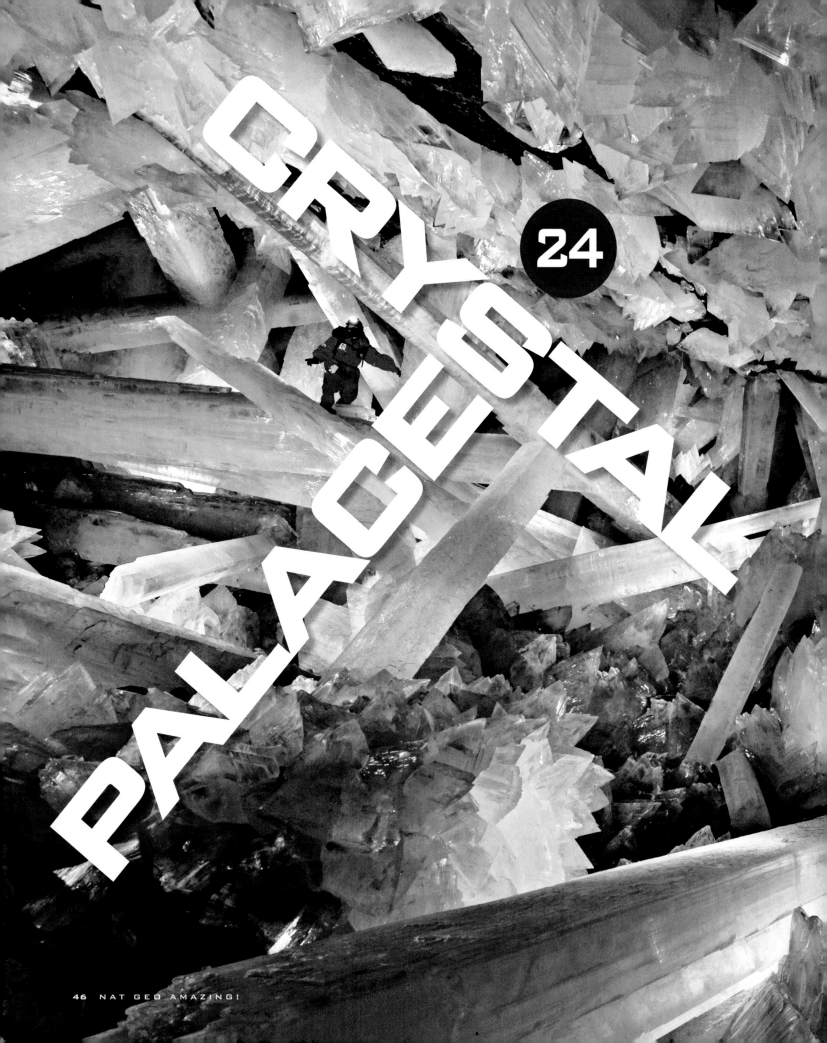

CRYSTAL PALACESTAL

24

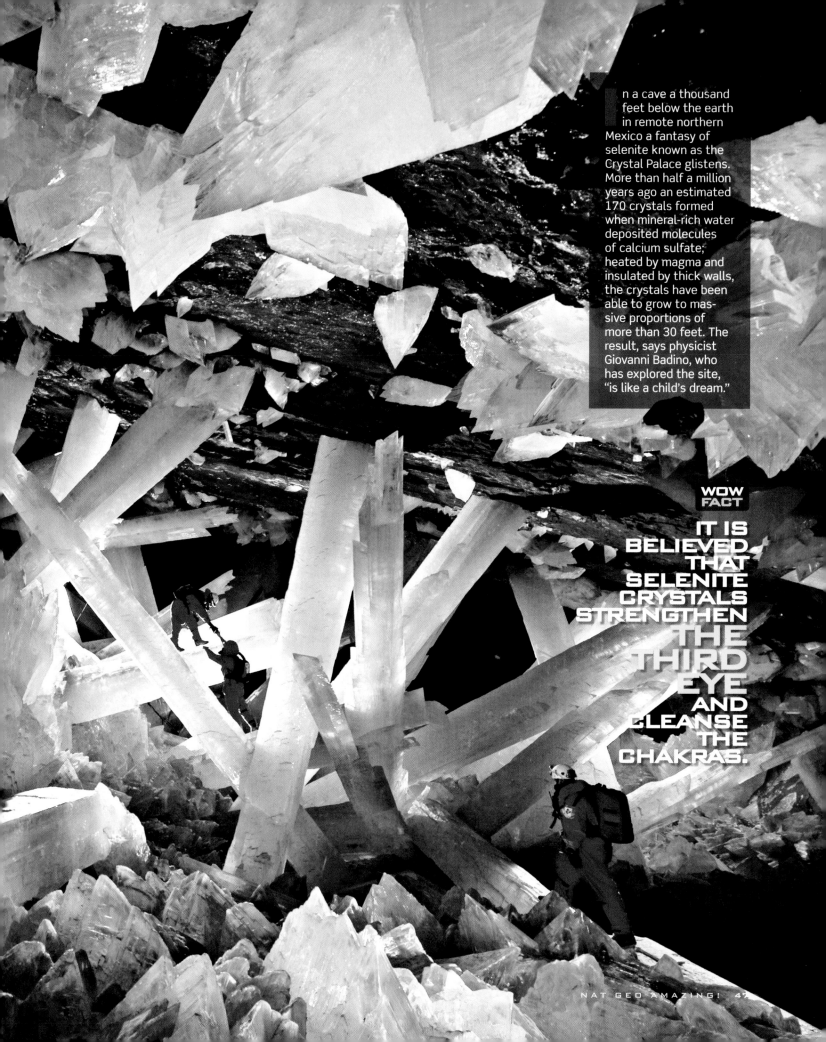

n a cave a thousand feet below the earth in remote northern Mexico a fantasy of selenite known as the Crystal Palace glistens. More than half a million years ago an estimated 170 crystals formed when mineral-rich water deposited molecules of calcium sulfate; heated by magma and insulated by thick walls, the crystals have been able to grow to massive proportions of more than 30 feet. The result, says physicist Giovanni Badino, who has explored the site, "is like a child's dream."

WOW FACT

IT IS BELIEVED THAT SELENITE CRYSTALS STRENGTHEN THE THIRD EYE AND CLEANSE THE CHAKRAS.

25 LEARN TO THINK LIKE A
KUNG FU MASTER

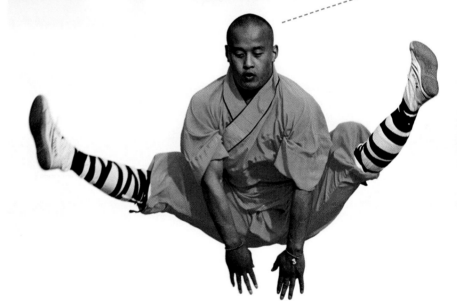

"War and peace" takes on a whole new meaning when it comes to the 1,500-year-old martial art of Shaolin kung fu. But what seems like a mass of contradictions to a Western mind—except, perhaps, to fans of David Carradine in *Kung Fu*—is perfectly sensible to the monks who practice the discipline.

To wit: Practice meditation to keep your mind quiet at all times, even when breaking an iron bar over your head or using your hand to cut through a two-by-four like a chain saw.

Still deeper: Accept that only through understanding violence can you avoid it. If violence cannot be avoided, parry only with the force initiated by the attacker, in essence taking the intent of harm and "returning to sender." Even if it's a battle to the death, you are merely avoiding another's attempt to inflict pain on you.

Needless to say, nailing these simple truths means that situations that cause stress to the less enlightened become nonissues for the monks. Take stage fright. The monks pictured here tour the world performing their combination of acrobatics and fighting skills for audiences. Photographer Philipp Horak, who tagged along to document them, said they keep their cool at all times. "You'd think they would have to prep and concentrate before a show," says Horak, "But they go to a Chinese restaurant at 6 p.m., eat so much they feel bad, and then perform."

 WOW FACT

KUNG FU WAS CREATED AROUND A.D. 500 AS SECRET FIGHTING TECHNIQUES FOR THE MONKS OF THE SHAOLIN TEMPLE.

THESE SHAOLIN WARRIORS HAVE FOUND THE PATH TO
INNER PEACE

The Seal Who Loved Me

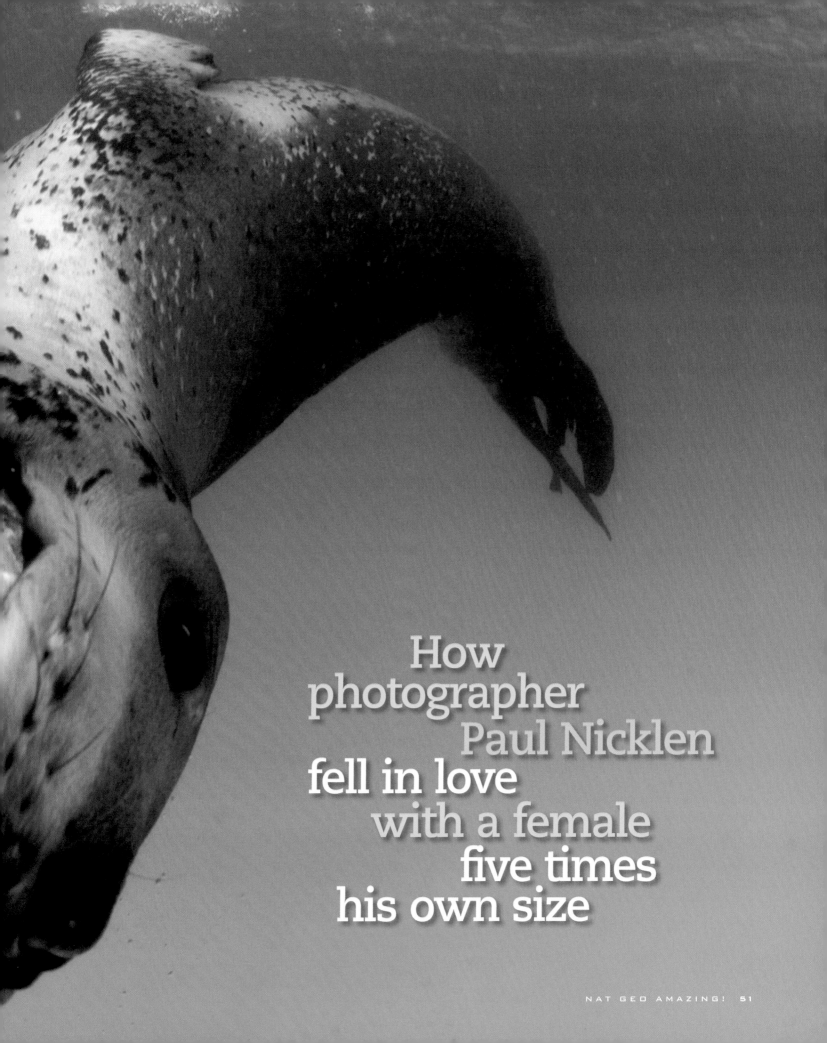

How
photographer
Paul Nicklen
fell in love
with a female
five times
his own size

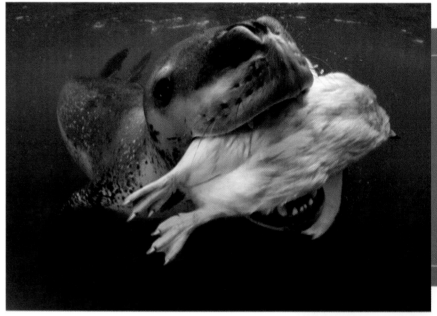

My name is Paul Nicklen. I am a wildlife photographer who has spent my life exploring the Arctic. The title of my book Polar Obsession *succinctly explains my passion. And one thing that I am particularly passionate about is dispelling the misinformation about the leopard seal.*

While leopard seals are portrayed as villains in movies like *Happy Feet, Eight Below,* and *March of the Penguins,* they are actually intelligent animals capable of interaction with humans. To document this, I travel with my friend Goran Ehlmé to Antarctica, home of the leopard seal.

After we cross the hellish Drake Passage—the 50-nautical-mile stretch of water between Argentina and the Antarctic—we instantly spot a massive female leopard. Goran, who has seen many leopard seals, says in his Swedish-accented English, "That's a bloody big seal, yah." We quickly launch our inflatable Zodiac and set out to get a closer look.

Almost immediately the seal swims over to our Zodiac and ducks underneath. She is as long as the boat, but what is most astonishing is her girth of three feet. (A large female can measure up to 13 feet long and weigh in excess of 1,100 pounds.) She is also clearly the alpha seal of the feeding ground, and she has the best territory—the place where penguin chicks enter the water and go out to sea. She runs off any other leopard seals that comes near, and both males and females give way to her.

While I am still trying to come to terms with her size, she swims off. She grabs a chinstrap penguin and comes back with the bird in her jaws. We watch as she starts ramming the bird against the underside of the boat with such force that she lifts the bow out of the water. I am thankful to be safely in the boat and not in the water. After she kills the penguin, the seal swims to within a few feet of us. She takes the penguin by the head and whips it from side to side, beating the 13-pound bird against the surface of the ocean, attempting to tear its head off and separate the skin from the meat so she can eat it. While this is hard to watch, the biologist/naturalist in me understands that there is no malicious intent when it comes to predator and prey. It is simply survival.

Now that the water is awash with blood, Goran turns to me and says, "It is time for you to get in the water, yah?" Even though my goal is to discover if leopard seals are really vicious, the thought of getting into the water with her makes my adrenaline surge. My mouth goes dry, my legs become numb, and I am momentarily paralyzed with fear. Goran says, "It doesn't get any better than this. Get in the water!" I can barely part my trembling lips to force the snorkel into my mouth. I pick up my underwater camera and slip over the side of the little dinghy into the cold, 30-degree Antarctic waters.

Objects appear 30 percent larger underwater, and as big as the seal had appeared from above, she seems incomprehensibly large underwater. I remain motionless on the surface. She immediately swims in my direction,

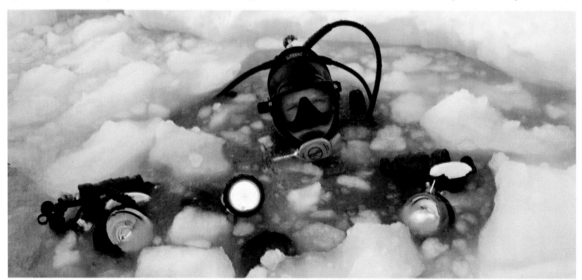

"SHE IS TRYING TO FEED ME PENGUINS because she realizes that I am an absolutely useless predator in her ocean, and my ineptness at securing a meal agitates her.**"**

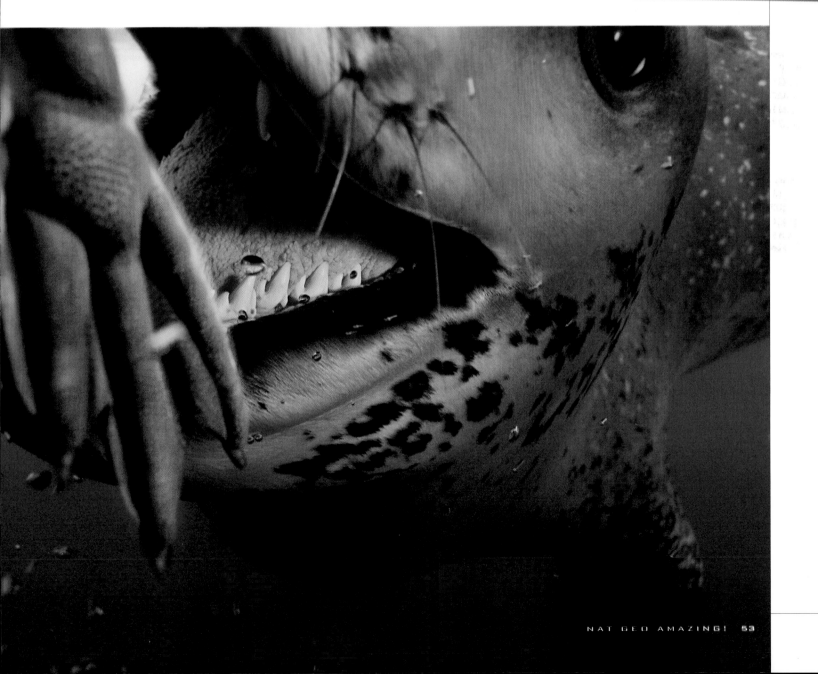

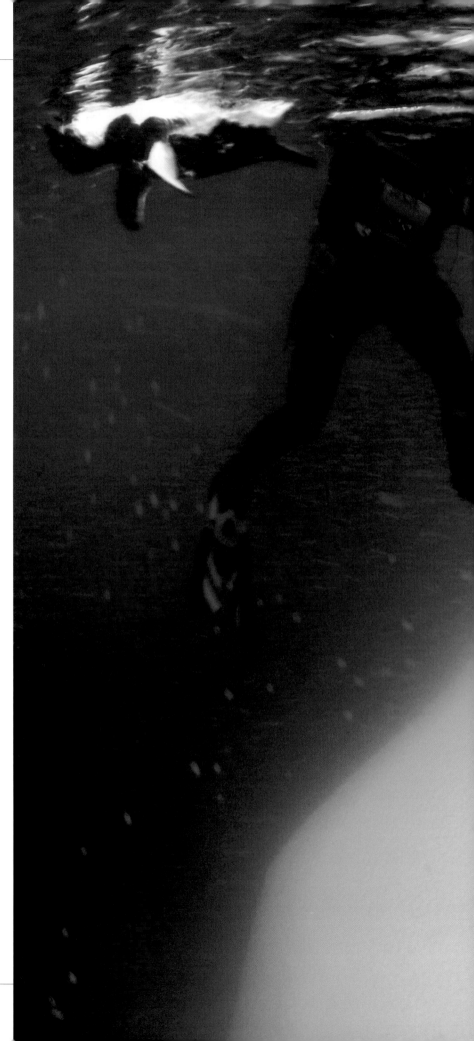

and without slowing down, opens her huge mouth and lunges at me so that the front of my camera lens is almost at the back of her throat. Her upper teeth are just inches above the top of my head, and her bottom canines come close to the bottom of my chin.

She maintains this pose for a few seconds, then pulls back and observes my reaction. She repeats this threat several times, striking out like a cobra but always stopping within inches of my camera. Goran has warned me that she will threaten me and that I simply need to hold my ground, but it is nerve-racking. I am happy to concede, but I do not retreat. I see this meeting as being all about communication. I don't believe she will bite me; in a strange way, it is a very gentle gesture, as if she is saying, "Look how big I am. What did you say you were doing here?"

Suddenly she stops all her threat displays and swims off, and I think the encounter is over. Then the truly unexpected happens. She returns with a live, freshly caught penguin in her mouth, swims about ten feet away from me, and releases it. The penguin swims toward me and veers off. She chases it, brings it back, and lets it go again, right in front of me. I believe that she is trying to feed me penguins because she realizes that I am an absolutely useless predator in her ocean, and my ineptness at securing a meal agitates her. I believe she thinks I am going to starve to death if I don't receive her help. She captures another penguin and eats it in front of me. She then captures another penguin, plays with it, and then offers it to me in this exhausted state. Finally, perhaps realizing the full extent of my incompetence as a hunter, she brings me a dead penguin and leaves it floating in front of my mask. When I don't touch her offering she appears frustrated and blows bubbles in my face. Ultimately, she forcibly places dead penguins on my head and underwater camera. I flood my mask because I am laughing so hard that water trickles in the sides.

Over the next four days, she tries to keep feeding me penguin after penguin. Once, during those four days, I become concerned that I've overstayed my welcome; she seems to have tired of my presence. Suddenly, during one of our "normal" feeding sessions, she visibly tenses and makes a deep guttural jackhammer-like sound—a threat display that I feel reverberate throughout my entire body. I sense that she is about to attack, but the moment quickly passes. What has actually happened is that another leopard seal has sneaked up behind me. Her threat display is intended to protect me, and clearly it works. As if to prove her point, as soon as the marauding seal turns away, she gives chase, takes that seal's penguin, and brings it to me.

As a biologist, I can understand that she is trying to feed me, but I think the reality is more complicated than that. Though I have never accepted her offerings, she has continued to bring me penguins. I'd like to think that at some level it is an attempt at interspecies communication.

I don't know if she has ever quite figured out who or what I am, or whether some part of her memory retains the experience of my visit. But for me, my relationship with this magnificent seal, so approachable, so tender, and yet so fierce, will stay with me forever. I know I will never forget her. ◢

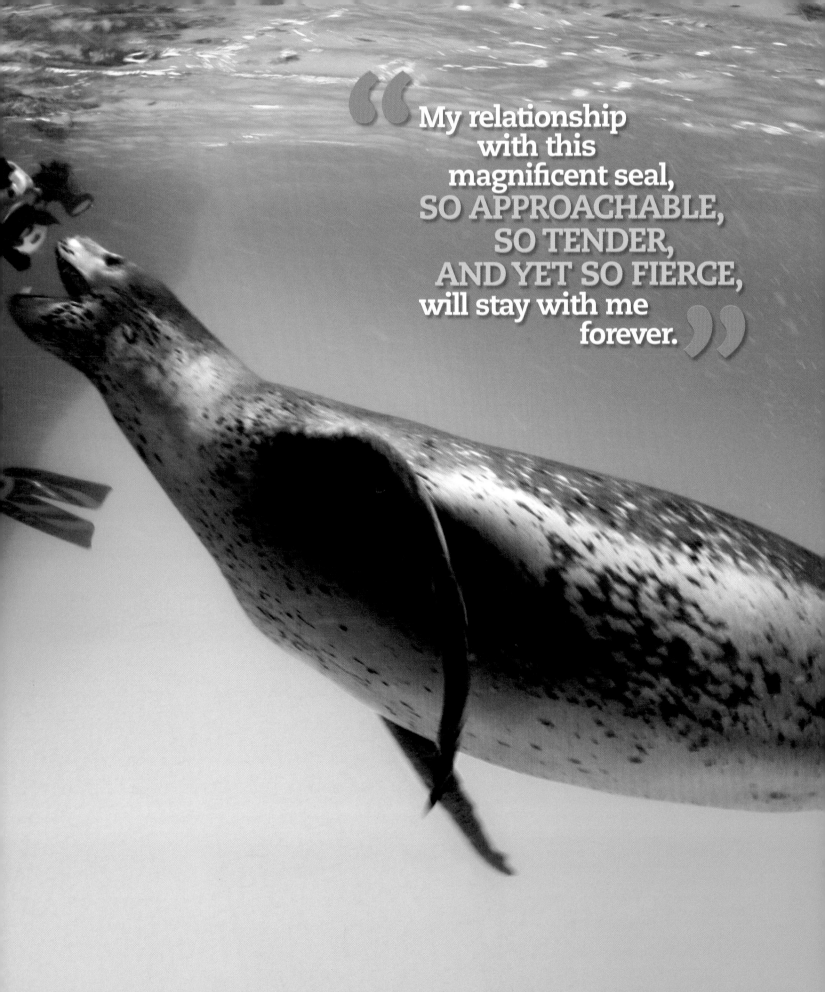

"My relationship
with this
magnificent seal,
SO APPROACHABLE,
SO TENDER,
AND YET SO FIERCE,
will stay with me
forever."

1984

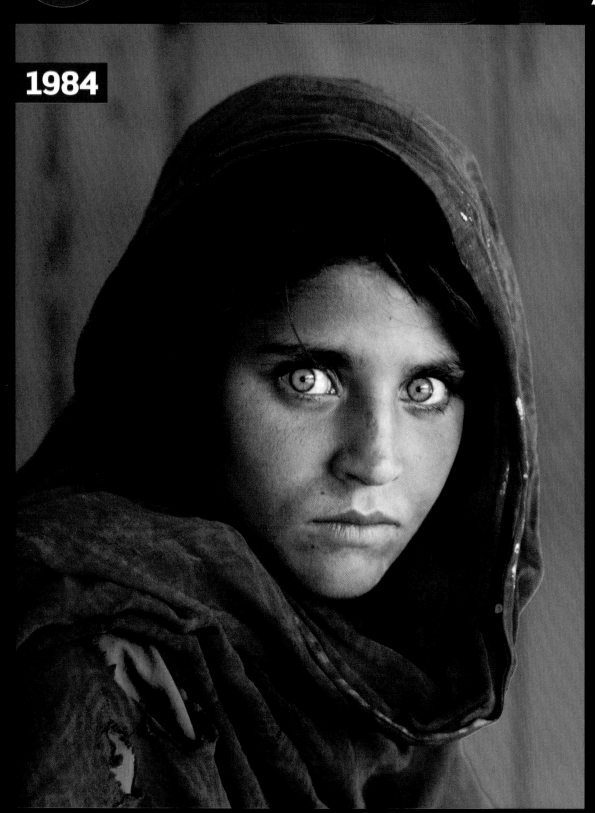

Brilliant sea green eyes haunted by what they have seen, her intense gaze is unwavering. In a life-changing nanosecond, during which inspiration and vision flash through an artist's mind, an image captured by photographer Steve McCurry became an icon.

In 1984, McCurry was traveling through Pakistan documenting the ordeal of Afghanistan's refugees in camps when he spotted his subject inside a school tent studying with other children. While his eye was drawn to the young girl first, he sensed her shyness and approached her last, asking for and receiving her permission to take her picture. "I didn't think the photograph of the girl would be different from anything else I shot that day," he says.

When the photograph ran on the cover of the June 1985 issue of *National Geographic*, McCurry and millions of others realized the power of what he had memorialized. The image speaks at once of an ideal of perfect beauty and the ravages of a reality marked by war. For the next 17 years, her face would continue to resonate, familiar to the masses. But her identity would remain a mystery.

More than 15 years later, McCurry and a team from National Geographic returned to Pakistan to search for

FOUND

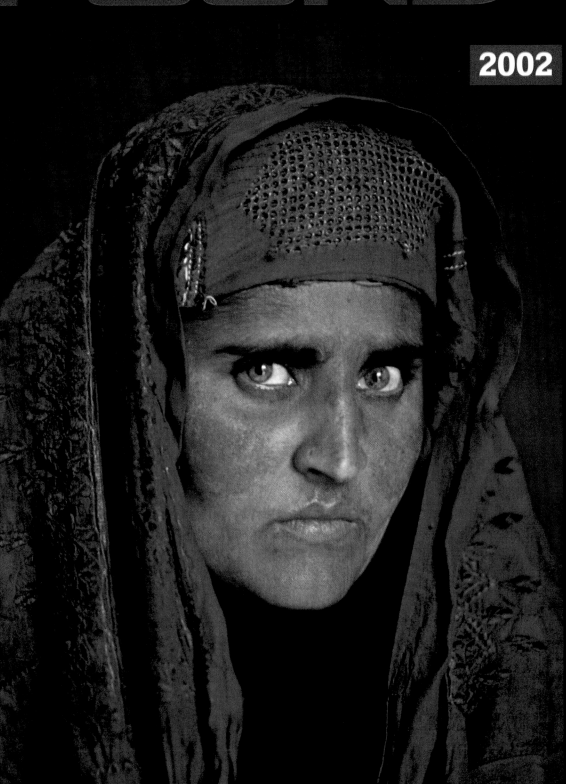

2002

the woman who was, unbeknownst to her, famous. After showing her picture around, the team learned that the woman had returned to Afghanistan and was now living in a village that was a three-day journey away.

A childhood friend offered to bring her to the team, and when she walked into the room, remembers McCurry, he recognized her right away. He learned her name—Sharbat Gula—and that she was from the Pashtun tribe. And although she was then no older than 30, she looked far more weathered to a Westerner's eye. "She's had a hard life," says McCurry.

By 2002 she had lived through 23 years of war, during which more than 1.5 million people have been killed. This time, says McCurry, "She found it easier to look into the lens than at me."

" SHE REMEMBERS THE MOMENT THE PHOTOGRAPHER TOOK HER PICTURE. SHE REMEMBERS HER ANGER. SHE HAD NEVER BEEN PHOTOGRAPHED BEFORE. UNTIL THEY MET AGAIN 17 YEARS LATER, SHE HAD NOT BEEN PHOTOGRAPHED SINCE. "

—NATIONAL GEOGRAPHIC MAGAZINE

28

WHEN WILL YELLOW BLOW?

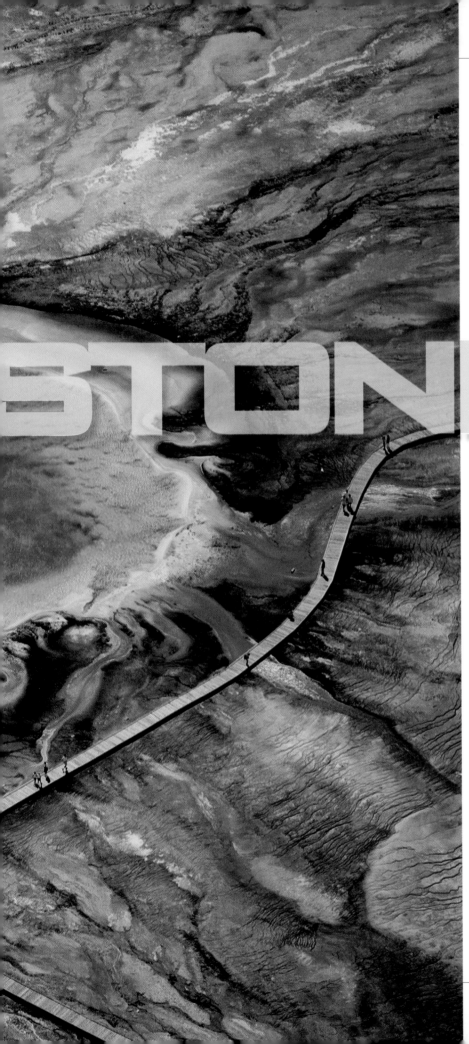

STONE

A treasure trove of nature, Yellowstone is the oldest, most famous national park in the United States. Its majestic land spans 3,468 square miles and is the largest nearly intact ecosystem in the northern temperate zone. Wolves, bison, and elk make their home here among hundreds of species of plants and animals, some of which are endangered. Since its creation in 1872, the park has hosted countless visitors, who travel here to gaze at the vistas of forest, grasslands, lakes, rivers, and geysers, reveling in a sense of spaciousness.

But all of this verdant, indigenous life might get blown to bits, because Yellowstone sits on top of one of the biggest volcanoes on Earth—and it is not extinct.

Known as a supervolcano, a term the U.S. Geological Survey (USGS) applies to any eruption that ejects more than 240 cubic miles of pumice and ash, what lurks beneath Yellowstone has the power to level mountains and threaten entire species with extinction by affecting the planet's climate. No supervolcano has erupted in recorded human history, but, says Robert Christiansen, a USGS scientist who pioneered research on the Yellowstone volcano in the 1960s, it would be akin to "opening the Coke bottle after you've shaken it." The last three supereruptions have been in Yellowstone, the most recent 640,000 years ago; it was a thousand times the size of the Mount St. Helens eruption in 1980, which killed 57 people in Washington State.

Scientists are trying to see beneath the surface, as it were, studying the size and structure of the park's volcano. At the shallowest level, surface water travels several miles deep, where it's heated and boils back up (feeding the geysers); five to seven miles deep is the top of what is known as the magma chamber, a reservoir of partially melted rock roughly 30 miles wide. This chamber is in turn fed by a gigantic plume of hot rock, its base located as many as 400 miles below the surface.

But for all the salient details, the larger, most pressing question remains unanswered: Will it blow, and if so, when? Christiansen, for one, is cautiously—very cautiously—optimistic that Yellowstone will remain a lovely place to visit, at least in our lifetime. "I think that the system has more or less equilibrated itself," he says. "But that's an interpretation that would not hold up in court."

WOW FACT

YELLOWSTONE'S LAST BLAST EJECTED 240 CUBIC MILES OF DEBRIS.

29

Universal Declaration of Human Rights

This silhouette contains the entire text of the declaration.

No one shall be subjected to torture or to cruel, inhuman or degrading treatment or punishment.

ARTICLE 5

Everyone has the right to rest and leisure...

ARTICLE 24

Motherhood and childhood are entitled to special care and assistance.

ARTICLE 25.2

Everyone has the right to education.

ARTICLE 26.1

All human beings are born free...

ARTICLE 1

No one shall be held in slavery or servitude...

ARTICLE 4

Everyone has the right to freedom of thought, conscience and religion...

ARTICLE 18

Everyone has the right freely to participate in the cultural life of the community, to enjoy the arts and to share in scientific advancement and its benefits.

ARTICLE 27.1

Words to Honor

More than sixty years ago, a document of fewer than 1,700 words gave birth to a dream. The Universal Declaration of Human Rights—proclaimed by the United Nations General Assembly in December 1948—envisioned a world that respected the dignity of every human being. In the bloody wake of World War II, the declaration was hope writ large and helped make human rights an accepted barometer of a government's legitimacy. It also led to broad initiatives, such as the creation of a UN High Commissioner for Human Rights in 1993, and focused ones, such as the Rwandan war crimes tribunal in 1994. "The declaration's words are inspiring," says Kenneth Roth, executive director of Human Rights Watch. "The challenge is enforcement."

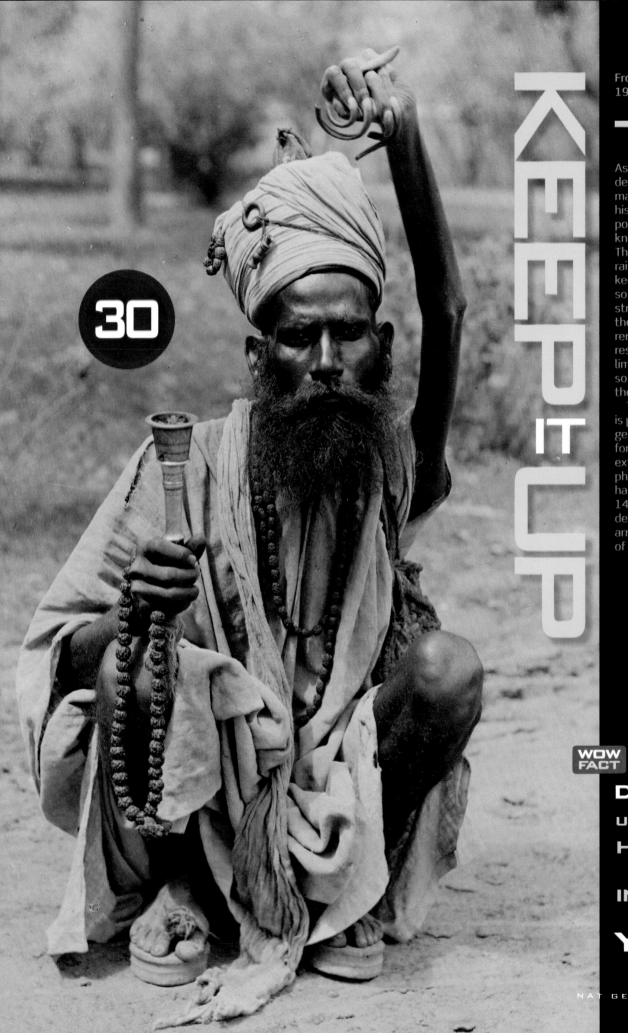

KEEP IT UP

30

This takes sun salutations to a whole new level. As a sign of spiritual devotion, this Indian holy man, or *sadhu*, has kept his arm raised in a fixed position in a practice known as *urdhavabahu*. The goal is not only raising the arm and keeping it up, but doing so gracefully: The straighter the arm and the closer to the head it remains, the better. The result is an atrophied limb and nails that grow so long they can pierce the wrist.

This particular sadhu is pushing the practice—generally endured for 12 years—to the extreme: When he was photographed, his arm had been raised for 14 years, and he was determined to keep his arm sky high for the rest of his life.

WOW FACT

THE DEVOTION OF URDHAVABAHU REQUIRES HOLDING AN ARM IN THE AIR FOR 12 YEARS.

REDWOO

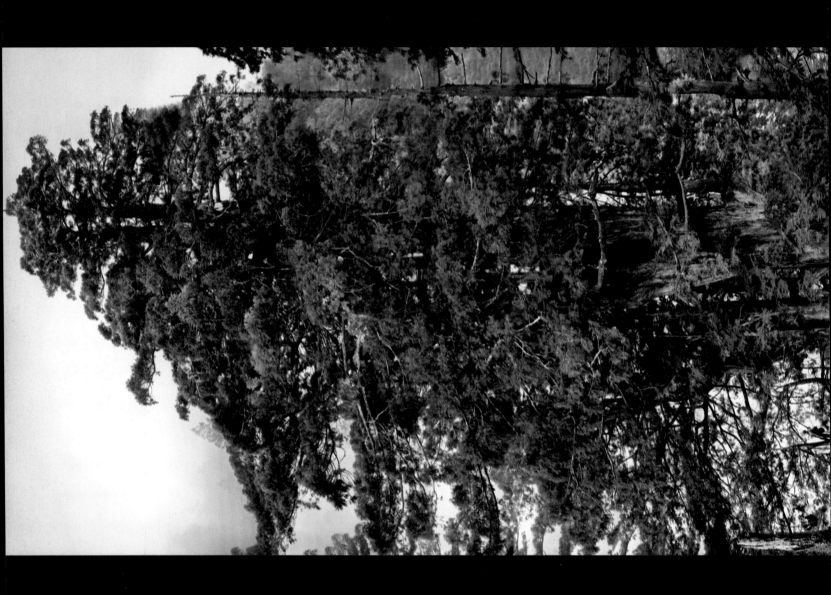

GIANT

WOW FACT

THIS PHOTO, TAKEN BY MICHAEL "NICK" NICHOLS, IS ACTUALLY A MOSAIC COMPOSED OF **84 IMAGES.**

Man is famous for slaying the mythic, from dragons to unicorns. Now we are coming dangerously close to doing the same with real-life legends: the redwoods. The tallest trees on Earth, which can grow more than 350 feet, provide shelter to countless forest species and safeguard clear waters. No wonder Steven Spielberg and George Lucas filmed scenes for *The Lost World: Jurassic Park* and *Star Wars Episode VI: Return of the Jedi* among these giants; no CGI animation could replicate their natural majesty.

But these majestic trees are also the target of loggers, who are decimating them at an alarming rate. To study logging's consequences and come up with alternatives to protect loggers' livelihoods, National Geographic Explorer-in-Residence Mike Fay and hiking partner Lindsey Holm walked the trees' 1,800-mile-long natural habitat, which stretches along the northwest coast of North America. The trip was the first of its kind and took almost a year. "You've got to start thinking of this as an ecosystem, because if you want clean water, salmon, wildlife, and high-quality lumber, you've got to have a forest," says Fay.

Fay's hope is that we might begin to grow and manage even bigger trees that will maximize wood production while providing good habitat. "In 20 years, we won't think of logging these lands like we do today," he says. "Our knowledge of these forests is constantly evolving."

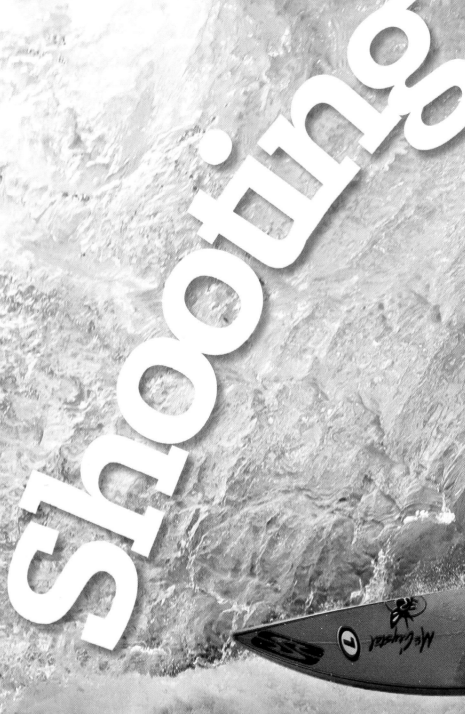

Ask surfer and photographer Scott Aichner about the allure of riding the waves, and he sounds like a man in love: "You feel at peace with the Earth, and everything is just perfect," he says.

Capturing other people riding the barrel, on the other hand—as he did here with fellow surfer Angelo Lozano in Mexico—is not a mellow experience. Aichner dons a pair of snorkeling fins and then waits—treading water, holding his camera, and hoping for the perfect shot. Being in the right place at the right time—a surfer can ride the barrel for an average of only four seconds—can mean Aichner may stay in the ocean for up to three hours at a time (he trains for these marathon swims by running). The photographer, who has surfed since he was ten years old, says understanding the ocean and the conditions is crucial, since catching the perfect ride (and the perfect picture) depends on all of the elements coming together.

As an artist, Aichner admits he must make personal sacrifices: There are plenty of days he wishes he were the one on the surfboard, rather than bobbing on the surface watching others ride the waves. "Surfing is my first love, and photography is my second. But I'm a better photographer than I am a surfer." Still, he jumps at any chance he can to ride the barrel himself, a thrill he admits can be daunting. "It's a controlled fear," he says. "Riding the currents is like merging onto the freeway when there's a semi in front of you and another one behind you. You just get in the flow of things and know everything will work out. Or, you prepare for controlled destruction."

Shooting

WOW FACT

It is possible to surf on rivers and in the middle of the ocean.

the curl

32

Surfer's Lingo

Just because you don't know your waffling (working the board quickly back and forth) from your wipeouts doesn't mean you have to sound like a swish (scared). Here, a primer for landlubbers at a rager (a good party).

BOTTOM TURN
A CRUCIAL SWEEPING MOVE WHERE THE SURFER ESTABLISHES SPEED AND DIRECTION

CARVING
CREATING SYMMETRICAL, FLUID TURNS

DOGGY DOOR
THE OPENING BETWEEN LIPS IN A WAVE THAT ALLOWS ESCAPE

FREIGHT TRAIN
A BARREL THAT GETS FAST AND SPOOKY

GREEN ROOM
THE INSIDE OF THE WAVE'S TUBE

MEATBALL FLAG
BLACK WITH A YELLOW DOT—NO SURFING!

PUCKER FACTOR
FEAR

RIP
SURFING TO THE BEST OF ONE'S ABILITIES

STUFFED
BEING SUBMERGED BY A WAVE

SWISH
A COWARDLY SURFER

TRIM
GETTING POSITIONED TO ACHIEVE MAXIMUM SPEED

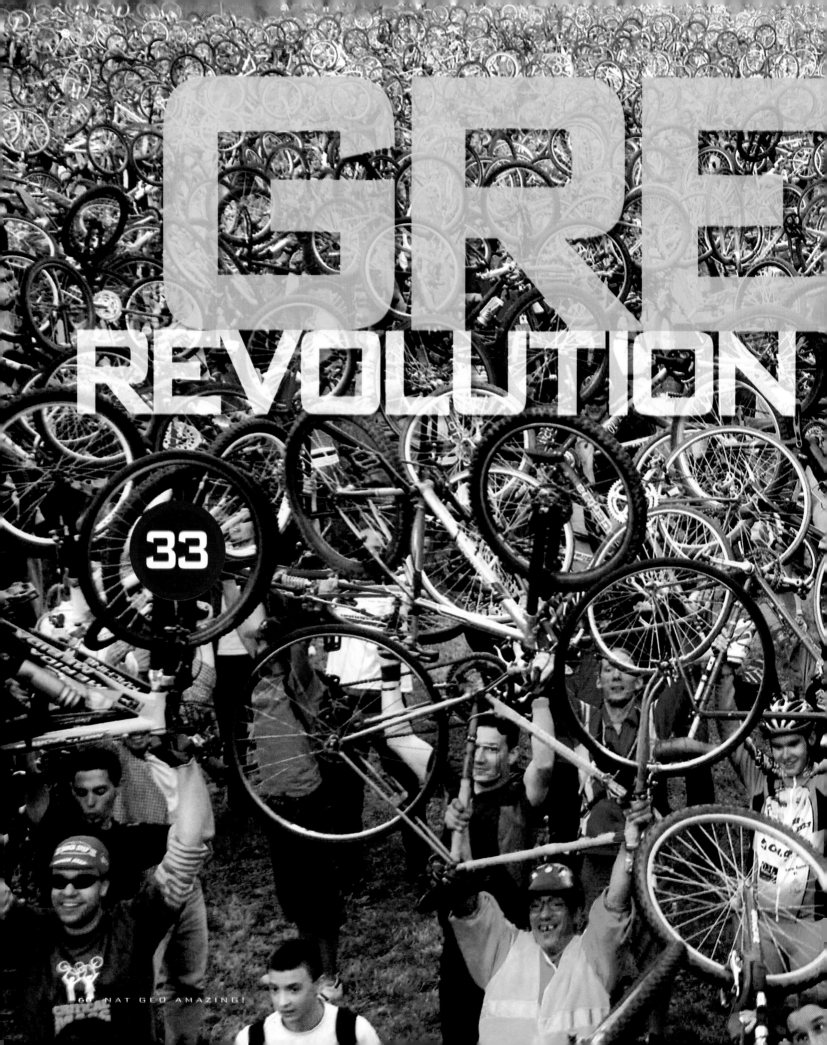

GRE REVOLUTION

33

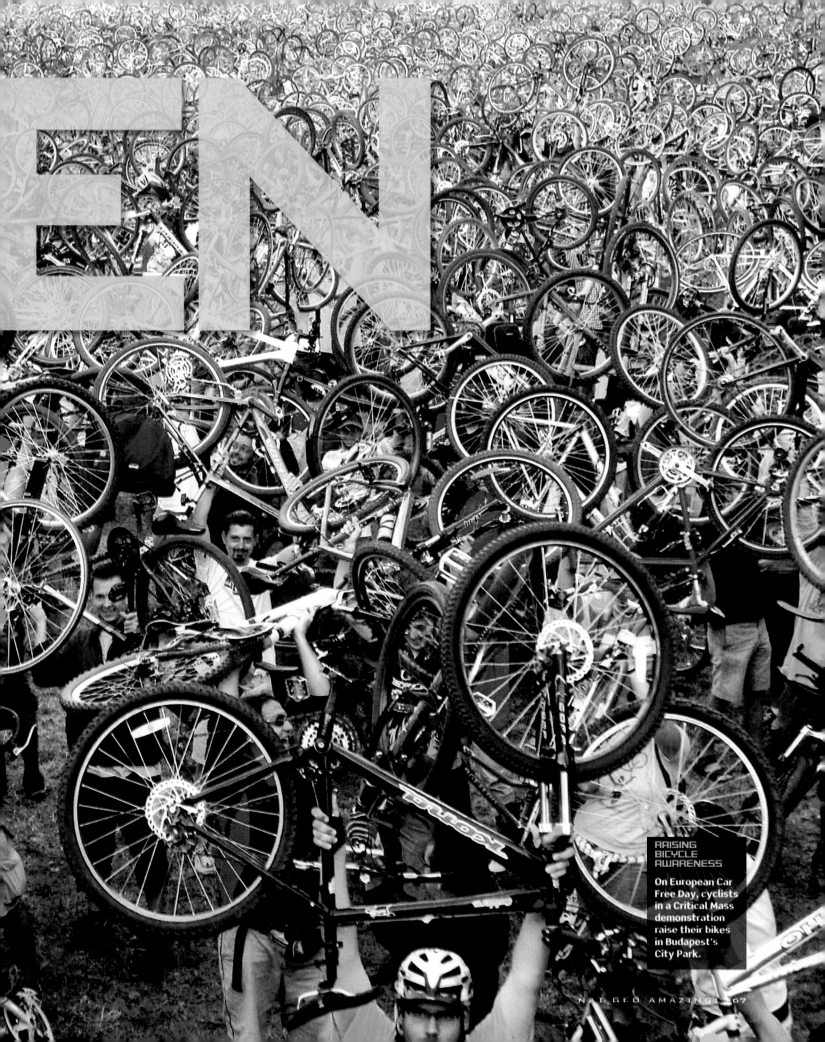

RAISING
BICYCLE
AWARENESS

On European Car
Free Day, cyclists
in a Critical Mass
demonstration
raise their bikes
in Budapest's
City Park.

Dressing up as flaming pandas. Powering a toaster with energy produced from an exercise machine rather than by plugging it into the wall. A book of cartoons entitled *101 Funny Things About Global Warming* that makes its serious point hilariously (in one cartoon, Atlas carries the weight of the world while wearing oven mitts). These are *not* your mother's ways of fighting the environmental crisis at hand.

To those for whom the news seems old or too disheartening to take on, a new generation is coming up with inventive and effective ways to raise awareness of and combat a crisis that is breaking down our ozone layer, drowning our polar bears, and destroying habitats. Not good news, for sure, and bad news is no fun. Except when it is. Because for those who are willing to get creative, fighting global warming is anything but a drag.

To wit: Renowned installation artist Spencer Tunick teamed up with Greenpeace and headed to the Alps to photograph 600 nude volunteers lying on top of a glacier. If things continue as they have been going, Greenpeace warns, most glaciers in Switzerland will be stripped away to bare rock by 2080. Over the past century and a half, glaciers have reduced about one-third of their surface and half their mass, and the melting rate is accelerating.

So what can be done? One British chemist at the University of Cambridge gave a lecture in which he proposed that people could begin by ceasing to find sports cars—and the people who drive them—sexy. For sure, changing one's means of transportation, regardless of the destination, can be a huge help, whether it's carpooling, or even better, carpooling in hybrid cars. Even Cadillac has unveiled a car that is both luxurious and eco-conscious, with leather interiors but capable of running on a rechargeable battery.

Celebrities are also putting their energy behind saving it. Robert Redford has spent more than three decades helping champion legislation like the Clean Air Act and the Energy Policy Act, and Ed Begley, Jr., is renowned for driving an electric car, living in a solar-powered home, and powering his toaster with his stationary bike. Al Gore's 2006 film on the subject, *An Inconvenient Truth,* was the first documentary to win two Oscars. And a new foundation, the British-based Global Cool, advocates doing one's part with the utmost hip factor; it gets shout-outs from musicians like Jason Mraz and also has the backing of corporate giants like Microsoft and the British Fashion Council.

As fighting global warming gets trendier—and more necessary by the minute—monolithic companies are having no choice but to pay heed. Dow, DuPont, and 3M have been models of showing that energy efficiency can be profitable: Since 1995, Dow has saved more than seven billion dollars by reducing its energy intensity—the amount of energy consumed per pound of product—and over the past few decades has reduced its carbon dioxide emissions by 20 percent. Most business leaders expect that there will be federal regulations of carbon dioxide emissions in the near future, with New York and nine other states agreeing on a plan that demands

WOW FACT

THE NORTHERN HEMISPHERE'S SNOW COVER DECLINE IS DOUBLE THE SIZE OF TEXAS.

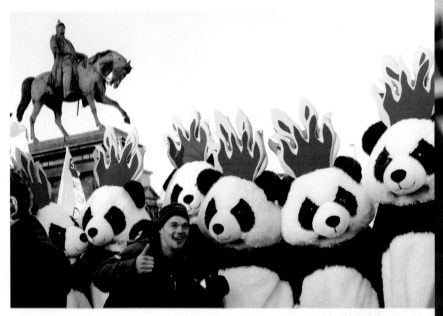

power plants either reduce emissions or purchase credits from other plants that have.

A study by management consultants McKinsey & Company estimates that the United States could avoid 1.3 billion tons of carbon dioxide emissions a year using only existing technologies that would pay for themselves in savings. That would mean that instead of growing by more than a billion tons annually by 2020, emissions in the U.S. would drop by 200 million tons a year. Already Sweden has pioneered carbon-neutral houses; Germany, affordable solar power; and Japan, fuel-efficient cars, and the Netherlands fills its traffic lanes with people on bicycles.

Former CIA director R. James Woolsey, who has served on the National Commission on Energy Policy and as chairman of advisory boards of the Clean Fuels Foundation and the New Uses Council, sees all of these factors coming together in a promising movement pushing for energy efficiency, the most crucial change in halting global warming. "I call it a growing coalition between the tree huggers, the do-gooders, the sodbusters, the cheap hawks, the evangelicals, the utility shareholders, the mom-and-pop drivers, and Willie Nelson."

PANDA POWER

In 2009, a costumed coalition of flaming pandas marched with more than 30,000 other people to declare war on greenhouse gases.

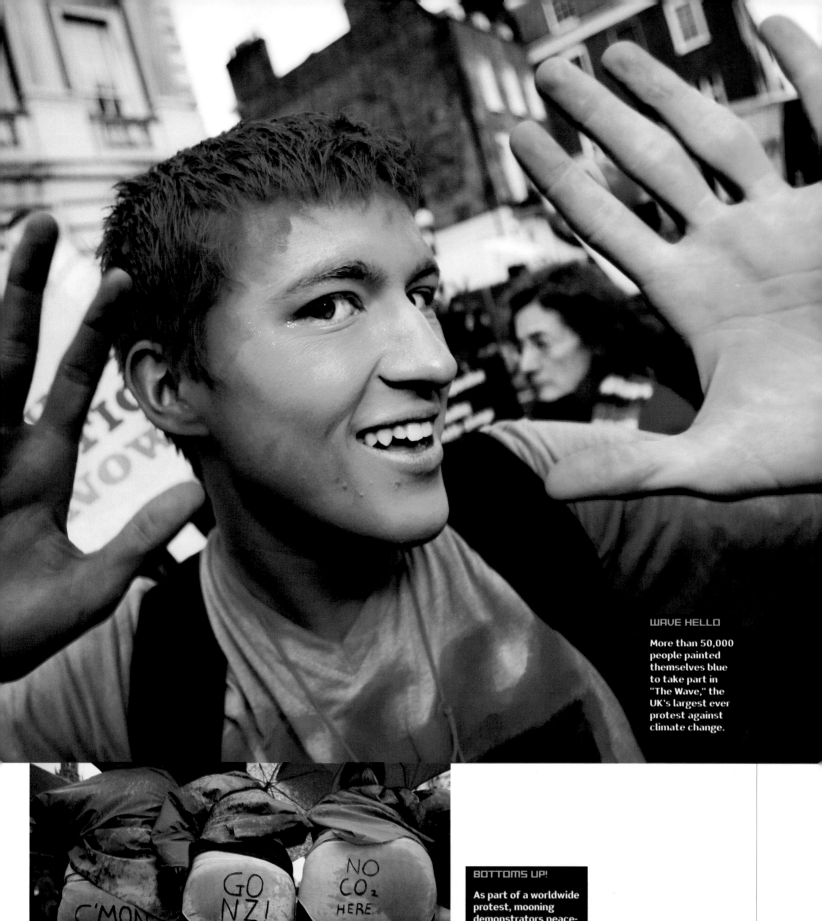

WAVE HELLO

More than 50,000 people painted themselves blue to take part in "The Wave," the UK's largest ever protest against climate change.

BOTTOMS UP!

As part of a worldwide protest, mooning demonstrators peacefully communicated their climate concerns via their underwear.

FEAR
FACTOR

34

When it comes to snakes, you either love them or you loathe them. Some keep them as pets and give them cute names—while others spy a serpent and run for the hills. But when face-to-face with an angry viper, it's hard to imagine not experiencing an adrenaline-fueled jolt of panic.

National Geographic photographer Mattias Klum held his ground in Thailand with this ten-foot king cobra trained in the sport of "king cobra boxing," which entails having people provoke the reptiles until they will strike at anything. "The people who do this don't think they're being cruel," says Klum. "They believe they're in touch with their religion's spirits." That Klum is still speaking about the experience owes to the fact that the snake attacked his camera rather than his face: The venom in a single bite is enough to kill an elephant.

WOW FACT

THE KING COBRA IS THE WORLD'S LONGEST **VENOMOUS** SNAKE.

Angeli

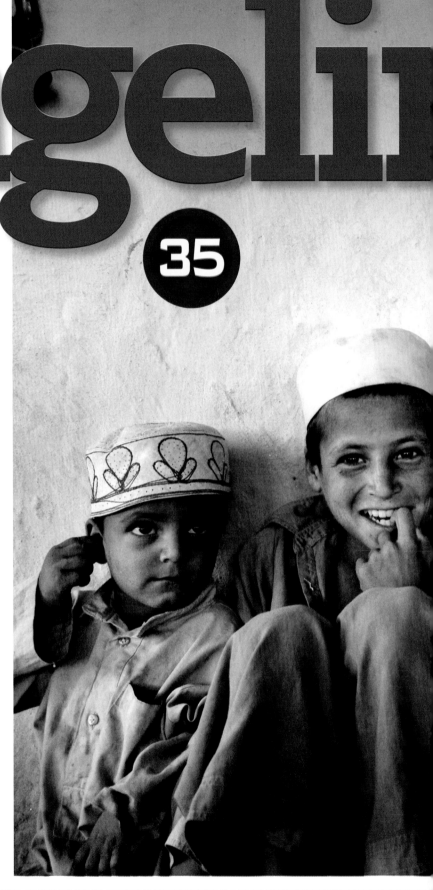

35

Ambassador

Whether she's playing movie star on the red carpet, accompanying partner Brad Pitt, or raising their six children, Angelina Jolie's every move is recorded breathlessly by the paparazzi and heralded by the tabloids.

But while the public seems to have an insatiable appetite for knowing the intimate details of her glamorous life, Jolie's most dramatic role is one she plays without the movie cameras rolling, unaccompanied by an entourage, and for free. Since 2001, she has served as a goodwill ambassador to the United Nations High Commissioner for Refugees, passionately lending her voice to those who have lost theirs in war-torn countries.

Visiting refugee camps in countries such as Tanzania, Pakistan, and Cambodia, Jolie has raised awareness of the plight of the displaced. Here, she is pictured during a visit with Afghan refugees from a recently closed camp in Jalalabad. Her work doesn't end when she returns back to the United States, where she furthers her efforts through addresses in Washington and her charitable work. (The Maddox Jolie-Pitt Foundation, for instance, set up in honor of son Maddox, whom she adopted from Cambodia, focuses on conservation of the country's endangered northern territory.)

Jolie is part of an elite tradition of women determined to use their fame to do good: Audrey Hepburn was a goodwill ambassador for UNICEF, as was Susan Sarandon; Drew Barrymore has been an ambassador against hunger for the UN, and Naomi Watts has served as a special representative of the Joint United Nations Programme on HIV/AIDS. But few if any people in the past have had the power of the media behind her in the way that Jolie does, where a single shot of her is picked up around the world in a matter of seconds to appear in tabloids and on the Internet. "You go to these places and you realize what life's really about and what people are really going through," Jolie has said. "These people are my heroes."

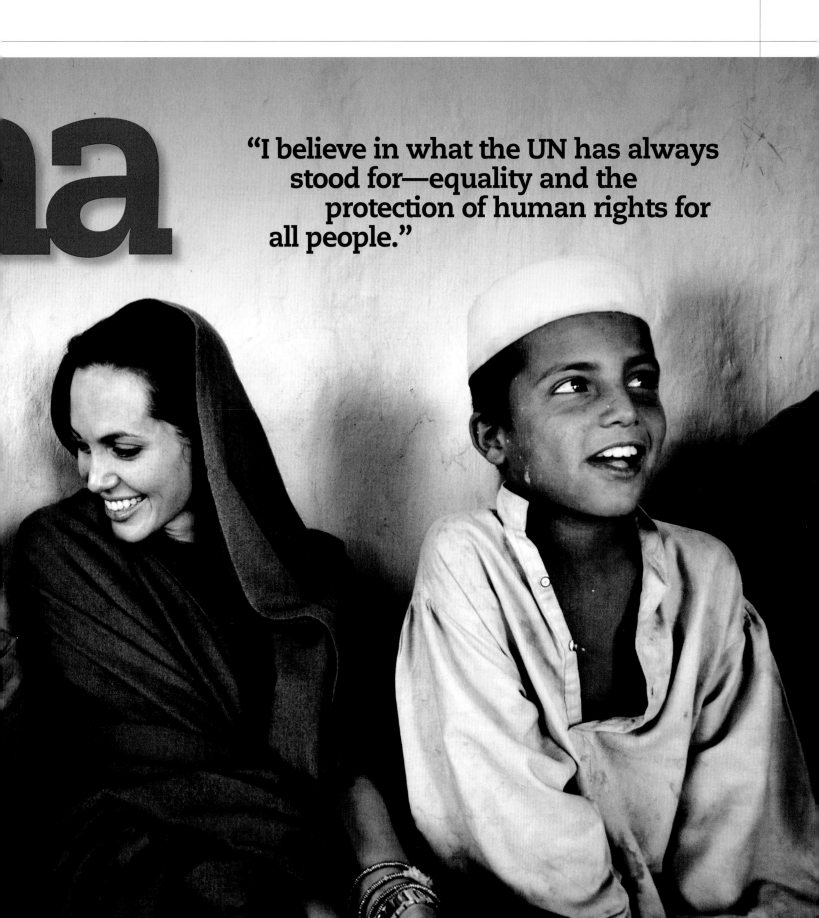

na

"I believe in what the UN has always stood for—equality and the protection of human rights for all people."

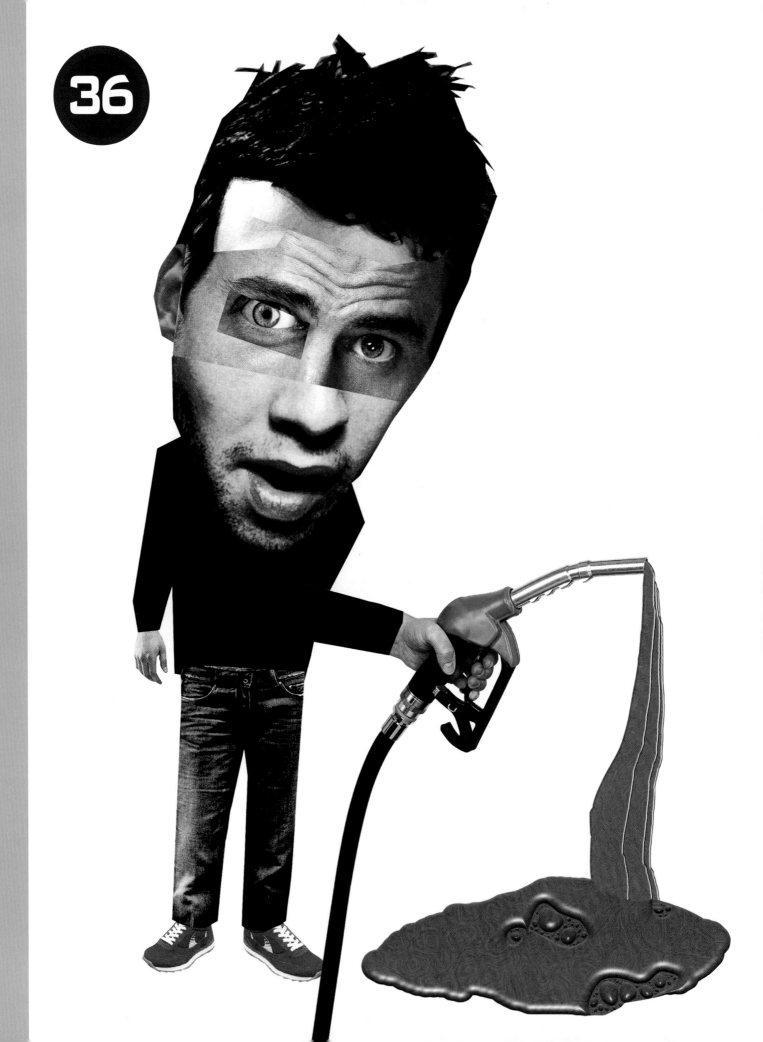

THE INCREDIBLE STORY OF THE GENTLEMAN WHO PUMPED GAS INTO AN IMAGINARY VEHICLE...

...AND FOUR OTHER VERY STUPID CRIMINALS

37

SAY CHEESE

North Richland Hills, Texas

It pays to read the signs. "Smile, you're on camera!" declares one at a spy shop in Texas, but that did nothing to deter two brothers who overestimated their own James Bond–like qualities: While they were hauling away $8,700 worth of equipment and loading it into a stolen car, their (mis)demeanors were being captured by 13 video cameras. After local TV channels broadcast the footage, the thieves were identified. Not their best candid shots, for sure. These guys might have done better to avoid the spotlight.

36

GAS PAINS

Louisville, Kentucky

What a waste of energy, indeed! When policemen arrived at a gas station here, they immediately smelled marijuana wafting from a man who was standing by the tanks. Not necessarily noteworthy in and of itself, except for one thing: The man was holding the gas pump in his hand, filling up a "car" that was real to him and him alone. When the officers searched the suspect, they discovered two big bags of marijuana and a large amount of the drug Ecstasy, which can cause confusion and hallucinations. They also found wads of cash and a cell phone, and subsequently arrested the suspect on charges of drug trafficking. Talk about running on empty.

> **THE BURGLAR GAINED ACCESS THROUGH THE CHIMNEY, BUT SOON FOUND HIMSELF STUCK INSIDE.** ▶ **NEIGHBORS WERE ALERTED THANKS TO THE INTRUDER'S PANICKED SCREAMS.**

TIGHT SQUEEZE

38

Kings Beach, California

Note to thieves: If you find yourself being inspired by Santa Claus, come up with a new plan. When one West Coast burglar was foiled gaining access to a home through the usual routes, he decided to lower himself down the chimney. Neighbors were soon alerted thanks to the intruder's panicked screams when he found himself trapped inside. He had plenty of time to consider the consequences of his actions: Firefighters had to spend hours dismantling the chimney brick by brick to free him, only to have the cops appear and imprison him all over again.

KNOCK, KNOCK ▶

Woodbine, Georgia

Prison breaks are the stuff of lore, inspiring endless movies and driving the plots of countless great works of literature. Famous breakouts have fueled the imagination; Frank Morris, John Anglin, and Clarence Anglin managed to escape the infamous fortress of Alcatraz in 1962, and nothing has been heard of them since. Mass murderer Ted Bundy managed to escape imprisonment in 1977—not once but twice. In 1984, six inmates sentenced to death and imprisoned at the Mecklenburg Correctional Center in North Carolina staged the largest death row escape in history. (All six were subsequently recaptured and later executed.)

This group of wannabe escapees, however, is not one of those stories. This story is more likely to inspire a skit on *Saturday Night Live*. In an Oregon prison, four prisoners banded together and managed to force open a door, allowing one of them to escape. With a loyalty that defies the imagination, the freed prisoner chose not to find his family or head to the nearest bar, but instead loped off to a convenience store, where he proceeded to steal treats.

He then returned to the prison, goodies stuffed in his pockets, to share them with his friends. When he discovered that the door through which he had escaped had been locked, he began looking for another way in. That's when he was spotted by a prison guard and recaptured. At least he was among friends?

DISCOVERING THAT HIS ESCAPE ▶ DOOR HAD BEEN LOCKED, HE BEGAN LOOKING FOR ANOTHER WAY IN, ONLY TO BE SPOTTED BY A PRISON GUARD AND RECAPTURED.

DROP IT!

Ferndale, Michigan

Fashion versus function, a never ending debate: What's more important, to look good or to move through the world with ease? Let's hope orange is a good color on this slippery-fingered thief, since the only thing he'll be wearing this season is a prison jumpsuit. After stealing a bunch of DVDs, he was spotted by the cops; spotting them spotting him, he made a run for it—only to fall down just seconds into the chase, felled by his baggy pants, which became unmoored and tripped him. That takes being caught with your pants down to a whole new level.

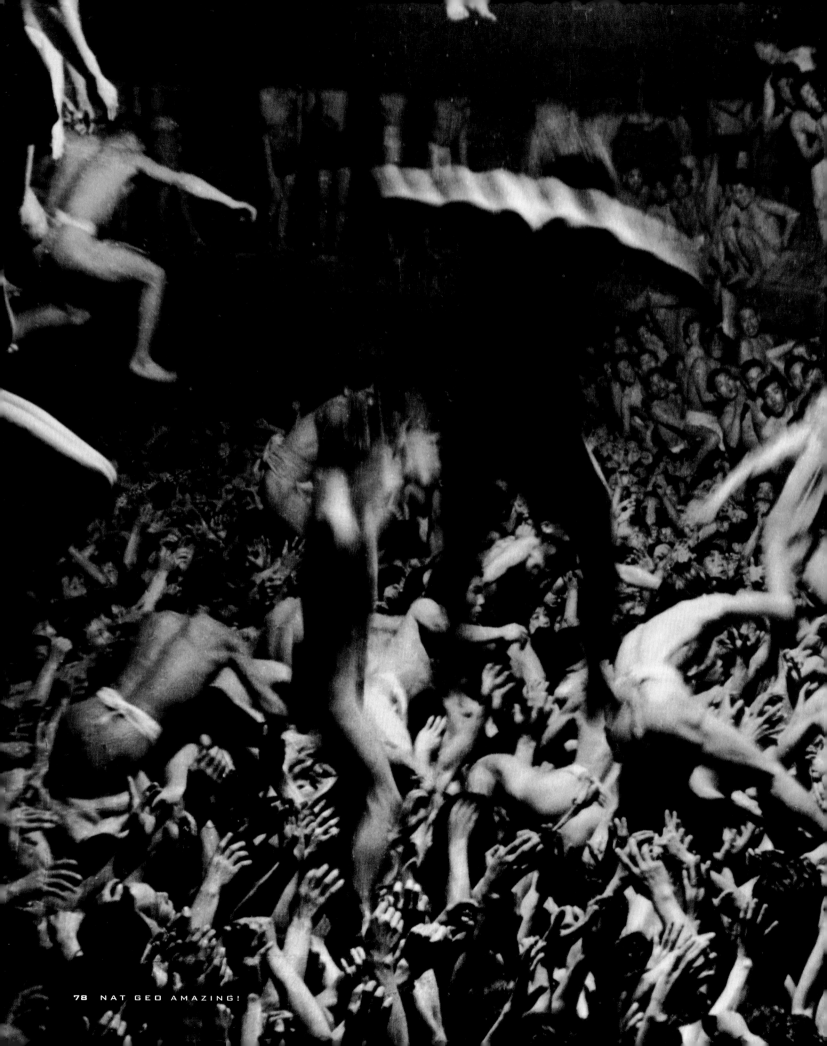

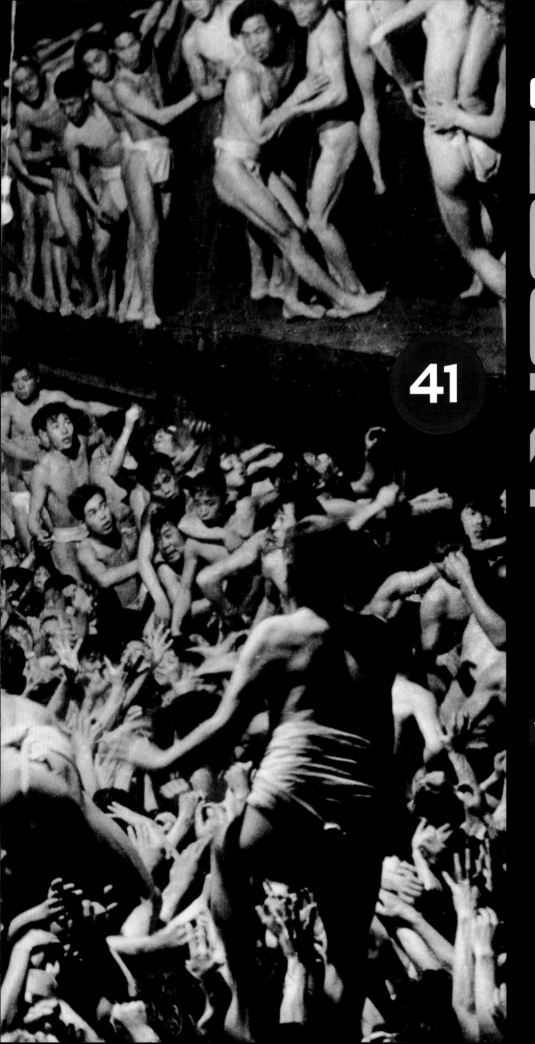

41

GETTING LUCKY

From the Archives,
1946, Okayama, Japan

Skip drinking brews at a ball game. When it comes to hanging with the guys, Japanese men know how to get close to each other—make that very, *very* close—in an annual ritual that is at least 500 years old and continues to this day.

As part of the Hadaka Matsuri (which means "naked festival") in Okayama, nearly 9,000, loincloth-clad men gather annually at midnight on a February eve to battle for two wooden sticks, talismans blessed by priests who throw them into the throng from an open window.

The goal: Grab a stick, known as a *shingi*, and place it upright in a wooden box to ensure good luck in the coming year. For those who prefer their winter sports as spectators, seats with a view can be reserved. Now, if only they served hot sake.

WOW FACT

MEN IN JAPAN STILL COMPETE FOR LUCK IN THE NEW YEAR WITH THIS ANNUAL OKAYAMA FESTIVAL.

VISIONS OF MARS

The more we've learned about Mars, the more curious we've become. In the past three decades, images have been taken by orbiters, and two mobile rovers, Spirit and Opportunity, were launched onto the red planet's surface in 2004. A sharper picture has come into focus. We now know that arid, cold Mars is home to the largest volcano and the deepest canyon in the solar system. We know that the planet has a diameter of 4,200 miles (as opposed to Earth's 7,926), that its year lasts 687 days, and that its atmosphere is made mostly of carbon dioxide and some water vapor. We also know that like Earth, Mars has systems of air, water, ice, and geology that interact to create regional environments with seasonal weather changes like shifting ice caps and spring and summer dust storms. Although the rovers' mission was originally supposed to last for just three months, they've spent the past six years collecting data. Even Spirit, now stuck in a sand trap and unable to move, continues to reveal new insights into the planet's core.

But although two rovers explored the surface, feeding information back to NASA, we have yet to be able to experience it ourselves firsthand. Thus, NASA has launched the Mars Exploration Program to see whether it is, or ever can be, a habitable world, containing or having the ability to maintain a biosphere. Until that question is answered, perhaps Mars is best described by the NASA scientists who romantically refer to it as "the ultimate lonely planet destination."

Crater Gullies

Marring the surface of a dune in Russell Crater, strings of gullies were formed from the accumulation of sand over millions and millions of years.

Dust Devils

Dunes in the Green Crater are marked by dust devils, which look like clumps of hair but are rising columns of warm air that pick up surface dust.

Northern Layers

Light- and dark-toned layers flow in the Chasma Boreale, a huge chasm that cuts through Mars's north pole deposits.

Polar Pits

Scarring the icy surface of the planet's southern polar ice cap, these rough, jagged-looking pits grow larger with every passing year.

Dust in the Wind

Creating strange arcs, windswept whorls, and swirling shapes, strong Martian winds blow dust and carbon dioxide frost across the dunes.

WOW FACT **THE TALLEST VOLCANO ON MARS IS ALMOST 17 MILES HIGH.**

THE MASK

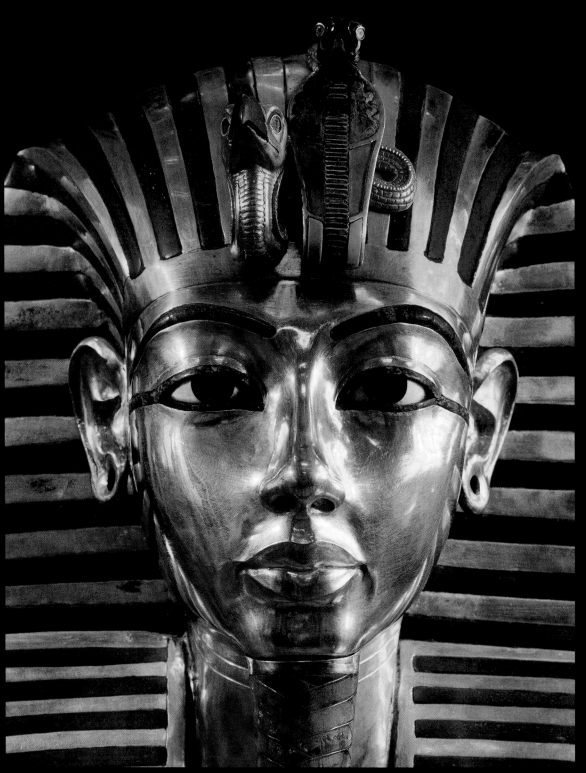

When British archaeologist Howard Carter found the tomb of Egyptian pharaoh Tutankhamun in the Valley of the Kings in 1922, it was an unprecedented discovery. Reigning roughly 3,300 years ago, Tut became king at age nine but ruled for only ten years before dying around 1324 B.C.

The antechambers of the underground tomb had been looted throughout antiquity, but the burial crypt was untouched—and full of golden treasures. But there were, touchingly, the accoutrements for the adolescent he was when he died, to use in his next life: board games, jars of medicines, and many canes.

Even more remarkable was the condition of the mummy. The boy king was buried within three coffins, one of solid gold, and he was mummified with such care that centuries after his death, under the now famous mask of gold, the kings's face might emerge.

Alas, when Carter tried to remove the body from the coffin, he found that resins had glued Tut to his coffin. He tried melting them by exposing them to the sun but had no success. His team eventually chiseled the body out, causing significant damage to the mummy. The true image of Tut's face was lost forever, or so we thought.

AND THE MAN

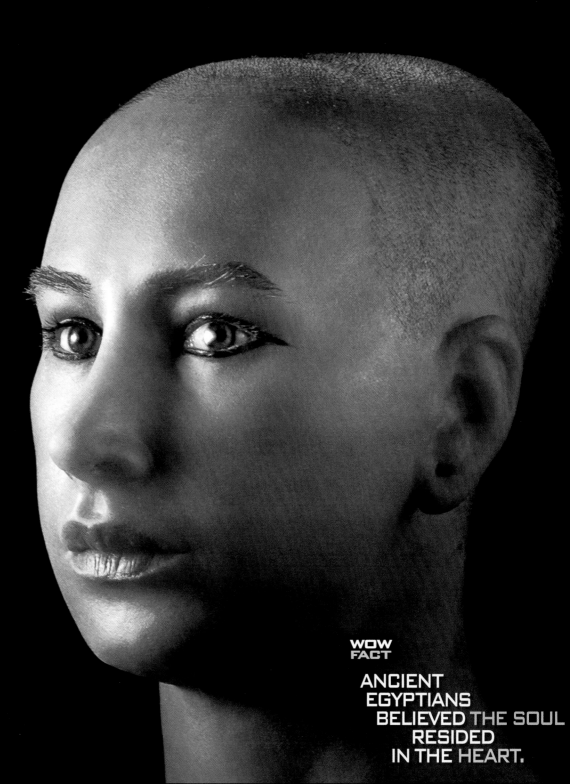

In 2005, a team of scientists used CT scans to examine his mummy. They put to rest the theory that he died from a blow to the head (his skull was probably fractured during the mummification process). They also established that Tut was about 19 years old and five and a half feet tall, and he had a fracture in his left thighbone. The scans allowed forensic scientists to build a facial reconstruction of the young king, unveiling for the first time the real visage behind the golden mask.

Five years later, DNA analysis revealed that Tut suffered from a bone-weakening genetic condition, repeated bouts of malaria, and malformations of his left foot caused by necrosis, or death, of his bone tissue. Rather than robust, he was a frail young man who needed a cane to walk, which explains the presence of canes and medical supplies in his tomb. Scientists speculated that malaria slowed the healing of his foot and thighbone fracture, and the combination most likely killed him.

This study was the first time the Egyptian government permitted genetic analysis of royal mummies. As project leader, Zahi Hawass, secretary general of Egypt's Supreme Council of Antiquities, says, "This will open us to a new era."

WOW FACT

ANCIENT EGYPTIANS BELIEVED THE SOUL RESIDED IN THE HEART.

44

DEPTH
DEFYING

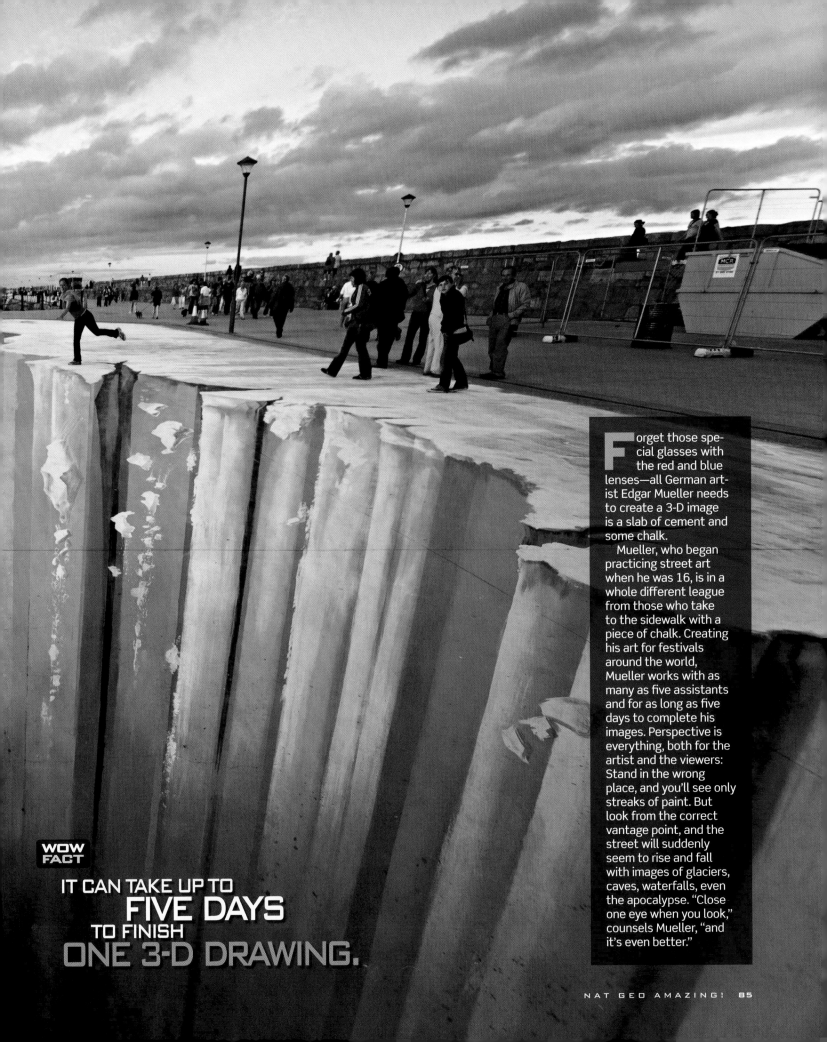

IT CAN TAKE UP TO
FIVE DAYS
TO FINISH
ONE 3-D DRAWING.

Forget those special glasses with the red and blue lenses—all German artist Edgar Mueller needs to create a 3-D image is a slab of cement and some chalk.

Mueller, who began practicing street art when he was 16, is in a whole different league from those who take to the sidewalk with a piece of chalk. Creating his art for festivals around the world, Mueller works with as many as five assistants and for as long as five days to complete his images. Perspective is everything, both for the artist and the viewers: Stand in the wrong place, and you'll see only streaks of paint. But look from the correct vantage point, and the street will suddenly seem to rise and fall with images of glaciers, caves, waterfalls, even the apocalypse. "Close one eye when you look," counsels Mueller, "and it's even better."

45

On a makeshift wood stretcher, villagers carry one of four executed mountain gorillas out of Virunga National Park in the Democratic Republic of the Congo. Many park rangers call the killings "political assassinations" by loggers from the illegal charcoal industry, who are battling the rangers for control of the forest.

Gorillas Under Attack

Stunned rangers are trying to make sense of what may be the worst slaughter of mountain gorillas in 25 years.

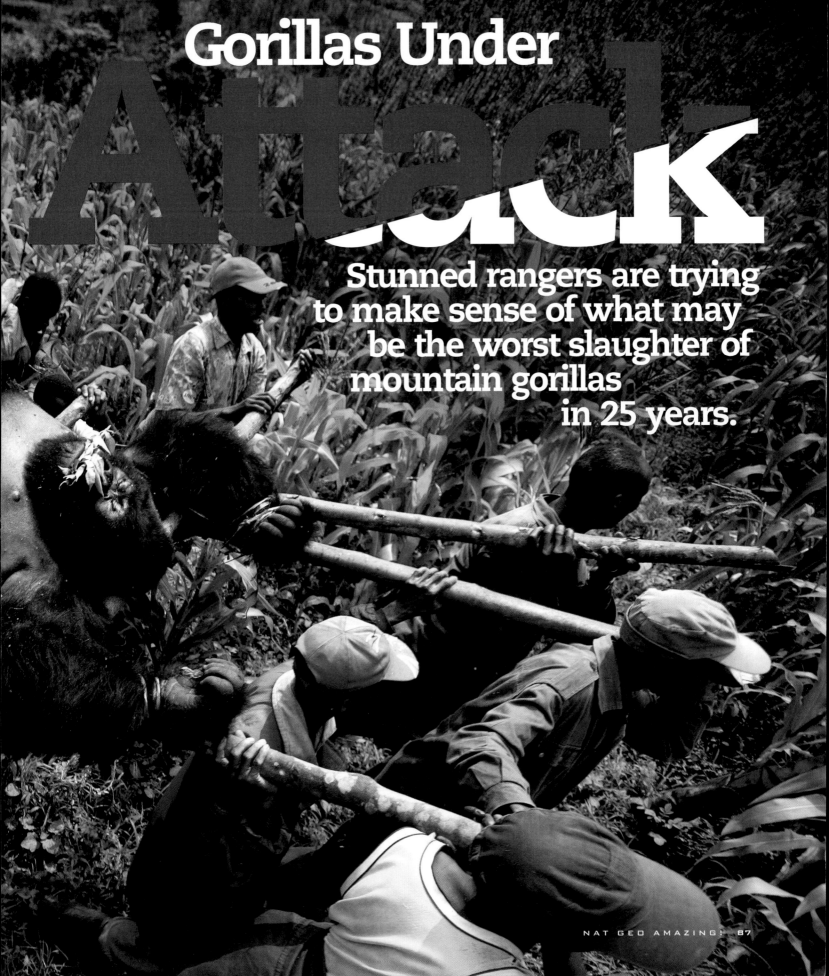

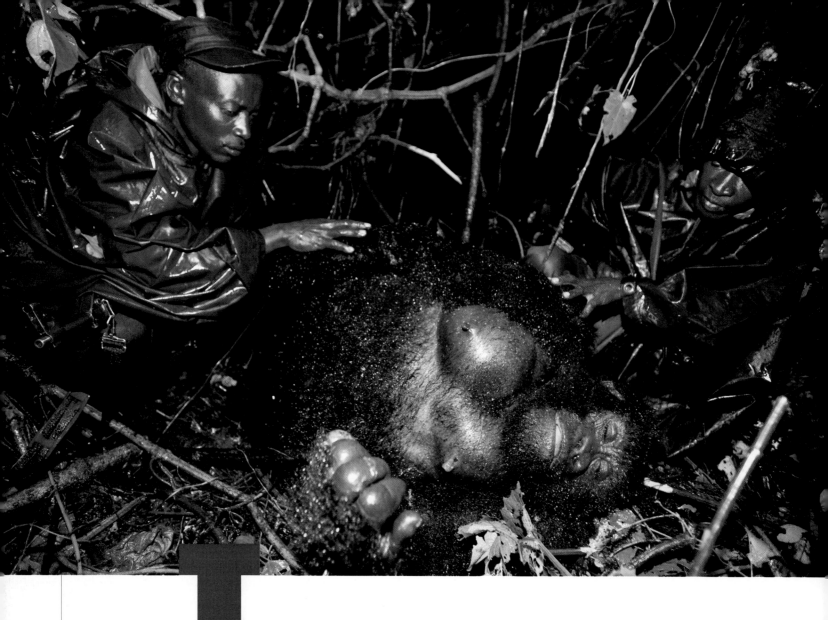

In the dark of night, beside the Mikeno volcano in eastern Democratic Republic of the Congo, unknown assailants waited, armed with automatic weapons. By morning, the Rugendo family of mountain gorillas, known by tourists and beloved by the rangers of Virunga National Park, lay decimated, seven of twelve members killed execution style over a period of less than two months.

Brent Stirton's photographs of the dead animals, being carried by weeping villagers in a funeral procession worthy of royalty, were published throughout the world. And while the world reacted with proper outrage at the murders, the killers remained at large.

The suspects seemed endless. Thousands of armed guerrillas, locked in a battle with two other militia groups as well as the Congolese army, have made the park their home. There are also poachers, who murder the adult gorillas by cutting off their hands and heads to be sold on the black market, and kidnap the infants. There are illegal charcoal producers, and there are refugees whose camps overflow into the protected area, which at almost two million acres, is only slightly smaller than Yellowstone. Additionally, the local politics

are rife with corruption. (The chief warden of the park at the time was ultimately charged with the murder of the gorillas.)

Named a World Heritage site by UNESCO in 1979, the park—which is home to 200 of the remaining 720 mountain gorillas in the world—has also been a constant on the UN's list of most endangered places: It lies at the epicenter of the 1994 genocide in nearby Rwanda, which killed more than 800,000 Tutsis, and two Congo civil wars that have left more than five million dead. In the past decade, 100 park rangers have been killed in the line of duty, the majority by militias. As *National Geographic* contributing writer Mark Jenkins, who traveled with Stirton to cover the murders and subsequent investigation, says, "Caught in this vortex of human misery, it would be a miracle if the animals remained unscathed."

And yet, in the midst of such human suffering, there is still some hope to be found: people at war with one another rallying around these helpless creatures. For a moment, anger is directed toward a shared heartbreak, the senseless murder of creatures the park rangers refer to simply as "our brothers."

WOW FACT

Only 720 mountain gorillas still exist in the wild.

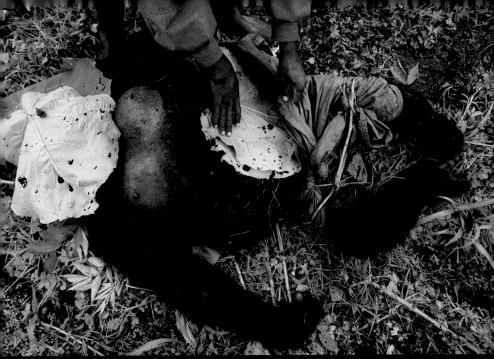

From top left: Rangers examine a slaughtered female gorilla, shot at close range like the other three; a villager covers a dead female with leaves to keep the flies away; park ranger Paulin Ngobobo, who has been physically flogged for his fierce defense of the mountain gorillas; the 600-pound silverback—the 12-member family's leader—was found with one arm over his heart, as if he had been thumping his chest when he died.

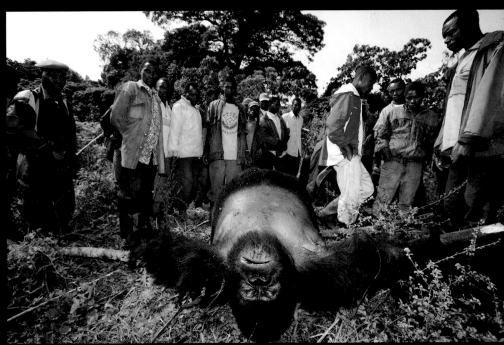

"The security of this species is not guaranteed."

—Richard Leakey, paleontologist and WildlifeDirect founder

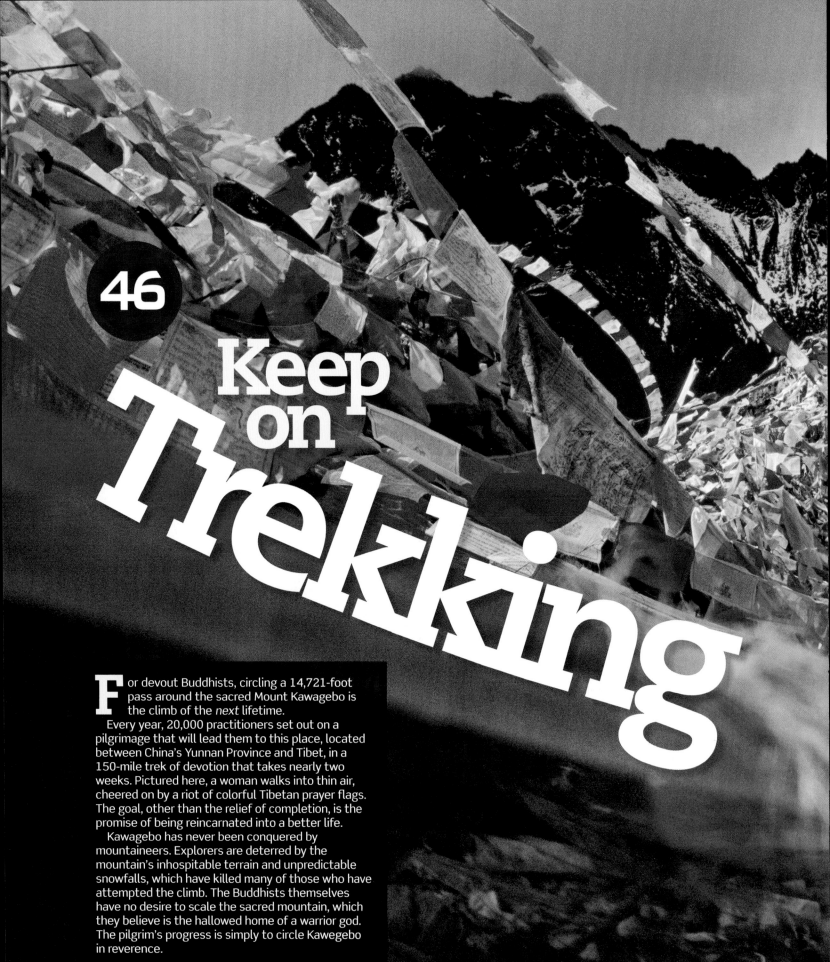

46

Keep on Trekking

F or devout Buddhists, circling a 14,721-foot pass around the sacred Mount Kawagebo is the climb of the *next* lifetime.

Every year, 20,000 practitioners set out on a pilgrimage that will lead them to this place, located between China's Yunnan Province and Tibet, in a 150-mile trek of devotion that takes nearly two weeks. Pictured here, a woman walks into thin air, cheered on by a riot of colorful Tibetan prayer flags. The goal, other than the relief of completion, is the promise of being reincarnated into a better life.

Kawagebo has never been conquered by mountaineers. Explorers are deterred by the mountain's inhospitable terrain and unpredictable snowfalls, which have killed many of those who have attempted the climb. The Buddhists themselves have no desire to scale the sacred mountain, which they believe is the hallowed home of a warrior god. The pilgrim's progress is simply to circle Kawegebo in reverence.

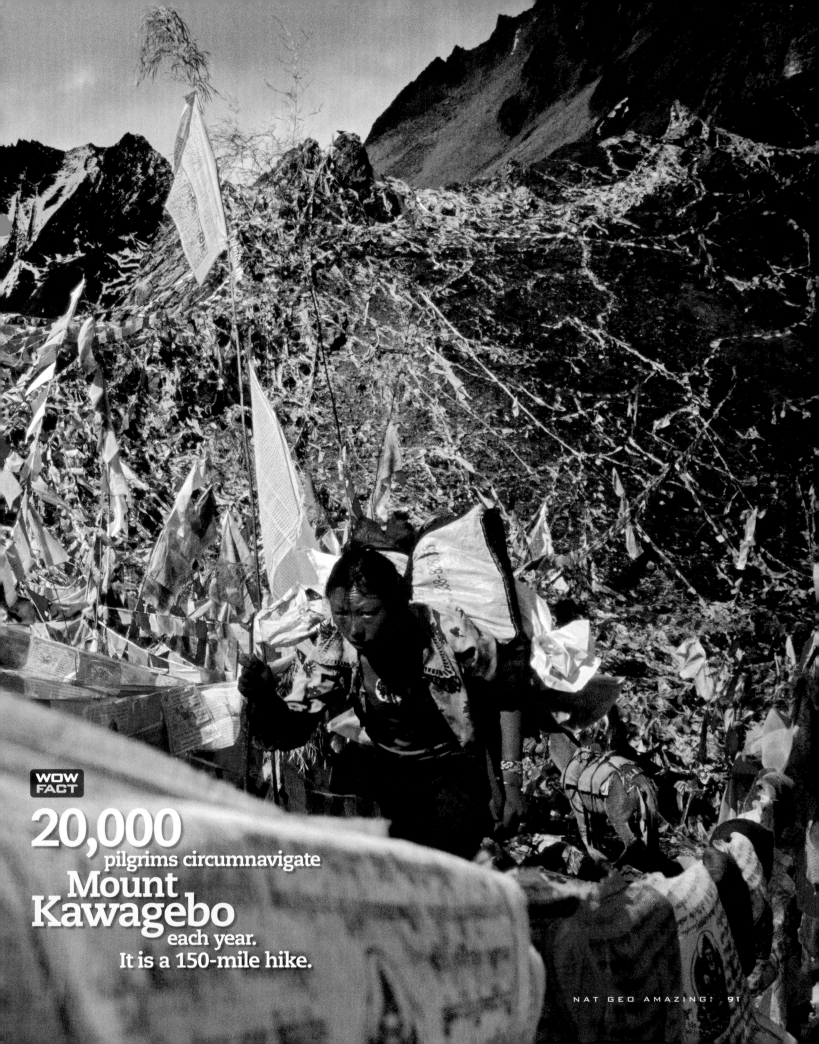

20,000 pilgrims circumnavigate **Mount Kawagebo** each year. It is a 150-mile hike.

47

In the Blink of an eye

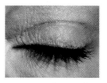

Nervous adult
50
blinks per minute

Human newborn
2
blinks per minute

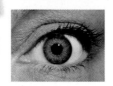
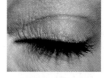
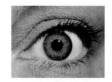

Staring at TV
7.5
blinks per minute

Calm adult
15
blinks per minute

What goes on in the blink of an eye? Most obvious, the lid spreads tears across the ball surface, warding off dryness and scratches. We blink less when reading or staring at a computer or TV—that's why eyes dry and burn—more when tired and at times of transition, such as turning a page. But blinking isn't just a reflex. Calm slows blinking; anxiety can cause eyeblink storms. Think of a nervous politician or a bad liar, who usually blinks fastest after a fib. Psychopaths, with altered brain function, are less likely to blink vigorously when startled than an average Joe. Also, blinks dull brain activity related to visual awareness, perhaps to keep us from noticing the microseconds of dark. Blink mysteries include why babies do it less than adults—maybe because of all the new stimuli to take in—and why so much variation exists in animals. Case in point: A parrot blinks 26 times a minute, an ostrich, just once.

Blink rate varies widely depending on mood, activity, concentration level, age, and species.

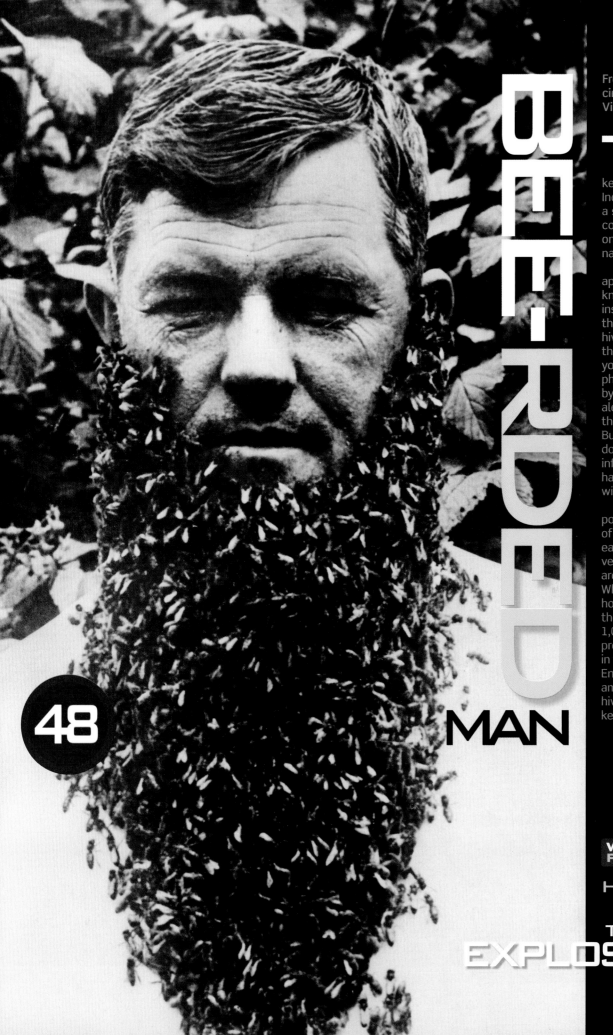

BEE-RDED MAN

48

This looks like one hairy situation. A beekeeper in Vincennes, Indiana, circa 1920, let a swarm of the insects cover his face to demonstrate the peaceful nature of honeybees.

Honeybees, 1 of approximately 20,000 known species of the insect, rarely sting when they are away from their hive. Come too close to their home base, and you risk a swarm: The pheromones released by one bee's sting alert the others to arm themselves for battle. But keepers breed for docility, and stings are infrequent for those who handle their charges with care.

Honeybees, which pollinate about one-third of the food Americans eat—from fruit and vegetables to grains—are on the wane. The White House has 60,000 honey-making bees, but there are only about 1,000 mass honey-producing beekeepers in the United States. Enthusiasts say if amateurs kept even one hive, that would help keep the world buzzing.

WOW FACT

HONEYBEES CAN BE TRAINED TO DETECT EXPLOSIVES.

WOW FACT

The National Dog Show is watched by **20 million viewers.**

Doggone Viral

People love an underdog, but they love a flying dog even more. Witness the fate of Sidney, a Labrador mix who leaped to viral fame after his owner, Jason Neely, caught him in a high jump.

"He's a crazy, crazy dog," says Neely, a research librarian who lives with his family in Connecticut. One day, when his wife brought the dog a pig ear from the pet store, Neely grabbed his camera and instructed the dog to jump for his treat. "He really is about five feet off the ground in the photograph," says Neely. "He's constantly jumping like that."

Neely published the photo online as part of National Geographic's Your Shot program, in which readers can submit their own photographs to the Society. Each month, the magazine features reader submissions in the magazine, and in 2009, Sidney got his big break.

National Geographic published Sidney's airborne act, and Neely began to receive a flood of emails. "People would send me emails saying, 'My dog looks just like that, and he's crazy too,' and then attach pictures of them," Neely remembers. "I think Sidney just has this 'every dog' kind of appeal." One morning, Neely awoke to find an email from Interscope Records: The manager of the band Weezer had seen the photograph in the magazine and wanted to use it for the cover of their new album *Raditude*.

Fans were invited to create their own Sidney covers. The dog appeared playing poker, jumping over the moon, and visiting the Tower of Pisa. Soon, Neely was fielding calls from MTV (they filmed and edited a video of Sidney so it looked like he was interviewing Weezer), and receiving front-row tickets to a Weezer concert. "I got to take pictures of the band right next to the stage," he says. "I never thought *that* would happen."

50

FEELING
CHUMMY

The name of the place where this photograph was taken seems redundant: Dangerous Reef, Australia.

"Every dive to photograph sharks is a bit of an experiment," says underwater lensman David Doubilet. Occasionally he comes close to playing doomed lab rat, despite being protected by a steel cage. "These magnificent predators usually just bump the cage, mouths barely open," he says. "This time, I got lucky. A 17-foot great white shark showed interest in eating me, opened its jaws really wide, and *click!* What a shot!"

This wasn't Doubilet's first close encounter of the great white kind: Before he learned better, he baited the sharks by tying fish to the cage with steel wire; when one shark got tangled in the wire, it pulled the cage sideways with such force the trapdoors fell open. "I scrambled to pull the doors shut," says Doubilet, "and luckily the shark broke free from the wire and swam off. But we learned never to do that again."

ROUGHLY
4
PEOPLE
DIE
FROM
SHARK
ATTACKS
EACH YEAR;

DIE FALLING
OUT OF BED.

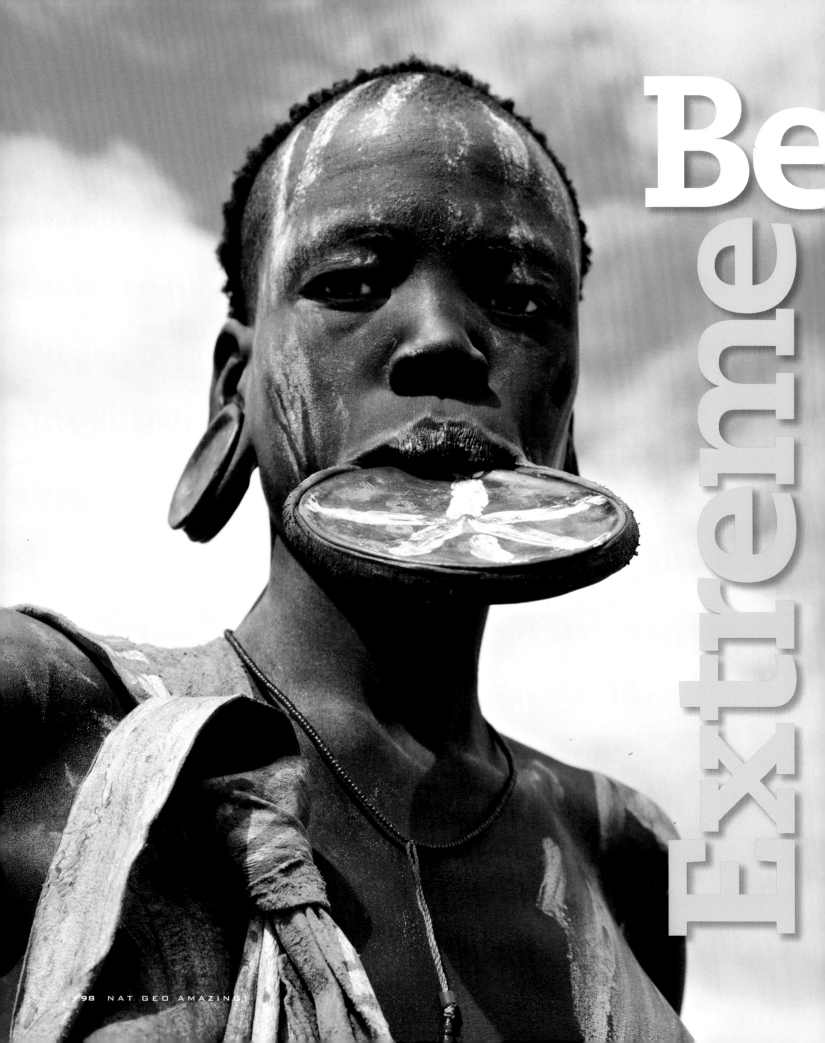

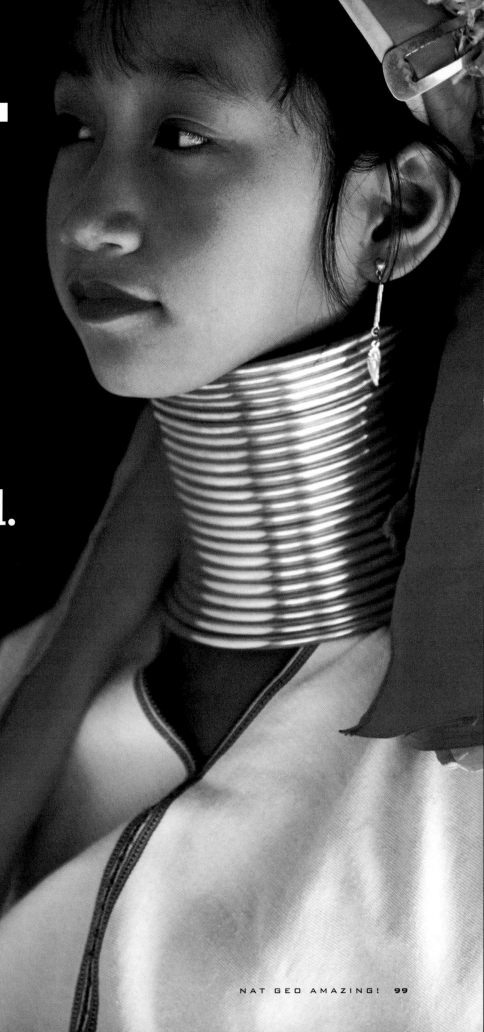

auty

51

Is glamour hardwired into our evolution? Behold beauty around the world.

E very year, more than 11 million people go under the knives of cosmetic surgeons, with breast augmentation, liposuction, eyelid lifts, rhinoplasty, and tummy tucks being among the most popular procedures. Is it just a frivolous waste of money and energy—even an unnecessary risk of one's life—or an evolutionary drive as hardwired as survival?

Scientists are discovering that beauty is not just an ideal. In fact, we may be born with an innate idea of what is attractive, just as we are born with our eye and skin color. Some evolutionary scientists see the full lips and curvaceous belly that certain men are drawn to as unconscious cues of a woman's fertility. Others may prefer large breasts, blond hair, and a small nose with a single-mindedness that obscures other cultures' tastes. Plastic surgeon Stephen Marquardt, guided by the idea of a "golden ratio" of an ideal face, and by the contours of some admired faces, has built a computerized beauty mask that shows what a perfect visage might look like.

Still other scientists believe that babies spend more time focused on "attractive" faces than unattractive ones. Some evolutionary scientists believe facial symmetry is key to

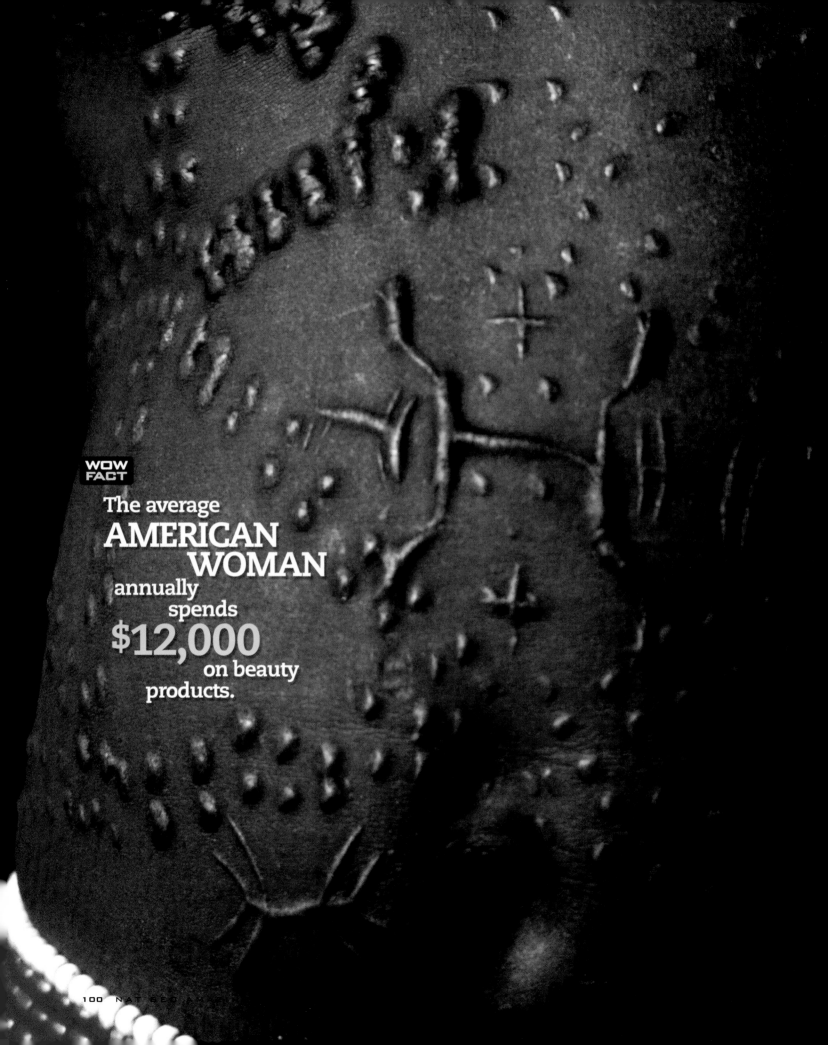

The average
**AMERICAN
WOMAN**
annually
spends
$12,000
on beauty
products.

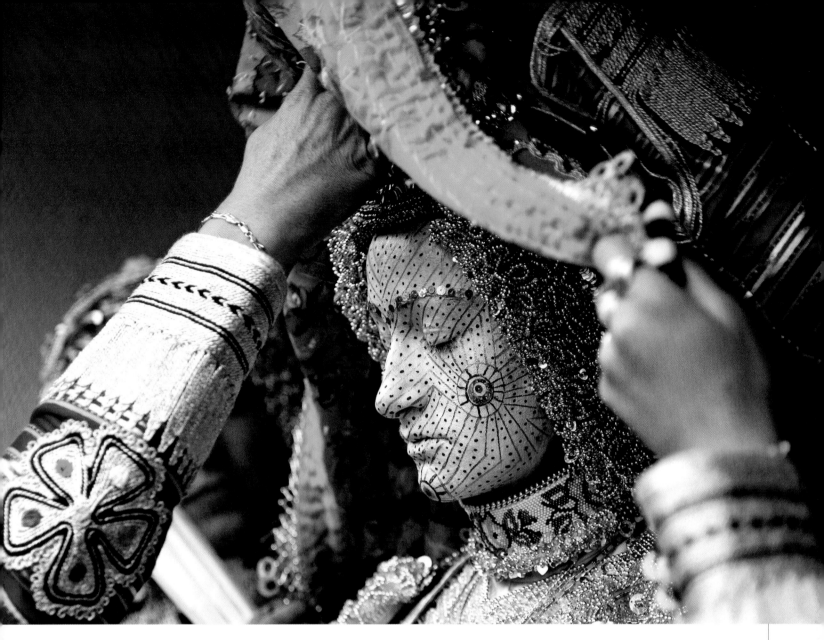

appeal, suggesting developmental stability; Donald Symons, an anthropologist at the University of California, Santa Barbara, was the first to propose, in the 1970s, that essential beauty hinges on "averageness." As Symons says, "Beauty is not whimsical. Beauty has meaning."

No wonder, then, that the pursuit of beauty drives nearly every culture on the planet. A little nip and tuck is nothing compared with the passion many women bring to the project. Scarification is a common practice among African tribes, denoting not just beauty but important passages in life, from puberty to marriage (although it is growing less popular among younger generations). The female members of Ethiopia's Mursi and Suri tribes wear lip plates that are inserted through a cut made in the lip when they are around 15, before marriage; the lip plates, made of pottery or wood, are switched out for larger ones as the girl grows.

For the remote Karen people, who live in Thailand's northern hills, beauty is the appearance of a long neck. The women begin adorning themselves with bands when they are as young as five, adding more as they grow. (Contrary to legend, the brass rings do not actually elongate a woman's neck, nor do they leave her neck in danger of breaking once they are removed.)

Incidentally, women aren't the only ones on the search for beauty. The Asaro warriors in Papua New Guinea (like Wodaabe men in Niger; see page 10) paint themselves with native potions. "Here men are the objects of beauty," says anthropologist Nancy Sullivan of the Asaro. "So to be masculine is to be well made up." Women, on the other hand, are believed to court danger if they are too attractive. "Men are already mortally afraid of the power of women's biology." **A**

Facial Symmetry

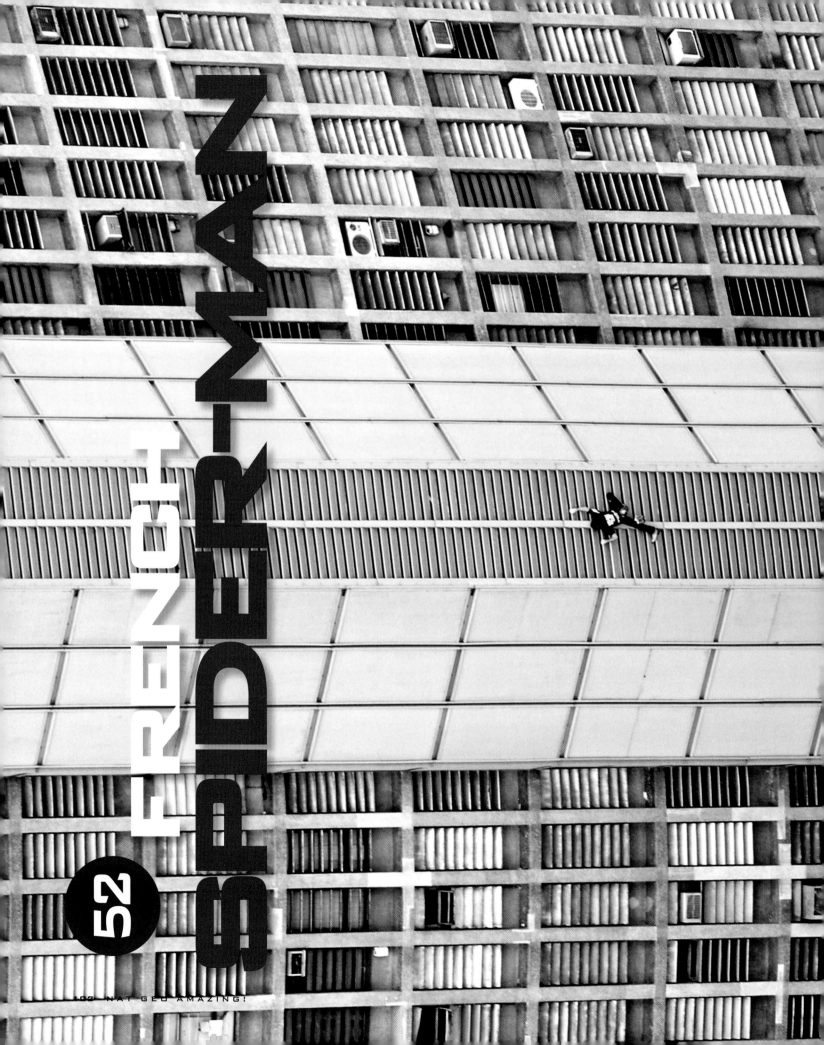

52 FRENCH SPIDER-MAN

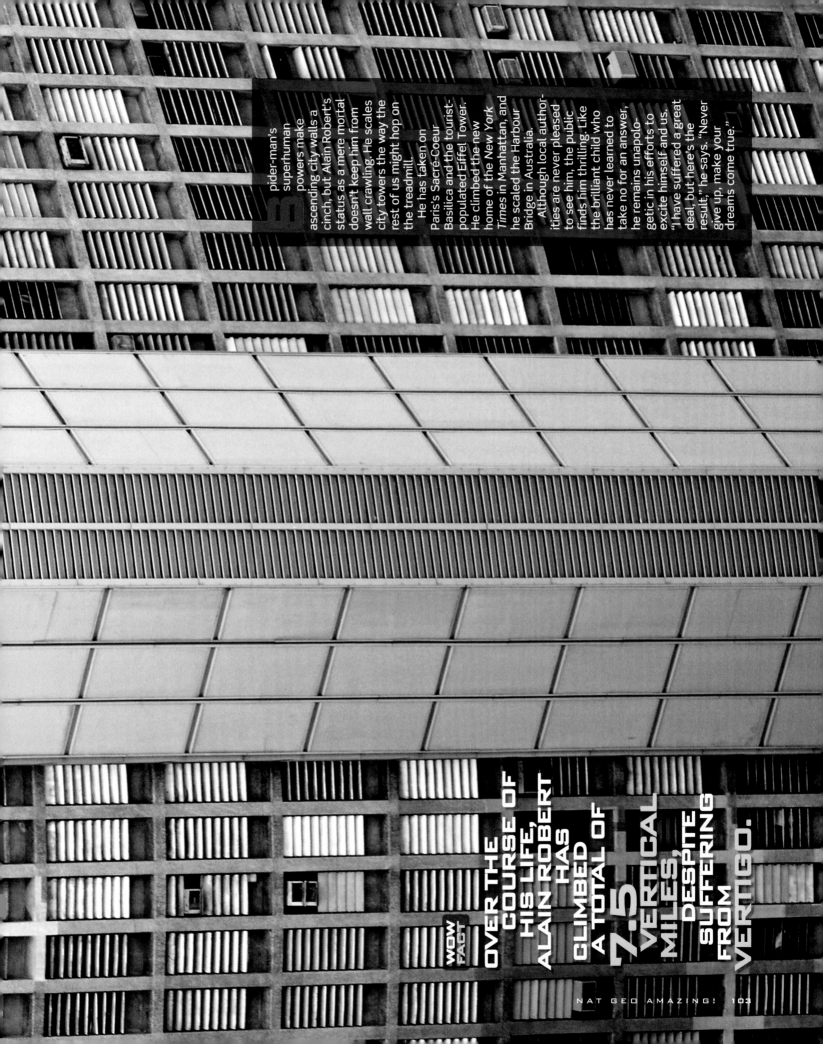

Spider-man's superhuman powers make ascending city walls a cinch, but Alain Robert's status as a mere mortal doesn't keep him from wall crawling. He scales city towers the way the rest of us might hop on the treadmill.

He has taken on Paris's Sacré-Coeur Basilica and the tourist-populated Eiffel Tower. He climbed the new home of the New York *Times* in Manhattan, and he scaled the Harbour Bridge in Australia.

Although local authorities are never pleased to see him, the public finds him thrilling. Like the brilliant child who has never learned to take no for an answer, he remains unapologetic in his efforts to excite himself and us. "I have suffered a great deal, but here's the result," he says. "Never give up, make your dreams come true."

WOW FACT

OVER THE COURSE OF HIS LIFE, ALAIN ROBERT HAS CLIMBED A TOTAL OF 7.5 VERTICAL MILES, DESPITE SUFFERING FROM VERTIGO.

Life Inside
One
cubic Foot

A cubic foot may seem small, but photographer David Liittschwager's work reveals it to be a kingdom of infinite space by uncovering the astonishing number of Earth's creatures that can live there.

Liittschwager wanted to show artistically how diverse and fascinating the world at our feet can be, so he came up with the idea of building a glass box that measured one cubic foot and took it to six different spots across the United States. In each place, his task was to record what life-forms walked through, lived in, or grew in that cubic foot. "I had spent years trying to figure out how to show how much life there is in a small spot," he explains. "My girlfriend, who is a painter, came up with the idea of the cubic foot. It seems simple now, but it took us a couple of years to work it out."

Liittschwager brought the idea to National Geographic, and the project went global: The cube, filled with four inches of dirt, would capture flora, fauna, and creatures at destinations around the world, from Moorea, in French Polynesia (where the cube was also placed in the water), to New York's Central Park and South Africa's Table Mountain (pictured here). Liittschwager, his assistant (who is trained as a biologist), and their cube would be accompanied by several biologists whose job it would be to identify and catalog the species. Says the photographer, "You need a biolo-

gist who is connected to a team of others, because the person who can tell you what an ant is won't necessarily be able to tell you about millipedes."

The logistics of Liittschwager and his team's plan seemed simple enough to execute: Head to a location, pick the perfect spot, put the cube down, and watch what surfaced. But accomplishing the task—and photographing the more than thousand individual organisms—would take an average of three weeks per location. And there were, of course, the unforeseen complications. Table Mountain, South Africa, is an area so rich in plants—there are some 9,000 native species—that to capture a full range in 12 inches, Liittschwager and his team had to find plants young enough that they could fit within the space.

"If a protea bush was a substantial part of the cube, there wouldn't be room for other species," Liittschwager explains. The team decided to find an area where a mild fire had burned the plants a year and a half earlier. (The scrub brush in the areas makes fires not infrequent.) "We were able to find that place, so the protea bush in our cube is only two inches tall, but it took us four days," says the photographer. "So then, all of a sudden we were in a hurry."

The team set up shop within the Table Mountain National Park, with a car parked on the road nearby

Inset: The carnivorous plant Alice Sundew; right: one cubic foot of South Africa's diverse fynbos vegetation contained 90 separate species.

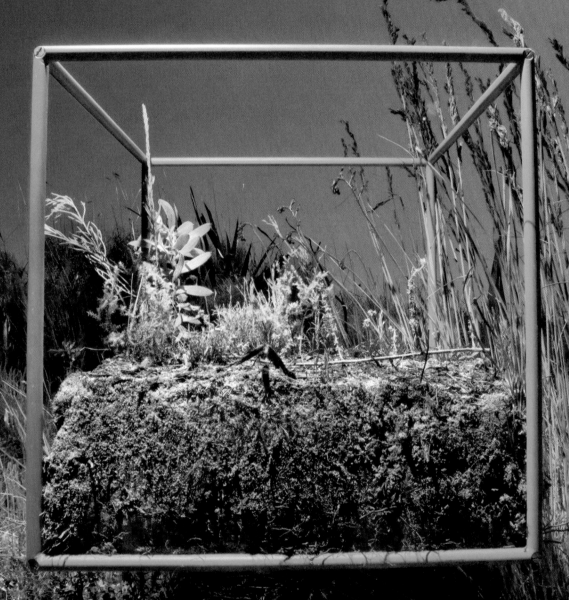

WOW FACT

About **60,000** species of fungi have been **classified,** but it is estimated that more than **1.5 million** species exist.

serving as Liittschwager's "studio," where he would run with species and snap their photos. After about a week, the photographer and biologists had counted 90 separate species, including 25 types of plants just on the soil's surface and some 200 seeds representing at least 5 of them, not to mention a host of creepy crawlies.

Duck River, Tennessee, another chosen spot, might seem less exotic, but it's one of the most biodiverse waterways in the U.S., harboring several endemic species that are found nowhere else on Earth. Why there? It's a question of time. "Part of an ancient watershed, the 290-mile Duck River has streamed over its limestone base for millions of years," says Don Hubbs of the Tennessee Wildlife Resource Agency. There, Liittschwager and his team found seven species of mussels, three of them endangered. "Several of the biologists collected every mussel in the area and made a little catalog for us," says the photographer. The cheat sheet, which contained pictures, sat in the back of the team's truck so they could quickly be identified when collected in the cube.

In Moorea, Liittschwager "eavesdropped" on a Smithsonian Institution/University of California, Berkeley, biocode project, which is already sequencing all the plants and animals on land and in the water. At Temae Reef, the team met postlarval octopuses and brown-eyed polychaete worms, with the photographer capturing total images of more than 600 individual water creatures, not counting tens of thousands of shrimplike hatchlings that drifted through the cube on a moonless night.

Biocode engineers are conducting DNA sequencing on Liittschwager's collection, part of a larger effort to assign a unique identifier to each species. "Such detail will give us a new way to look at the ecosystem," says Smithsonian research zoologist Chris Meyer, who notes that the survey can't begin to plumb the reef's actual depths. "If you move the cube over just a few feet, a third of your finds might be different."

In New York's Central Park, Liittschwager was allowed to explore a nature conservancy that sits in the middle of the park, untouched since 1939—on the condition that he deliver his soil to the Museum of Natural History when he was finished. He agreed, using a pillowcase from his hotel to bring the sample safely to the museum. As for the raccoon that disturbed the cube one evening, he remained at home in the park, free to roam.

The team took a loftier view of things when they headed into the Monteverde cloud forest in Costa Rica, making their home 100 feet off the ground in a treetop, where the thriving ecosystem consists of hummingbirds, rodents, monkeys, and insects, more than 100 species of which were seen within the cube's borders. "It's a little uncomfortable, sitting in a tree for hours on end," Liittschwager admits. "But I only fell out once, and I only fell five feet because I was secured by a harness."

The cube fared less well: On the last night, it went crashing to the ground. Luckily, an engineer was on hand to repair the box. Says Liittschwager, "Cube 2.0 is actually stronger and better." Sounds like a sequel in the making. ◭

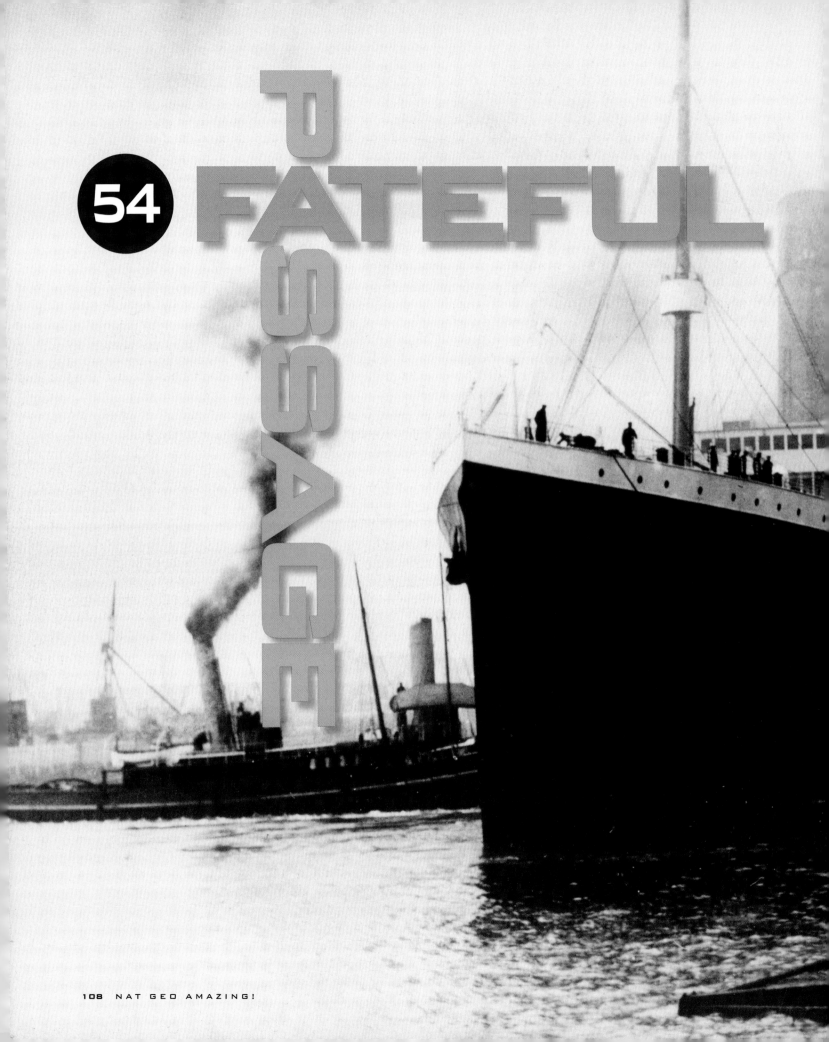

54 FATEFUL PASSAGE

I'm Bob Ballard, oceanographer and National Geographic Explorer-in-Residence, and I was part of the French-American diving team that discovered Titanic *in 1985.*

In the intervening years, *Titanic* has weathered the impact of many visitors and has also suffered from natural disasters. In order to see the damage done, I decide to team up with Capt. Craig McClean, director of ocean exploration at the National Oceanic and Atmospheric Administration, to cosponsor an expedition. And so I find myself in *Hercules,* our newest robotic vehicle, 350 miles off the coast of Newfoundland, two and a half miles beneath the sea.

The debris field hits me the hardest. Here in that ghostly expanse of seafloor, the people who died during the frigid early hours of April 15, 1912, speak to me again. A case of champagne lies on the bottom, its bottles still corked—a reminder of *Titanic*'s role as a floating palace of the rich and powerful. The box holding the bottles has long ago disappeared, consumed by wood-eating mollusks. Next to them are tiles decorated with a red-and-white design, possibly from a public room. Suddenly my eye is drawn to a woman's shoe, lying on its side. Nearby are three large combs and a pair of smaller shoes that may have belonged to a child. Beside them is a hand mirror.

How did these objects find themselves together on the bottom? Did the larger shoe belong to a mother, who combed her daughter's beautiful long hair? What did the girl's face look like that may once have been reflected in this mirror? A short distance away are more shoes, a pair from a young girl and another pair near what looks to me like a sailor's black slicker. A pair of shoes cannot fall 12,500 feet by themselves and land like this. Their journey was together.

We glide a few meters over *Titanic*'s famous bow. When the luxury liner had smashed into the bottom, her bow had pushed up a great wave of mud, as if she was still under steam trying to complete her maiden voyage to New York. It surprises me how little has changed on the bow, the best-preserved part of *Titanic.* As *Hercules* passes over the foredeck, I spot a black blemish on the forward anchor boom that may have been caused by the glancing bow of a passing

> **FOR A LONG TIME I'D RESISTED THE URGE TO RETURN TO TITANIC. MY DISCOVERY OF HER IN 1985 HAD CHANGED MY LIFE, AND NOT ALL FOR THE BETTER.**

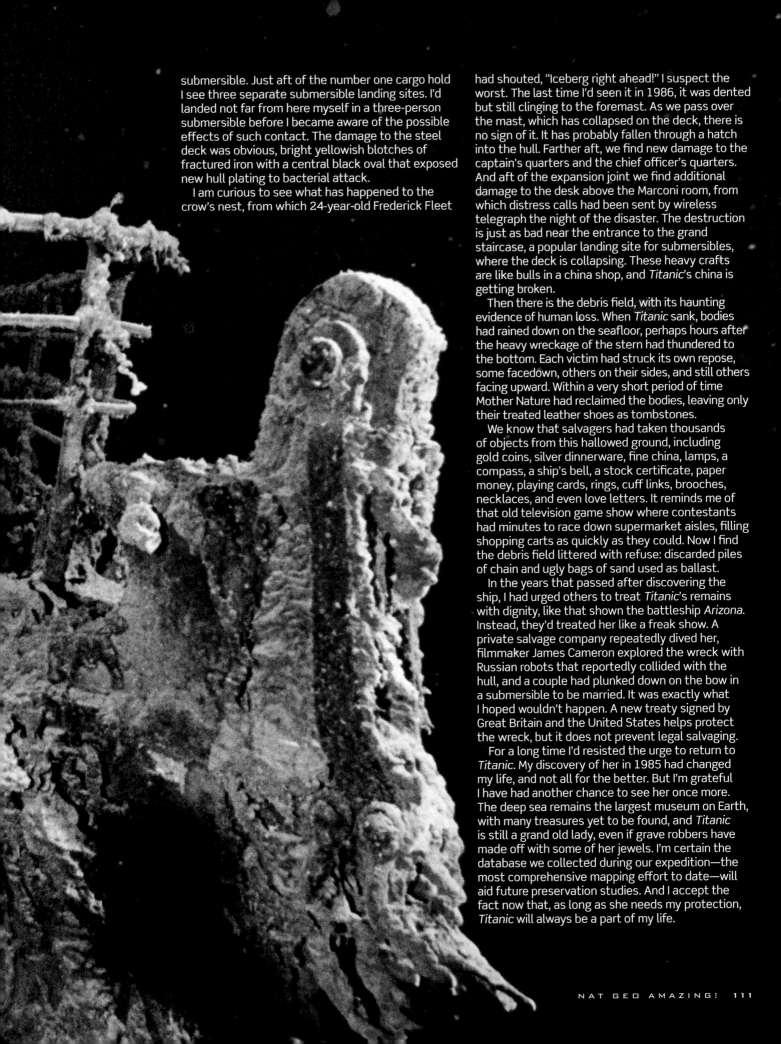

submersible. Just aft of the number one cargo hold I see three separate submersible landing sites. I'd landed not far from here myself in a three-person submersible before I became aware of the possible effects of such contact. The damage to the steel deck was obvious, bright yellowish blotches of fractured iron with a central black oval that exposed new hull plating to bacterial attack.

I am curious to see what has happened to the crow's nest, from which 24-year-old Frederick Fleet had shouted, "Iceberg right ahead!" I suspect the worst. The last time I'd seen it in 1986, it was dented but still clinging to the foremast. As we pass over the mast, which has collapsed on the deck, there is no sign of it. It has probably fallen through a hatch into the hull. Farther aft, we find new damage to the captain's quarters and the chief officer's quarters. And aft of the expansion joint we find additional damage to the desk above the Marconi room, from which distress calls had been sent by wireless telegraph the night of the disaster. The destruction is just as bad near the entrance to the grand staircase, a popular landing site for submersibles, where the deck is collapsing. These heavy crafts are like bulls in a china shop, and Titanic's china is getting broken.

Then there is the debris field, with its haunting evidence of human loss. When Titanic sank, bodies had rained down on the seafloor, perhaps hours after the heavy wreckage of the stern had thundered to the bottom. Each victim had struck its own repose, some facedown, others on their sides, and still others facing upward. Within a very short period of time Mother Nature had reclaimed the bodies, leaving only their treated leather shoes as tombstones.

We know that salvagers had taken thousands of objects from this hallowed ground, including gold coins, silver dinnerware, fine china, lamps, a compass, a ship's bell, a stock certificate, paper money, playing cards, rings, cuff links, brooches, necklaces, and even love letters. It reminds me of that old television game show where contestants had minutes to race down supermarket aisles, filling shopping carts as quickly as they could. Now I find the debris field littered with refuse: discarded piles of chain and ugly bags of sand used as ballast.

In the years that passed after discovering the ship, I had urged others to treat Titanic's remains with dignity, like that shown the battleship Arizona. Instead, they'd treated her like a freak show. A private salvage company repeatedly dived her, filmmaker James Cameron explored the wreck with Russian robots that reportedly collided with the hull, and a couple had plunked down on the bow in a submersible to be married. It was exactly what I hoped wouldn't happen. A new treaty signed by Great Britain and the United States helps protect the wreck, but it does not prevent legal salvaging.

For a long time I'd resisted the urge to return to Titanic. My discovery of her in 1985 had changed my life, and not all for the better. But I'm grateful I have had another chance to see her once more. The deep sea remains the largest museum on Earth, with many treasures yet to be found, and Titanic is still a grand old lady, even if grave robbers have made off with some of her jewels. I'm certain the database we collected during our expedition—the most comprehensive mapping effort to date—will aid future preservation studies. And I accept the fact now that, as long as she needs my protection, Titanic will always be a part of my life.

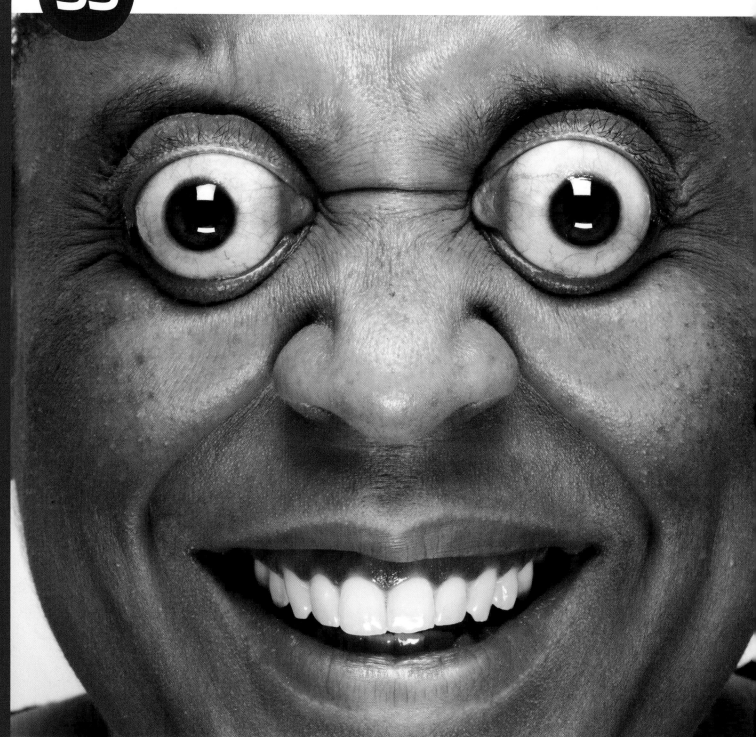

THE INCREDIBLE STORY OF THE GOOGLY-EYED WOMAN...

...AND FOUR OTHER VERY UNIQUE INDIVIDUALS

56

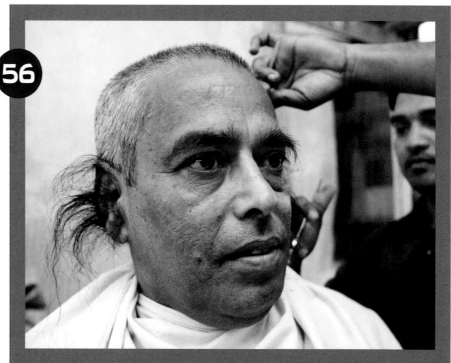

THAT'S EAR HAIR
Naya Ganj, India

As far as Guinness World Records go, this would seem like a pretty easy one to win, given how few people would allow themselves to stay in the running. When he first won the title for longest ear hair, Radhakant Bajpai of India sprouted strands that grew 5.19 inches from the center of his outer ear. Guinness World Records found the "feat" so odd that they listed it in a special edition dedicated to "gross" records—perhaps yet another reminder that some things are best shared on a need-to-know basis.

55

THE EYES HAVE IT!
Chicago, Illinois

Here's the good news: It's painless. At least that's what Kim Goodman says of her unique ability to thrust her eyeballs 0.43 inch beyond her eye sockets—and keep them there long enough to be measured. That makes her the Guinness World Record holder for eye-popping endeavors. Goodman says that at first her eyes went AWOL whenever she yawned, but now she has learned to control them to pop (and not) at will. Talk about a good party trick.

> ◀ GOODMAN SAYS THAT AT FIRST HER EYES WENT AWOL WHENEVER SHE YAWNED, BUT NOW SHE HAS LEARNED TO CONTROL THEM.

HIRSUTE OF HAPPINESS ▶
Zacatecas, Mexico

57

Larry Ramos Gomez (right) and his brother, Danny, refer to themselves as Wolf Men due to the hair that covers their bodies. They have a genetic condition known as hypertrichosis; indeed, 19 other members from five generations of the Gomez family have hypertrichosis, making them the Guinness World Record holders for the hairiest family. Although the brothers were originally part of a sideshow as children, they are now trapeze artists in a Mexican circus. Danny has said of suffering from others' unkindness, "I don't take it seriously. I know who I am inside."

STRETTTTCCCHHH

Lincolnshire, United Kingdom

Is there a record holder at Guinness World Records for the person who comes up with the weirdest category (and then, amazingly, manages to find people who might qualify)? It's the only way to fathom finding Garry "Stretch" Turner, who holds the Guinness World Record for the stretchiest skin.

In addition to looking like Jim Carrey in *The Mask* when he pulls on his cheeks (this Englishman is an otherwise handsome guy when he's not playing with his epidermis), Turner can yank skin from his neck over his mouth and catch a half-size basketball in the stretched-out skin from his stomach—although he's never been overweight.

Turner, who realized when he was eight years old and playing with friends that his ability to stretch himself to the limit was out of the norm, was born with Ehlers-Danlos syndrome. A rare condition that occurs in only 1 out of about 500,000 people, the syndrome results in joint hypermobility, tissue fragility, and, because of faulty collagen, elastic skin. There is no specific cure, but people affected by it have a normal life span.

Turner, for one, professes to see his disability as a gift. He appears on talk shows shirtless, gamely showing off how the tree tattooed on his arm can grow at warp speed, and pulling his neck over his chin like a turtleneck. He has also been a member of Britain's Circus of Horrors. One audience member responded to his act, professing, "He seems to really take pleasure in frightening the women of the audience . . . but he is a fabulous performer."

TURNER CAN YANK SKIN FROM HIS NECK OVER HIS MOUTH AND CATCH A HALF-SIZE BASKETBALL IN THE STRETCHED-OUT SKIN FROM HIS STOMACH.

59

SHE REALLY NAILED IT!

Salt Lake City, Utah

For those who rue the time wasted on bodily maintenance, here's an idea: Skip it. That's what Lee Redmond decided to do when it came to weekly manicures. In fact, she's skipped 1,300 of them, growing her nails for 30 years and capturing the Guinness World Record for longest nails. The result was talons that, combined, measured more than 28 feet. When her nails were at their longest, Redmond could still cook and drive, and even cut her own hair. In fall 2009, the nails were broken when Redmond was involved in a car accident. At age 68 she doesn't have plans to regrow her superlong nails, given how long it took her the first time around.

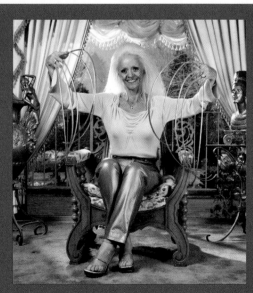

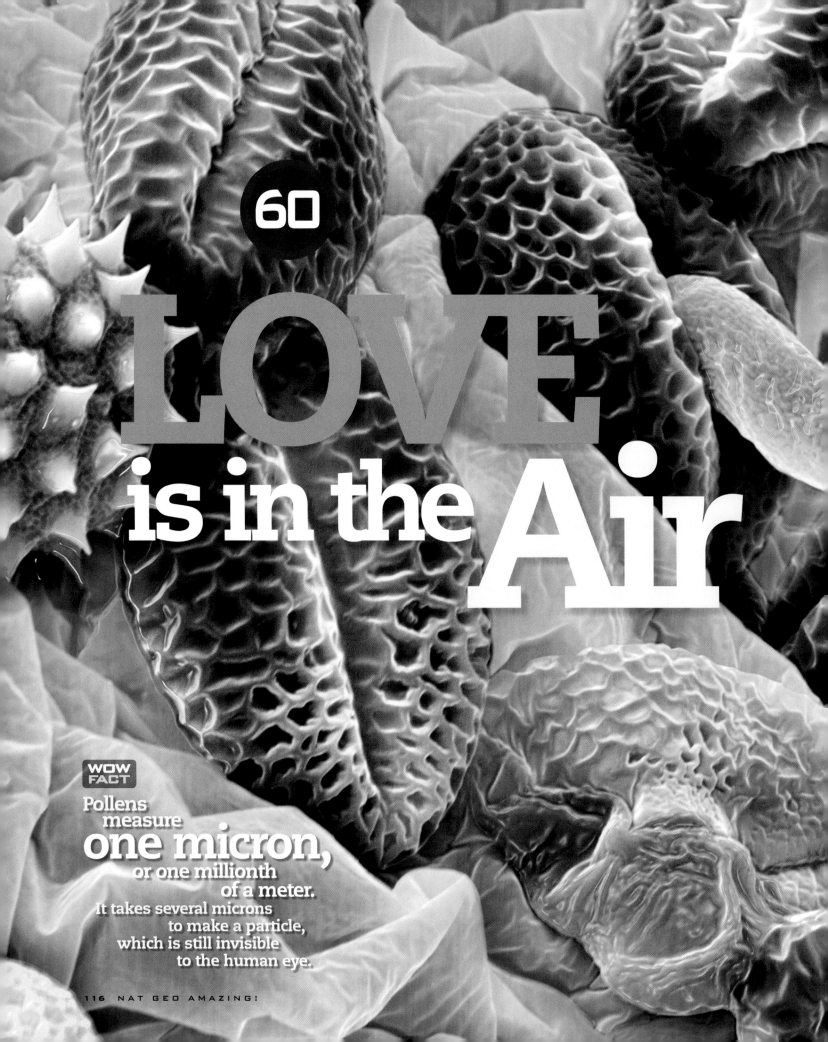

60

LOVE
is in the Air

WOW FACT

Pollens measure **one micron,** or one millionth of a meter. It takes several microns to make a particle, which is still invisible to the human eye.

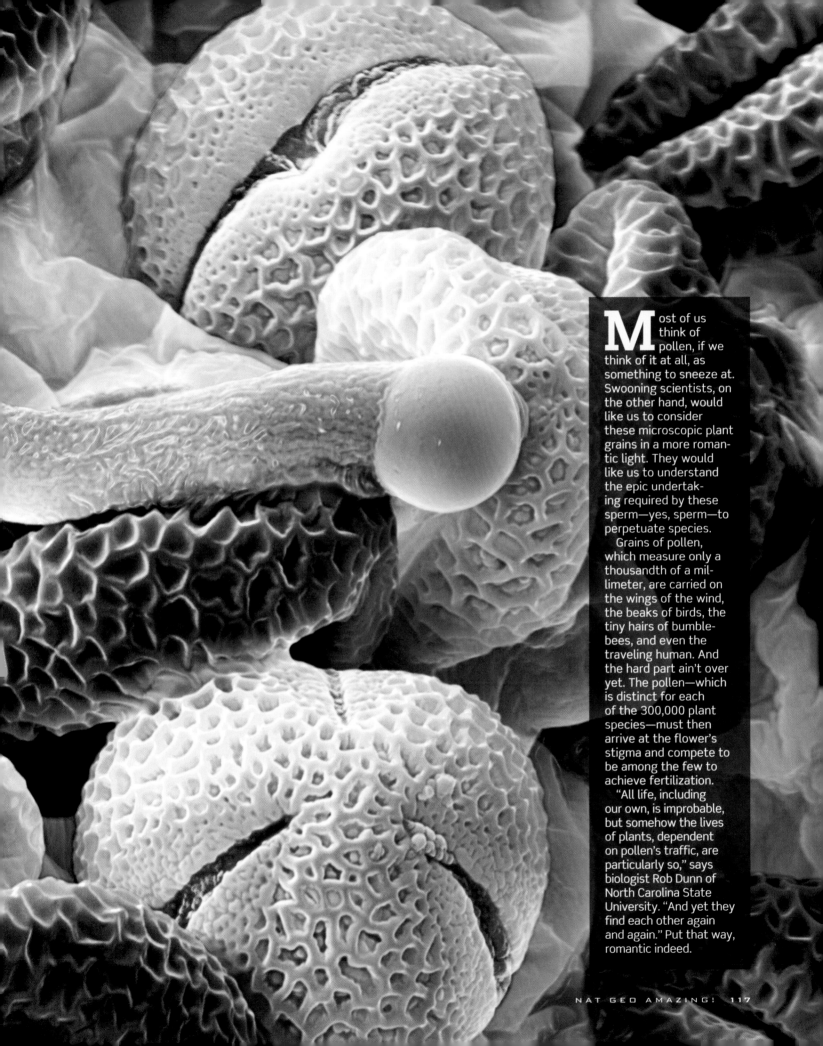

Most of us think of pollen, if we think of it at all, as something to sneeze at. Swooning scientists, on the other hand, would like us to consider these microscopic plant grains in a more romantic light. They would like us to understand the epic undertaking required by these sperm—yes, sperm—to perpetuate species.

Grains of pollen, which measure only a thousandth of a millimeter, are carried on the wings of the wind, the beaks of birds, the tiny hairs of bumblebees, and even the traveling human. And the hard part ain't over yet. The pollen—which is distinct for each of the 300,000 plant species—must then arrive at the flower's stigma and compete to be among the few to achieve fertilization.

"All life, including our own, is improbable, but somehow the lives of plants, dependent on pollen's traffic, are particularly so," says biologist Rob Dunn of North Carolina State University. "And yet they find each other again and again." Put that way, romantic indeed.

BURN AND

Greg Carpenter was ten years old when he set his first car on fire. So perhaps it was inevitable that he would grow up to become Dr. Danger, stuntman and thrill seeker. "I do the flaming car thing real, real good," says Carpenter, also a songwriter.

For this particular act, he ignites a car with 20 to 30 gallons of gas and drives it into a pile of junk cars, exiting at precisely the right moment. But the day this photograph was published, Carpenter performed the same trick with a different result: The car crashed and the seat belt pulverized his intestines. He was given a 5 percent chance of survival, but 21 days later, he was back at work.

"As a child, I used to wonder what I would do in a battle. Would I have hidden, or gone behind enemy lines?" he says. "I think I've figured out I would have gone behind enemy lines."

> " I DO THE FLAMING CAR THING REAL, REAL GOOD. "

CRASH

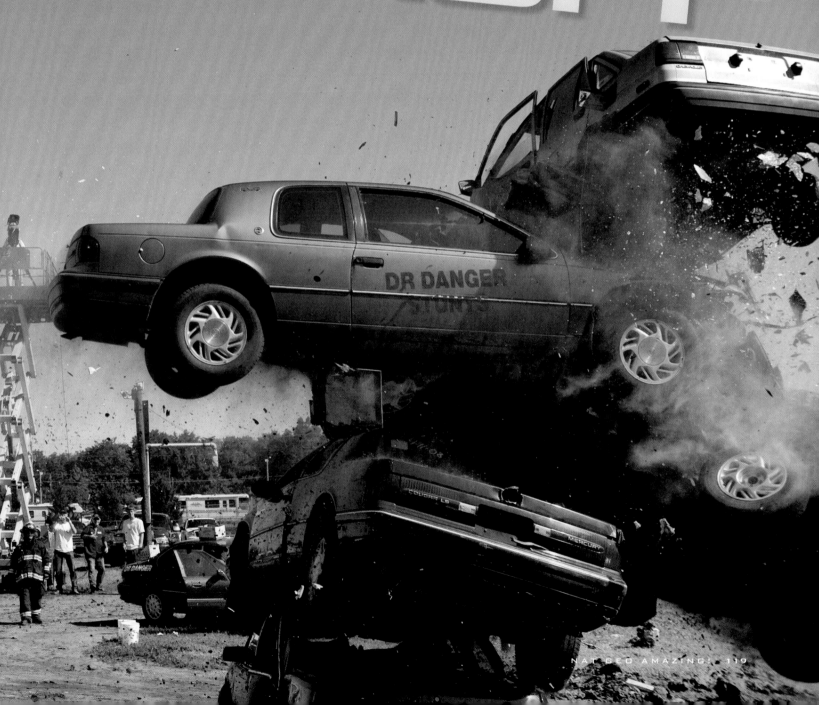

62 FLYING MAN

He is a modern-day Icarus. But where the son of a Greek god flew too close to the sun, Swiss adventurer Yves Rossy has technology on his side, helping him soar on more than a wing and a prayer.

The former military and commercial pilot uses no equipment to navigate, but make no mistake: this is sophisticated stuff. After years spent paragliding and relying on the power of wind, Rossy—who refers to himself as "fusionman," part bird and part man—contacted a model jet engine company that agreed to help give him a boost.

With 3-meter (10-foot) carbon wings powered by fuel, Rossy became able to maintain a 1,600-meter (5,250-foot) altitude. As pictured here, he flew above the Alps on a five-minute, 186-mile flight. He then soared across the English Channel in a 22-mile, 10-minute crossing from Calais, France, to Dover, England.

His subsequent attempt at the first intercontinental jet-wing crossing, from Morocco to Spain, resulted in an aborted mission due to weather conditions, but he is determined to try again—perhaps with company. "I love sharing my passion," he says, "and dream in a few years of having an air show with several jet-propelled wings in formation!" Volunteers, anyone?

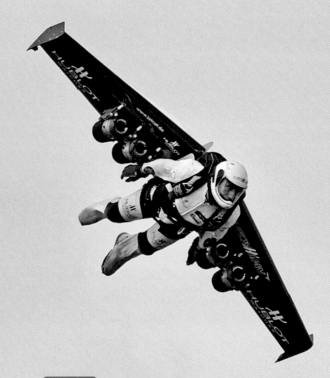

WOW FACT

YVES ROSSY WAS THE FIRST SELF-PROPELLED PERSON TO CROSS THE 22 MILES OF THE **ENGLISH CHANNEL** IN 13 MINUTES, FINISHING HIS JAUNT WITH A FIGURE EIGHT.

63 The Gospel of Judas

An ancient Christian text, recently found after being lost for 1,700 years, closes with a simple—yet controversial—phrase: "The Gospel of Judas." This last line belonged to a book denounced by early church leaders as heresy. The book was written by the Gnostics, an early Christian group that believed that Christ's betrayer was, in fact, his truest disciple.

It's riveting reading, for sure, contradicting the New Testament's assertion that Judas mercilessly turned on his Lord. "The secret account of the revelation that Jesus spoke in conversation with Judas Iscariot," it begins, going on to assert that Jesus *asked* Judas to betray him, thereby freeing his soul from his body. Judas becomes a hero, the only one to understand Jesus' message, and willing to bear what Jesus predicts for him: "You will be cursed."

A copy of the text, which was written in Coptic, the language spoken in Egypt at the beginning of Christianity, was uncovered in the Egyptian desert late in the 20th century; after being passed among antiquities dealers, the papyrus landed safely in the hands of experts in Coptic who translated it. Carbon dating—commissioned by the National Geographic Society, which is helping support the restoration and translation of the book—places the codex's creation sometime between A.D. 220 and 340.

Biblical scholar Marvin Meyer of Chapman University, who helped translate the text, says the Gnostics "believed that there is an ultimate source of goodness, which they thought of as the divine mind, outside the physical universe. Humans carry a spark of that divine power, but they are cut off by the material world all around them." Christians emphasized that only Jesus was simultaneously human and divine, but the Gnostics proposed that ordinary people could be connected to God as well. "The people were mystics," Meyer explains. "And mystics have always drawn the ire of institutionalized religion. Mystics, after all, hear the voice of God from within and don't need a priest to intercede for them."

As for the text itself, although the subject matter is still fiercely debated almost two centuries later, what is inarguable is its importance historically. "This changes the history of early Christianity," says Elaine Pagels, a professor of religion at Princeton University. "We don't look to the Gospels for historical information, but for the fundamentals of the Christian faith."

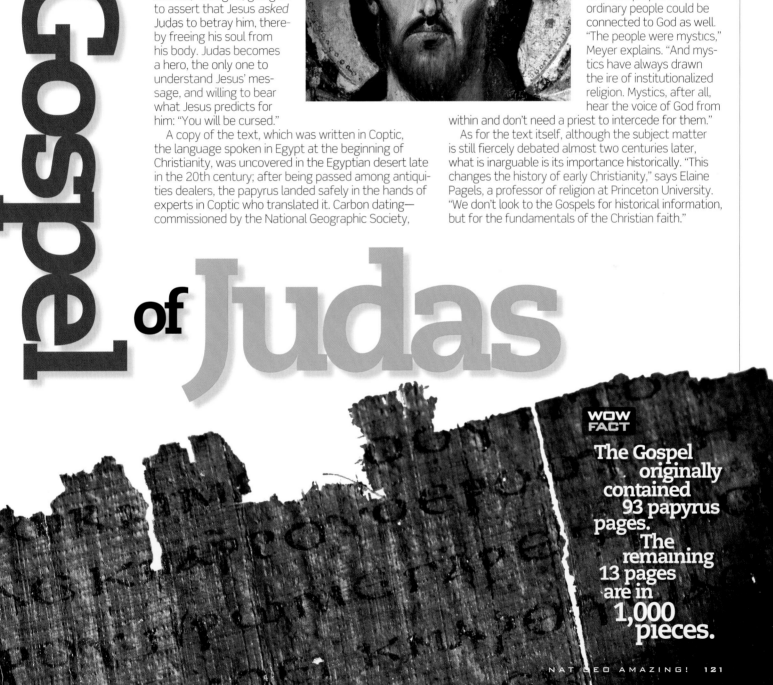

WOW FACT

The Gospel originally contained 93 papyrus pages. The remaining 13 pages are in 1,000 pieces.

The ~~Dog~~ Spouse Whisperer

64

Best-selling author and National Geographic Channel TV star—the Dog Whisperer himself—Cesar Millan has taken an understanding of canines and parlayed it into a one-man industry, offering comfort to all who fret about how we might improve our relationship with our four-legged companions. They're beloved, for sure, but occasionally seem so hard to understand.

In other words, they have quite a lot in common with our romantic partners.

Little wonder, then, that people are turning to his tenets of dog training when it comes time to improve relations with the two-footed members of their households. "Whenever you want to have a fulfilled relationship—human-canine, human-human, whatever—the goal is to respect and be respected, to trust yourself and to create trust, and to be loyal," says Millan.

The idea of looking to other mammalian behavior for insight into humans isn't necessarily new. As early as 1890, Ivan Pavlov's famous studies on dogs and the discovery of the relationship between stimulus and response yielded insights into both human and canine psychology. More recently, author Amy Sutherland spent a year in a school for exotic-animal trainers, then applied what she had learned to her spouse, and wrote about it in the best-selling book *What Shamu Taught Me About Life, Love, and Marriage*. Millan even dedicated an episode (called, appropriately enough, "Can This Marriage Be Saved?") to counseling a couple who were arguing over their canines. (Both the dogs and the couple are now living happily ever after; as Millan

You must inspire. You must motivate. You must encourage and reward at the right time.

says, "I helped them to be aware of their state of mind. I trained the people, and I rehabilitated the dogs.").

But there's no need for a dog to be in the room translating the behaviorist's techniques to help us relate to fellow humans. As Millan says of his philosophy, "The basic principles can be transferred to any other relationship. You must inspire. You must motivate. You must reward and encourage at the right time."

Millan's not just talking the talk: He lives by the same rules whether he is working with dogs or relaxing with his own family. "In any relationship, I must be mindful, aware, and emotionally in tune so that I can be responsible for the energy that I project. That way, I know what reaction I am capable of triggering."

Being aware of your state of mind is only one half of the process. Understanding how you can fulfill the needs of the other individual in the equation—be it your dog or your spouse—is a key part of Millan's methods. Gaining insight into their "psychological wiring" and learning what makes them happy can help shape the behaviors you'd like to see. Millan adds, "If each person in a relationship understands the other's psychology, they're going to be in good shape. They'll all be clear on what they need to do."

And maybe, we should not think it's a disgrace to be compared to a dog. "We both have the ability to be amazing when our mind is in the right place," he says of our commonalities with dogs. "We both have the capability to achieve unconditional love. We both love to live a joyful life. We both will give our lives for each other."

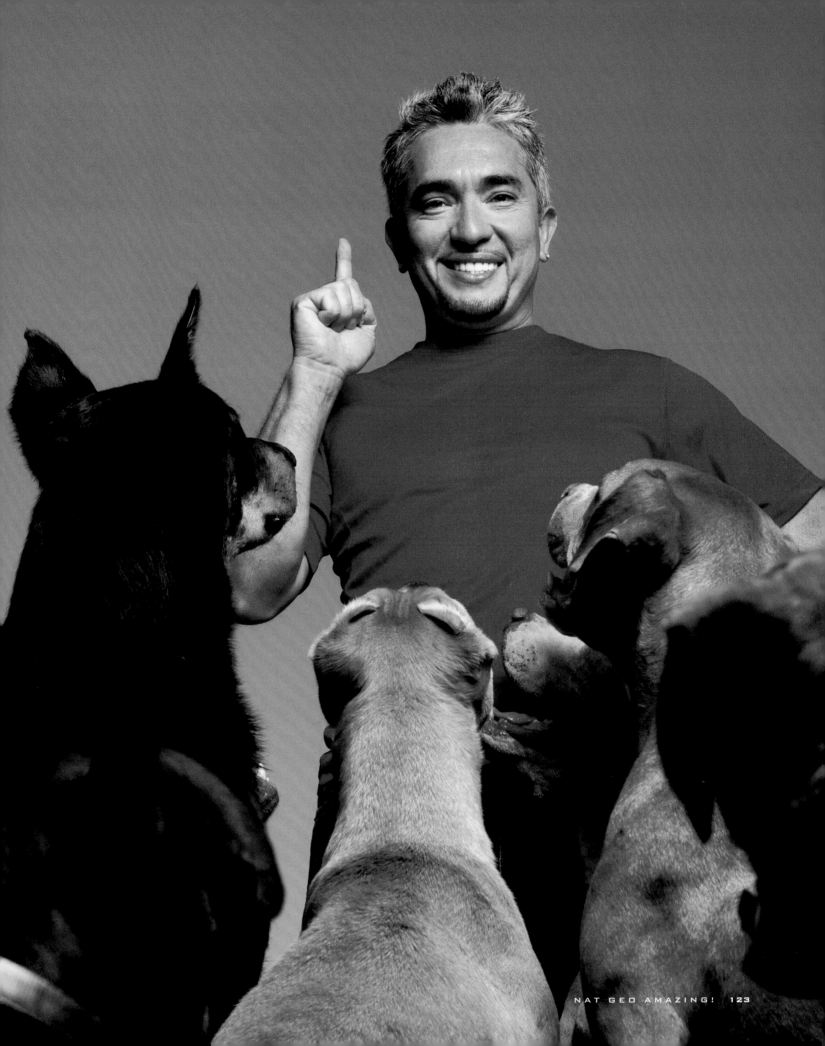

ELEPHANTS UNDER

65

CAN THIS ENDANGERED HERD BE SAVED?

My name is Mike Fay. I have walked more than 2,000 miles across central Africa. I am a conservationist and National Geographic Explorer-in-Residence who is determined to do everything I can to help save the elephant population that lives there.

I have learned to speak their language—not literally, of course, but I feel as though I understand them. I know their habits, their personalities, their moods. I have laughed with them, and I have played their jousting game. Once, I almost died from tusk wounds inflicted by a frightened female on a beach in Gabon. After that, my African bush friends said, "Your blood is now part elephant blood."

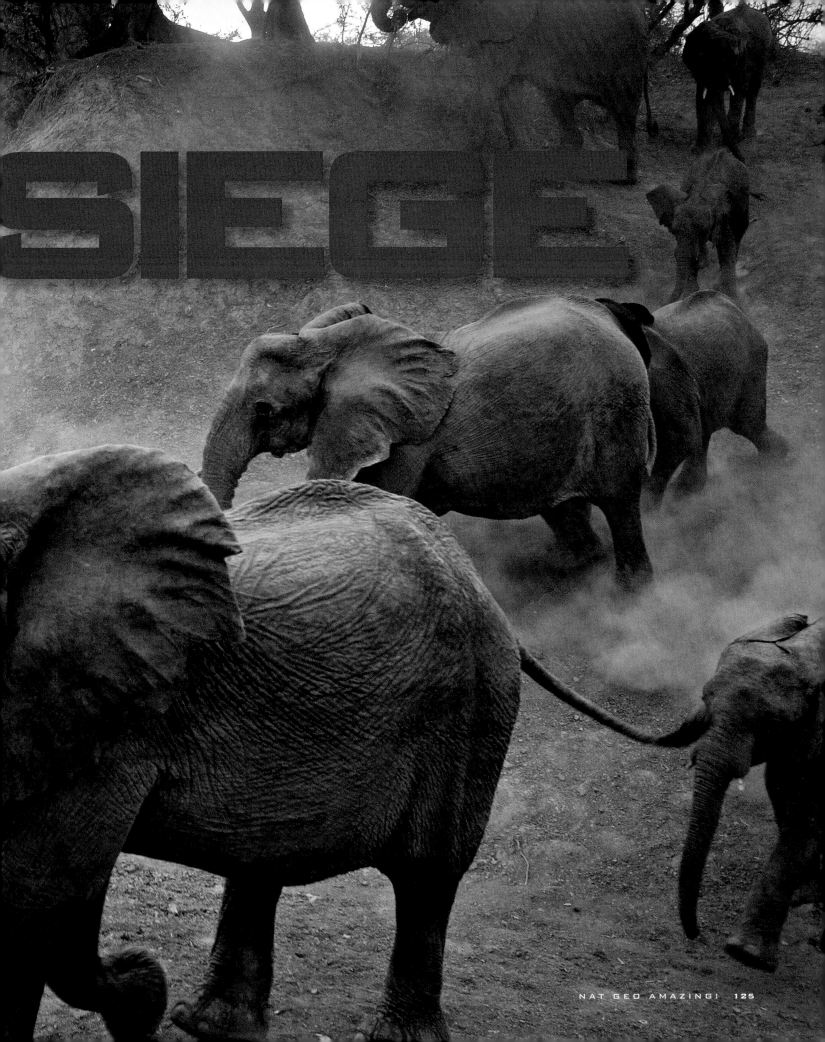

SIEGE

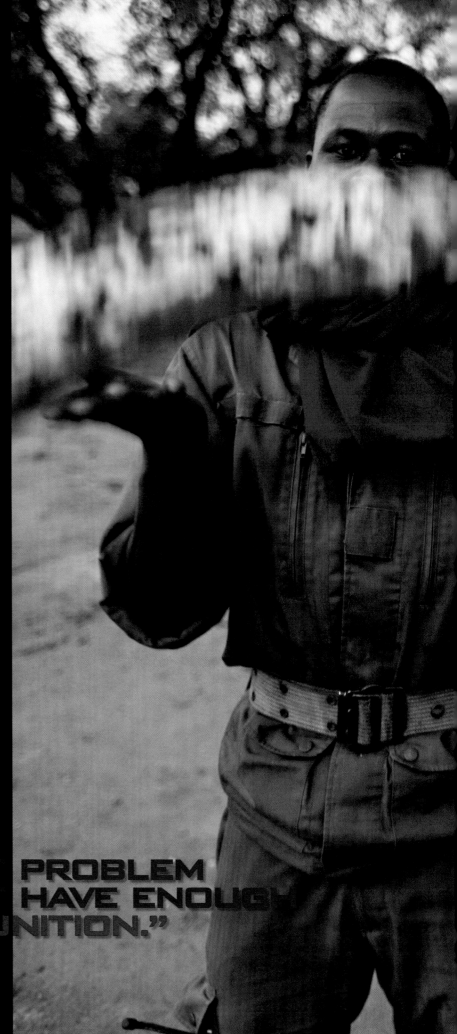

I visit Zakouma National Park in war-torn Chad, which is one of the most important refuges for elephants, which are the prey of poachers intent on harvesting their tusks. I hear 48 shots ring out, and a group of rangers follow the sound to find a dead elephant, a huge bull, lying on his side, right leg curled as if in wrenching pain. Dirt covers the exposed eye—work done by poachers to hide the carcass from vultures. The smell of musk and urine, of fresh death, hangs over the mound of the corpse. It is a sight I have seen hundreds of times in central Africa. As I pass my hand over his body from trunk to tail, tears pour down my cheeks. I lift the bull's ear. Lines of bright red blood bubble and stream from his lips, pooling in the dust. The base of his trunk is as thick as a man's torso. Deep fissures run like rivers through the soles of his feet; in those lines, I can trace every step he has taken during his 30 years of life.

At Zakouma National Park, antipoaching is a serious business. Officially, guards are allowed to defend themselves if poachers shoot. Unofficially, it is shoot-to-kill on both sides, so better to be the first to pull the trigger. In the past eight years, six guards have been killed by poachers, and at least six poachers by guards.

Meanwhile countless elephants are being murdered. This elephant has survived through civil wars and drought, only to be killed today for a few pounds of ivory in some distant land. (China is the fastest growing consumer, with dealers selling worked ivory on the Internet, and shipping it worldwide.) There are tender blades of grass in his mouth. He and his friends had been peacefully roaming in the shaded forest, snapping branches filled with sweet gum. Then, the first gunshot exploded. He bolted, too late. Horses overtook him. Again and again, bullets pummeled his body. We count eight small holes in his head. Bullets have penetrated the thick skin and lodged in muscle, bone, and brain before he fell.

Souleyman Mando, the commander of our detachment of mounted park rangers, is silent. I sense a dark need for revenge. The feeling is mutual. "Next time, you will get them," I offer.

Finding ivory in the bush provokes a fever in most Africans I have known. Every year, some 3,500 elephants leave this tiny, not even 1,200-square-mile area, searching for better forage. Danger awaits them. In a Texas-size region stretching from southern Sudan, southeastern Chad, and eastern Central African Republic down to the edge of the Congo forests, humans have been responsible for a precipitous decline of elephants, from perhaps 300,000

"OUR BIGGEST PROBLEM IS WE DON'T HAVE ENOUGH GUNS OR AMMUNITION."

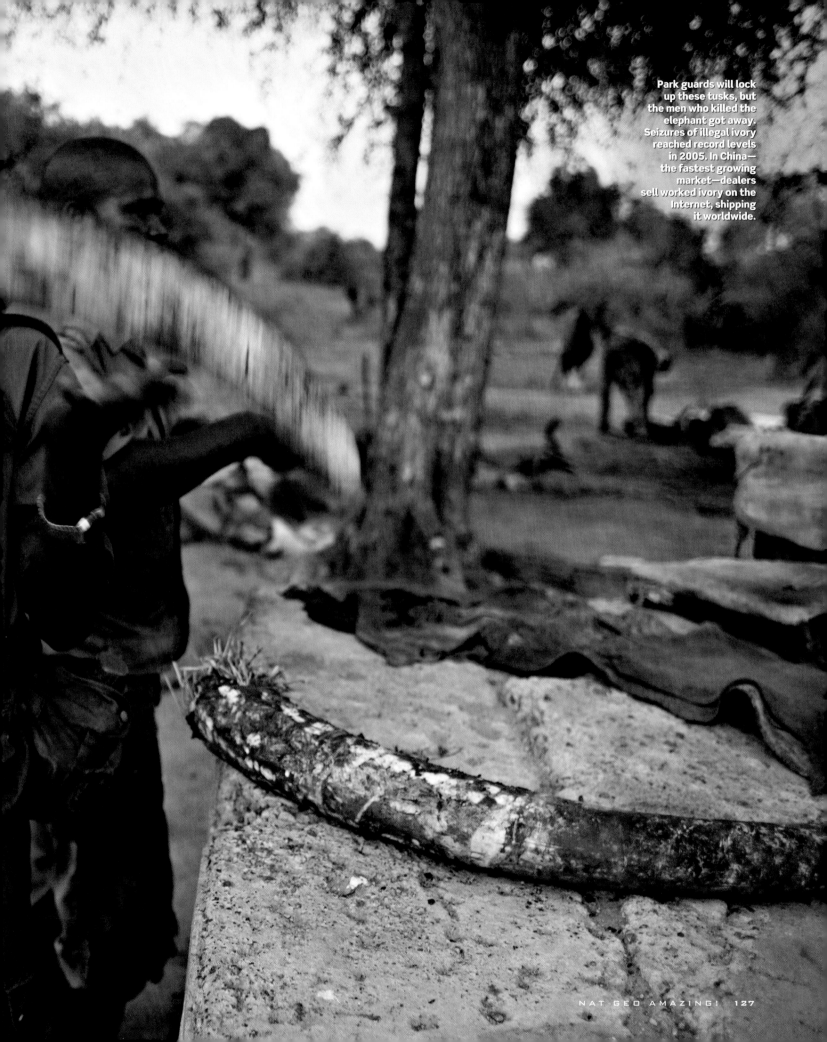

Park guards will lock up these tusks, but the men who killed the elephant got away. Seizures of illegal ivory reached record levels in 2005. In China—the fastest growing market—dealers sell worked ivory on the Internet, shipping it worldwide.

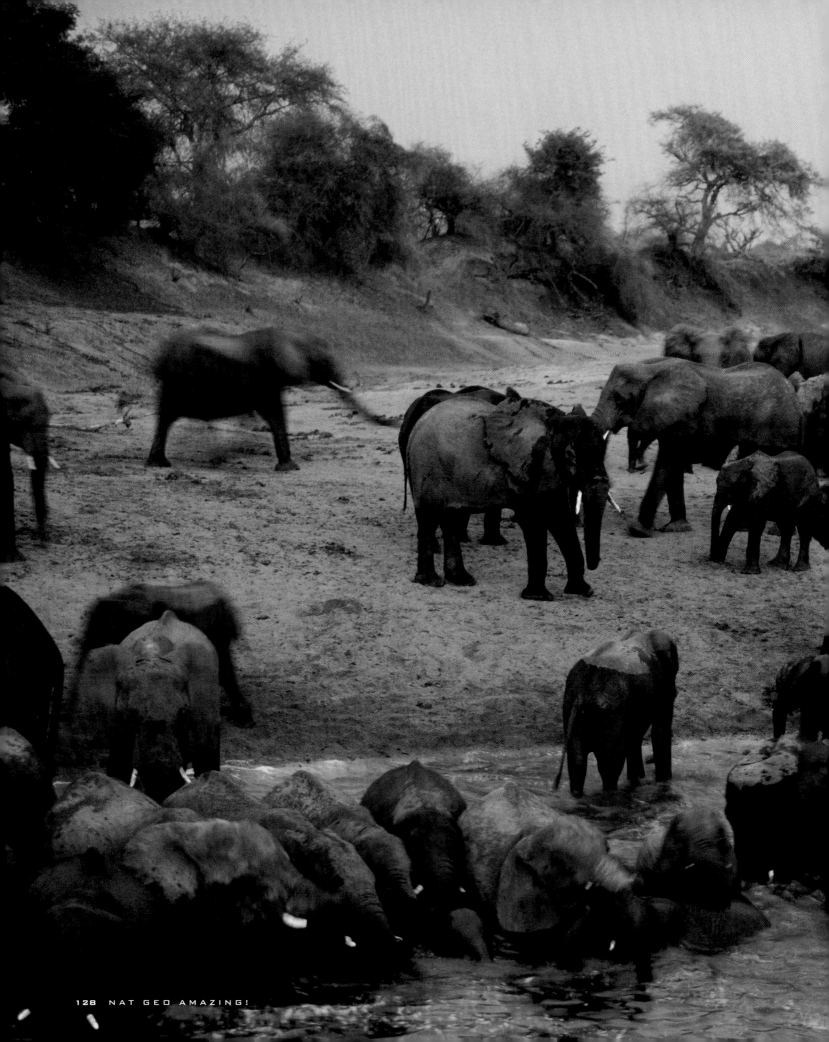

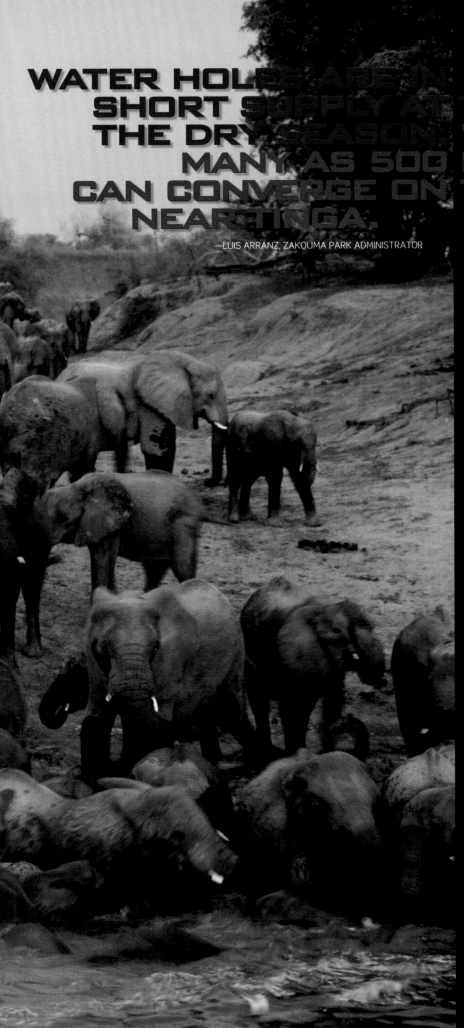

WATER HOLES ARE IN SHORT SUPPLY AT THE END OF THE DRY SEASON, WHEN AS MANY AS 500 ELEPHANTS CAN CONVERGE ON THIS POOL NEAR TINGA.

—LUIS ARRANZ, ZAKOUMA PARK ADMINISTRATOR

in the early 1970s to some 10,000 today.

In May, when the heavy rains start, elephants begin to leave the park's boundaries. They will return in October, if they're lucky. Because beyond the jurisdiction of Zakouma's armed patrols live clans of Arab nomads who survive by herding cattle and poaching elephants.

To track the migration of herds in and around Zakouma, researchers have fitted elephants with collars equipped with GPS transmitters. One elephant, named Annie, took off on an 86-day, 1,015-mile trek before being killed by poachers north of the park. During the 2006 wet season, 100 elephants killed by poachers were found outside the park, and 27 inside. "Our biggest problem," says park administrator Luis Arranz, "is we don't have enough guns or ammunition."

A year after I find the body of the 30-year-old bull, I am back at the park. This time, we find a fresh elephant carcass in the bed of the river. It is also a bull. His face is chopped off, his tusks gone. We camp with him for three days, mourning him.

Then, we head upstream. We see elephants approaching the river. We loop around. More elephants. And then more. At least 500. Moms are leading their families up the river, the kids goofing around, whipping their trunks from side to side and splashing each other as they run. For an hour, I watch, marveling that these elephants, who spend their lives being hunted and killed by men, can find peace. How do they endure the terror and despair?

Because its staff has stood firm in the face of adversity, Zakouma remains the best protected park in central Africa. But the fight to save the elephants is urgent. The Chadian authorities have pledged to safeguard the herds when they leave the park during the wet season. Information networks must be strengthened, and collaboration with Chad's military enforced.

I think about the humans living in this area, their lives ravaged over centuries. In Zakouma, the Goula people built their villages near the rocky crags in the west of the park, in an attempt to escape mounted Arab and Ouaddian raiders, who savaged, captured, and sold them as slaves, decimating their numbers. I have seen contemporary savagery on the same scale in civil war in Africa, where friends of mine were hunted, raped, starved, and killed. Yet their kids still played; their women still laughed.

It is a sad fact that the vast majority of elephants in southeastern Chad don't die of old age. They die at the hands of men. Yet when I meet the Zakouma elephants, all I see is joy. ▲

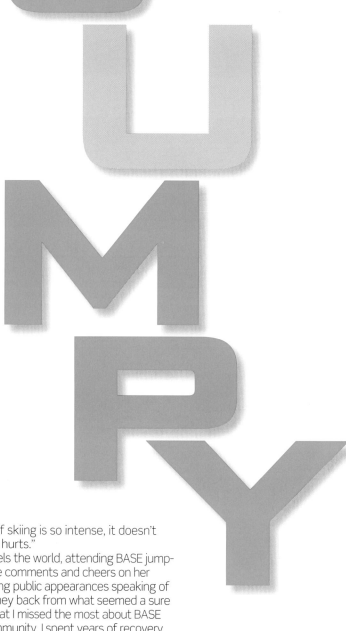

Karina Hollekim's most meaningful moment in life didn't come when she made her first free jump. It didn't happen when she threw herself untethered off a mountain in Mali, from a skyscraper in Las Vegas, or any of the other 400 or so times she has hurtled herself through midair as an extreme sportswoman practicing BASE jumping, which stands for "building, antenna, span, or earth," the four categories of inanimate objects from which participants leap.

Instead, Hollekim's greatest achievement, and her most emotional one, came recently, at the age of 33, when she put on a pair of skis in the mountains of her native Norway and made it down the hill. Because in 2006, Hollekim was in an accident that doctors told her would leave her unable to walk again.

BASE jumping is a sport only for those who dream of flying—and are willing to risk crashing to earth. Already a champion skier, Hollekim took her first jump off a bridge in Idaho at age 25. But when infamous BASE jumper Jeb Corliss offered to teach her the art of the free dive, she hopped a plane from Norway to the States to learn from him. The only problem: He broke his ankle on the first dive, so he had to teach her via walkie-talkie from his car. Relegated to a bridge in California, where such pursuits are illegal, Hollekim was forced to go in the middle of the night. "It was one of the most horrendous moments ever, because I'm scared of the dark," she says. Her next jump, in the light of day, convinced her that she had stumbled on her true passion.

Over the next five years, Hollekim traveled the world, often with a film camera in tow, making director Jens Hoffmann's award-winning documentary about her, *Twenty Seconds of Joy*. The film also spawned a separate movie about a jump off a sandstone pillar in Mali, *The Hand of Fatima;* prize money from that film funded a school for local children as well as the building of a well. Hollekim seemed literally on top of the world: With corporate sponsorship, the superstar was able to travel the world performing her sport with artistry and daring seldom seen, including becoming the first woman to perform a ski BASE.

Then, in 2006, a fateful moment: While Hollekim was simply skydiving with friends, her parachute failed to open. She crashed to the ground at 100 miles an hour, shattering her legs in 25 places and losing more than three liters of blood in 45 minutes. Told by doctors she was lucky to live and likely to spend her life in a wheelchair, she fought for her recovery. After four months in a hospital, six months in a wheelchair, and a year in rehab, Hollekim can now walk—and rock climb, bike, and ski. It is still slow going, but, she says, "Before, I used to measure risk versus pleasure, and now, I measure pain versus joy."

She adds, "The joy of skiing is so intense, it doesn't matter how much it hurts."

Hollekim now travels the world, attending BASE jumping events where she comments and cheers on her colleagues and making public appearances speaking of her inspirational journey back from what seemed a sure death. She says, "What I missed the most about BASE jumping was the community. I spent years of recovery in the café at the bottom of the mountain, hearing my friends' stories. Now I have stories again of my own." She is, true to her character, making the most of her time, even if she is not yet able to jump again.

"It's a shock to me to realize how inspired people are by my story, but the story seems universal to anyone who's faced a challenge," she says. "What I used to do wasn't everyday life—a girl throwing herself off of thousand-meter cliffs isn't that common. But everyone knows what it's like to need to find the strength and motivation to get back on their feet. I followed my heart, and I followed my dream. That's something everyone can understand."

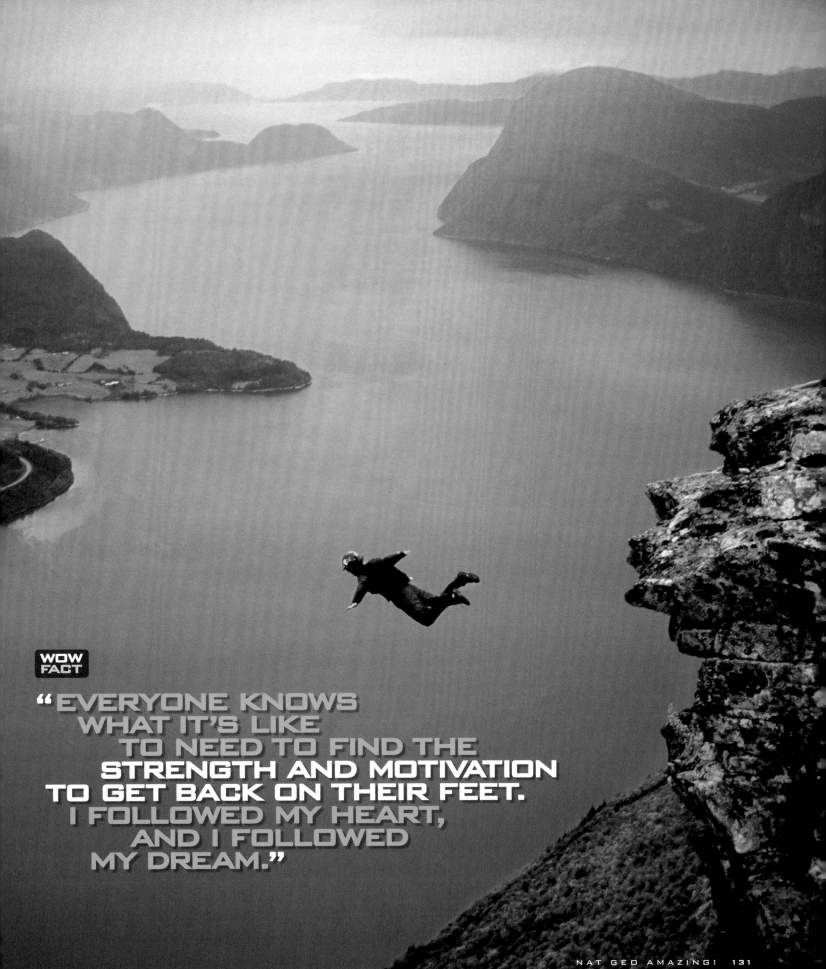

WOW FACT

"EVERYONE KNOWS WHAT IT'S LIKE TO NEED TO FIND THE STRENGTH AND MOTIVATION TO GET BACK ON THEIR FEET. I FOLLOWED MY HEART, AND I FOLLOWED MY DREAM."

Rest in Peat

A human sacrifice, Tollund Man emerged from a Danish peat bog—perfectly preserved with the leather cord used to kill him still tethered around his neck. A horrifying image still, even 2,300 years after the murder occurred.

Nor was Tollund Man alone. Bodies discovered in the bogs of northern Europe number in the hundreds, preserved for eternity thanks to chemicals in the peat acting as a mummification agent. The finds date from 400 B.C. to A.D. 400 in the Iron Age, when the region's Celtic and Germanic people believed in human sacrifice and thought that the bogs were portals to the supernatural world.

Modernity offers sophisticated tools to aid in determining the ages of the bodies and the artifacts discovered around them, including CT scans, three-dimensional imaging, and radio carbon. Scientists also have determined that often the bodies of the sacrificed knew their fate. The discovery of stubble on the jaw of one suggests he stopped shaving before his death. What cannot be known: Was he frightened as the rope tightened around his neck, transitioning him from one world to the next?

67

WOW FACT

Peat bogs grow at the rate of about a **millimeter** per year.

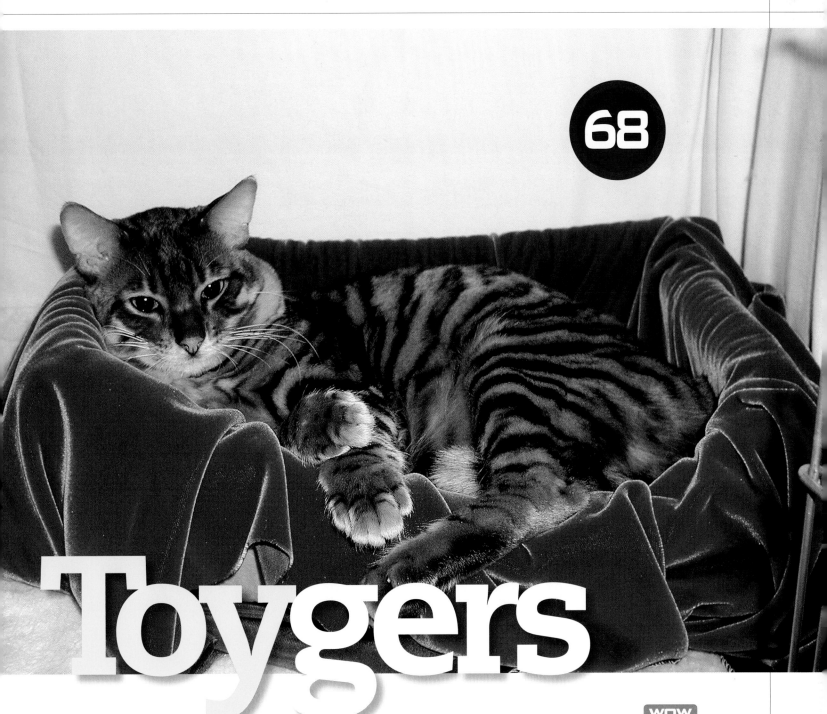

Toygers

Don't let this wild-looking cat scare you—he was born to look like a tiger, not fight like one. Neither a toy nor a tiger, this housecat breed was developed in the 1980s and has been registered with the International Cat Association (and thus eligible for showing) since 1993.

The brainchild of breeder Judy Sudgen, who donates a portion of the cats' sale price to tiger conservation, toygers are generally the result of uniting Bengal housecats and non-purebred tabbies. "It's selective breeding as one would do with chickens, cows, or pigs," says breeder Bob Rohrbaugh, who

has about ten litters a year with an average of four kittens per litter, and guesses there are about 600 toygers roaming the Earth. "There's no wild animal in there, or genetic engineering of any kind."

Although the animals are meant to look ferocious, Rohrbaugh says their personalities make for ideal housecats. "They're very interactive and friendly, generally sticking very close to their people. And they like to play a lot, even into their adult years." For the mice with the misfortune of meeting up with these "playful" creatures, that sounds like a cat-astrophe.

WOW FACT

Cats communicate using at least 16 known "cat words."

ARE WE AL

I t looks like an art installation rather than a window into our galaxy. But at NASA's Advanced Supercomputing facility in California, the stunning displays of color across 128 monitors are in fact nebulae, interstellar clouds of gas and dust.

The question remains: *Is* there life out there? "There will be nothing to hinder an infinity of worlds," wrote Greek philosopher Epicurus some 23 centuries ago. More than 370 planets outside our solar system have been discovered, and astronomers expect to discover other Earthlike planets out there too, perhaps some with the possibility of life.

NASA's Kepler satellite is now monitoring stars up to 6,000 light-years distant along the Orion Spur (the arm of the Milky Way in which our solar system lies), searching for Earth-size planets.

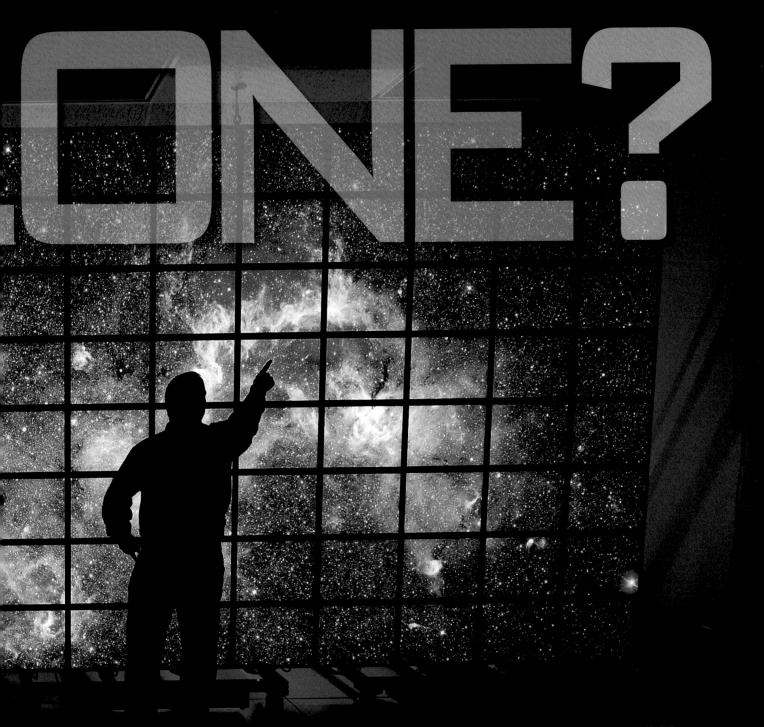

ONE?

Sunlike stars 600 to 1,800 light-years away are thought to be the most promising; the most likely contender so far is the "super Earth" Gliese 581 d, which is seven times Earth's mass.

There are also discoveries bizarre enough to fuel sci-fi fantasies: a planet 260 light-years from Earth that spins around its parent star so rapidly that a year there lasts less than three days; on another, the upper atmosphere is being blasted off to form a gigantic, cometlike tail. "To see a planet as small and dim as ours amid the glare of its star is like trying to see a firefly in a fireworks display," says veteran stargazer Timothy Ferris. "Yet by pushing technology to the limits, astronomers are rapidly approaching the day when they can find another Earth and interrogate it for signs of life. The curtain is going up on countless new worlds with stories to tell."

WOW FACT

A BRITISH WEB SITE SELLS LAND ON MARS AND VENUS FOR **$29** AN ACRE.

70

Parkour is more than just acrobatic leaps and flips. It's a state of mind.

It is ballet on amphetamines, high-wire acts without the net, action scenes from *The Matrix* played out on urban streets. Developed as French military training during World War I, the sport has expanded to cities around the world with practitioners, or traceurs, following a simple tenet: Get from one place to another as efficiently as possible.

But we're not talking the most direct subway or taxi route. Parkour is practiced on foot with no tools, a challenge when a wall, a moving car, or building is in the way. That's when jumping, swinging, rolling, and even leaping across rooftops come into play. In other words, if you see someone running away from the police but there's nobody in pursuit, she or he is probably practicing parkour.

The parkour community, like the punk community in the 1970s or skateboarders in the '80s, thrives on an underground, antiestablishment vibe (understandable, given that often it involves trespassing). Yet as parkour photographer and former practitioner Andy Day says, "It also has to embrace popular culture to create a business. It perpetuates this myth that it's subversive when it's essentially a bunch of middle-class white kids. I say that as a middle-class white kid who was in the sport for a long time." The number of women who practice the sport is growing as well; they are referred to as traceuses.

Although there are occasional parkour "competitions," the sport, like yoga, is meant to be about improving one's own performance. Indeed, even those within the

A student at the Beijing Film Academy trains in parkour, which allows participants to acrobatically leap over rooftops, jump over walls, and run along the sides of buildings. Recent movies featuring parkour include *Casino Royale* and *The Bourne Ultimatum.*

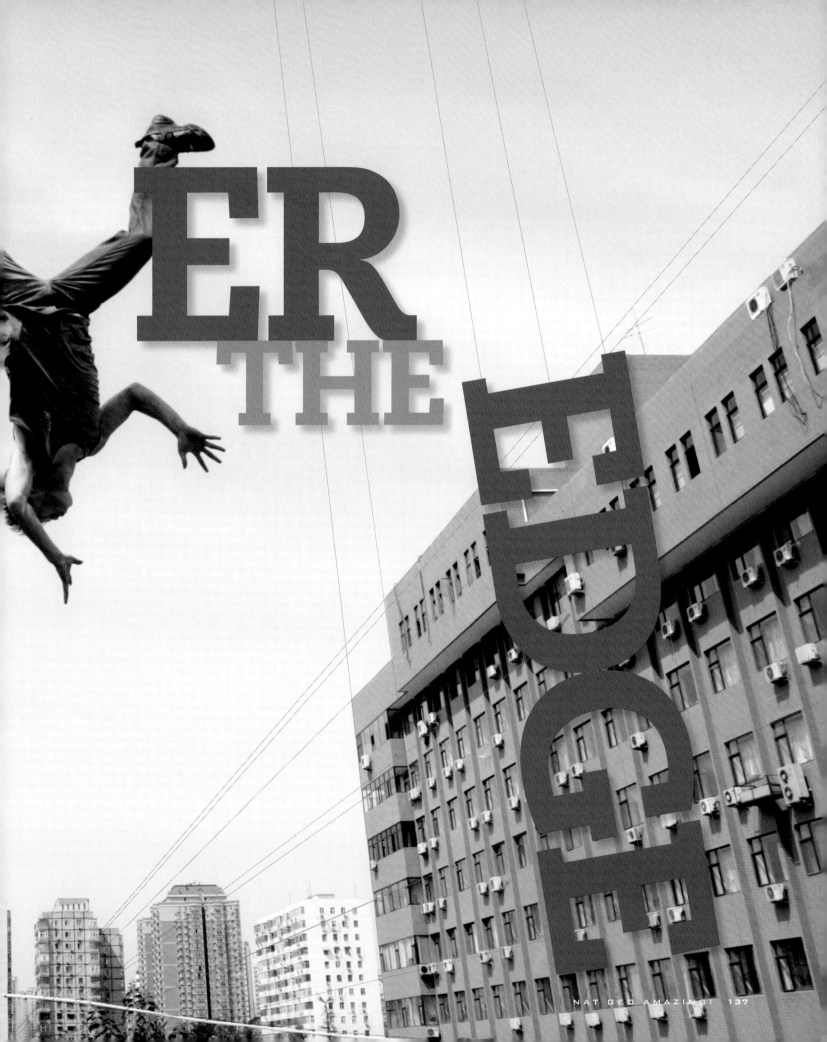

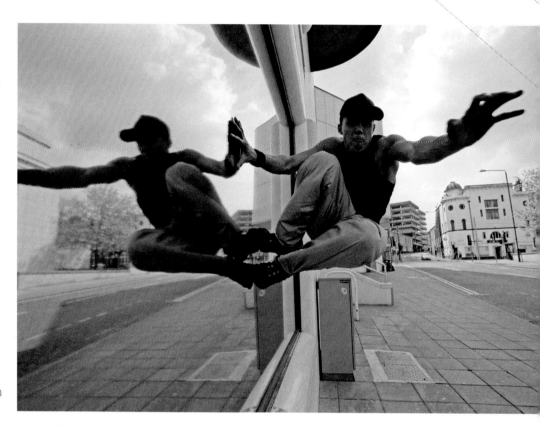

community disagree at times on its definition: Some say that parkour and "free-running," are two words for the same activity; others, like Day, see a distinction. "Parkour is about getting from point A to point B as efficiently as possible with things like jumps, whereas adding embellishments like somersaults and twists is freerunning."

Of course, the more parkour catches on, the less underground it becomes. Its popularity has burgeoned on the Internet with videos on YouTube. Action movies and video games now feature chase scenes that incorporate parkour, and MTV has done a special, "MTV's Ultimate Parkour Challenge," where eight top performers competed for a $10,000 prize. In Europe, the soft drink company Red Bull has sponsored freerunning competitions. The winner in Vienna, Austria, broke his leg in the final move, but Day says that injuries are surprisingly rare.

The philosophy behind the practice emphasizes safety, self-discipline, and personal responsibility while discouraging reckless behavior of any kind. "Guys sprain ankles, but that's about it," says Day. ◾

Parkour was first developed in France and is based on military maneuvers that soldiers used to overcome physical obstacles.

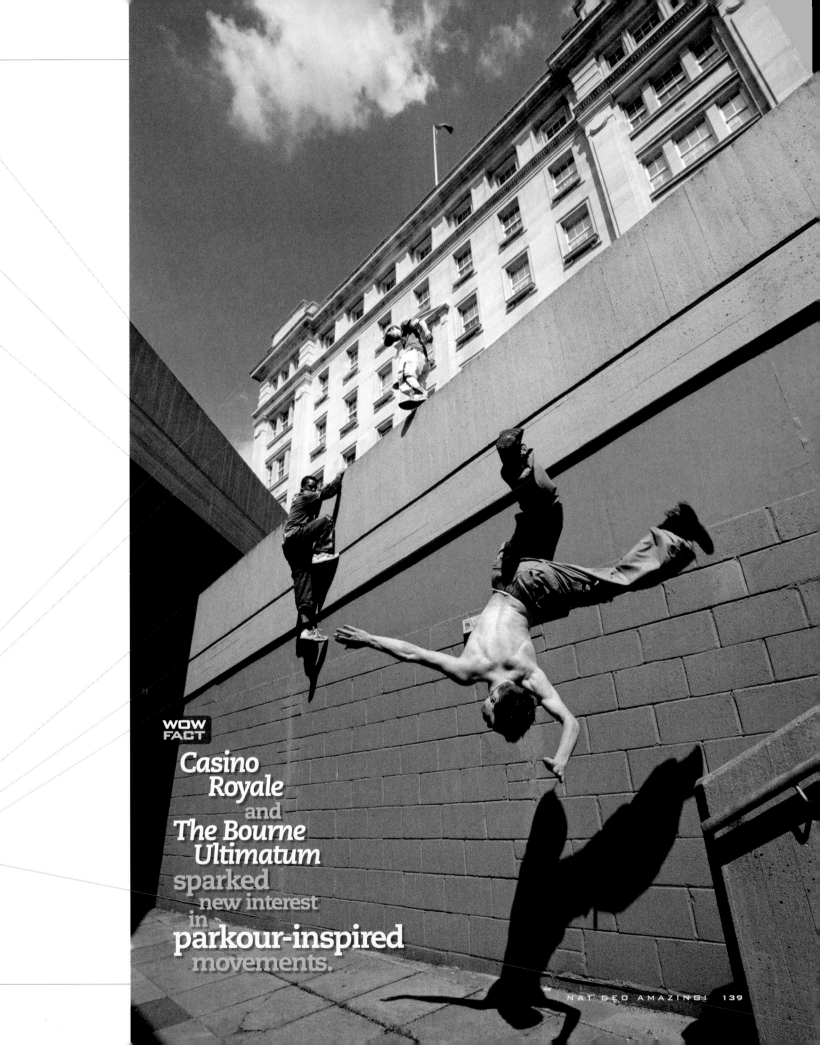

WOW FACT

Casino Royale and *The Bourne Ultimatum* sparked new interest in **parkour-inspired** movements.

71 Funeral Procession

"Many of them were so quiet... To see them so focused on Dorothy, silently, was **humbling.** It was their grieving process, and it was an honor to be a part of it."

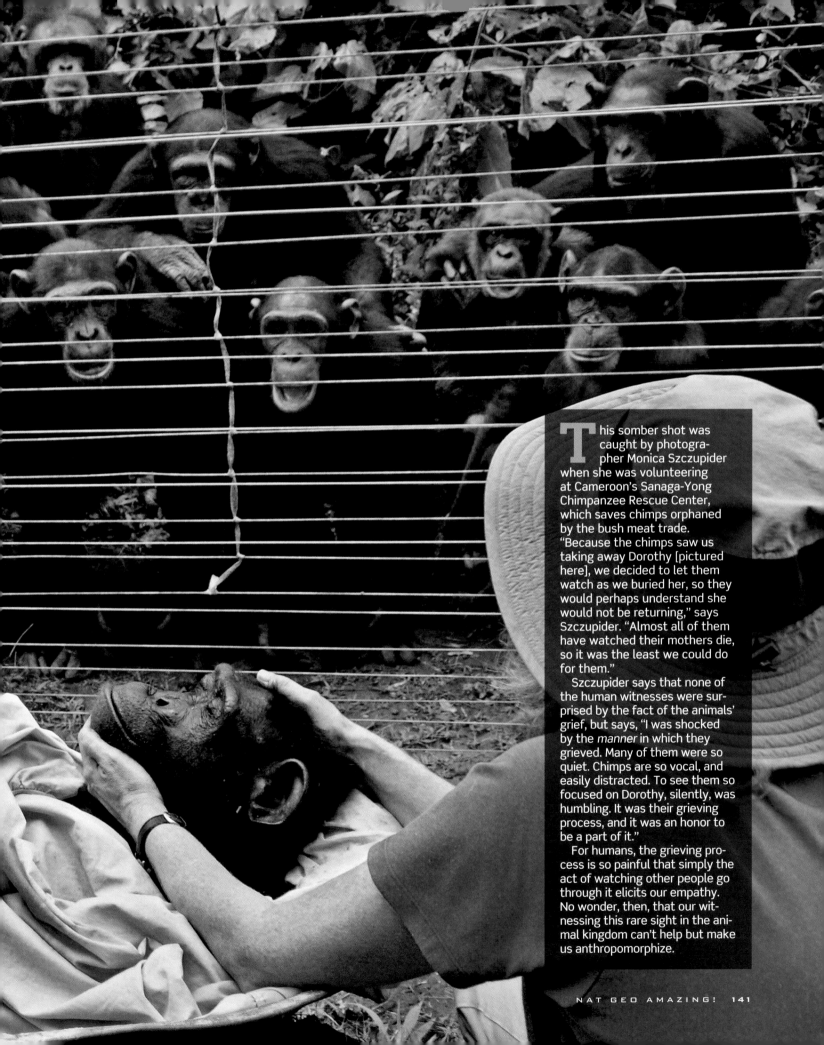

This somber shot was caught by photographer Monica Szczupider when she was volunteering at Cameroon's Sanaga-Yong Chimpanzee Rescue Center, which saves chimps orphaned by the bush meat trade. "Because the chimps saw us taking away Dorothy [pictured here], we decided to let them watch as we buried her, so they would perhaps understand she would not be returning," says Szczupider. "Almost all of them have watched their mothers die, so it was the least we could do for them."

Szczupider says that none of the human witnesses were surprised by the fact of the animals' grief, but says, "I was shocked by the *manner* in which they grieved. Many of them were so quiet. Chimps are so vocal, and easily distracted. To see them so focused on Dorothy, silently, was humbling. It was their grieving process, and it was an honor to be a part of it."

For humans, the grieving process is so painful that simply the act of watching other people go through it elicits our empathy. No wonder, then, that our witnessing this rare sight in the animal kingdom can't help but make us anthropomorphize.

UNION AND

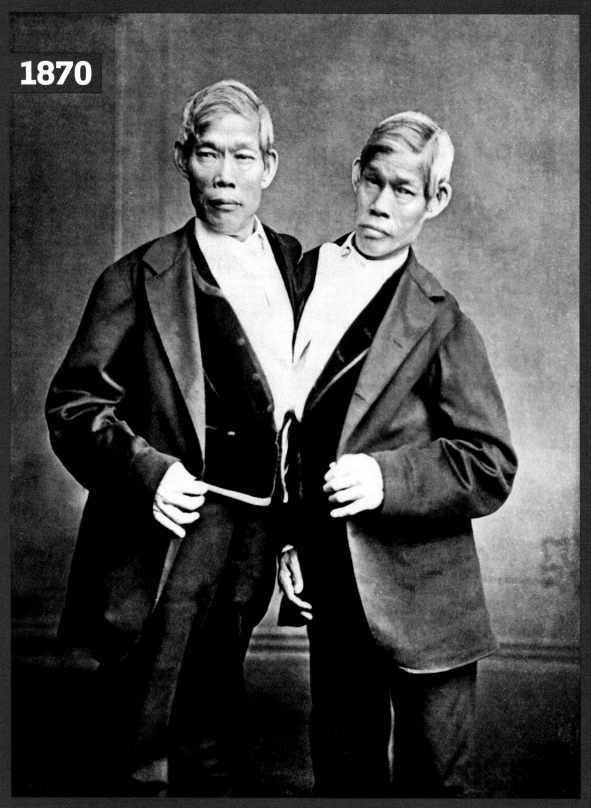

1870

The least extraordinary thing about Eng and Chang Bunker may have been the fact that they shared one body.

Born in Siam (now Thailand) in 1811, the original "Siamese twins" were connected at the chest by a six-inch-long piece of flesh. Even as children, they proved able to move in tandem, doing gymnastics and playing chess. They grew into men who appreciated fine cigars, literature, and clothing. And at the age of 21, after years of performing in theaters, they visited North Carolina's Mount Airy region and decided to become farmers. And they decided to marry.

It was Chang's idea. "We are not responsible for our physical condition, and we should not have to die childless on that account," he told his brother. And so they began courting the Yates sisters, who lived down the road. Chang successfully wooed Adelaide; Eng did the same with Sarah.

After 14 years of living together, tensions led to the twins' splitting their property, building separate houses, and arranging to spend three days in one house, then three days in the other. It was obviously a good call: The couples had a combined 21 children.

Their descendants now number around 1,500, many of whom still live in Mount Airy, a town of 8,000 near the Blue Ridge Mountains.

REUNION

Succeeding generations have produced 11 sets of twins, all of whom were not conjoined. The first born since the original set were Eng's great-grandsons, also named Chang and Eng. They are fraternal, rather than identical. "We'd get teased all the time when we were in school," Eng recalls, "But after all, it was four fists against them instead of two."

The Bunker legacy is a proud one. Says Kester Sink, whose late wife, Adelaide, was a Chang granddaughter, "They were human beings who had a tremendous physical adversity to overcome. They left their home in Siam, their mother and family, and immediately picked up the language, mores, and manners of their adopted country. They were gutsy, smart, and self-confident." And Sink stresses, "They were not freaks."

WOW FACT

IF ONE SIAMESE TWIN WERE TO BE CONVICTED OF MURDER, IT IS NOT CLEAR WHAT THE JUSTICE SYSTEM WOULD DO FOR THE OTHER TWIN.

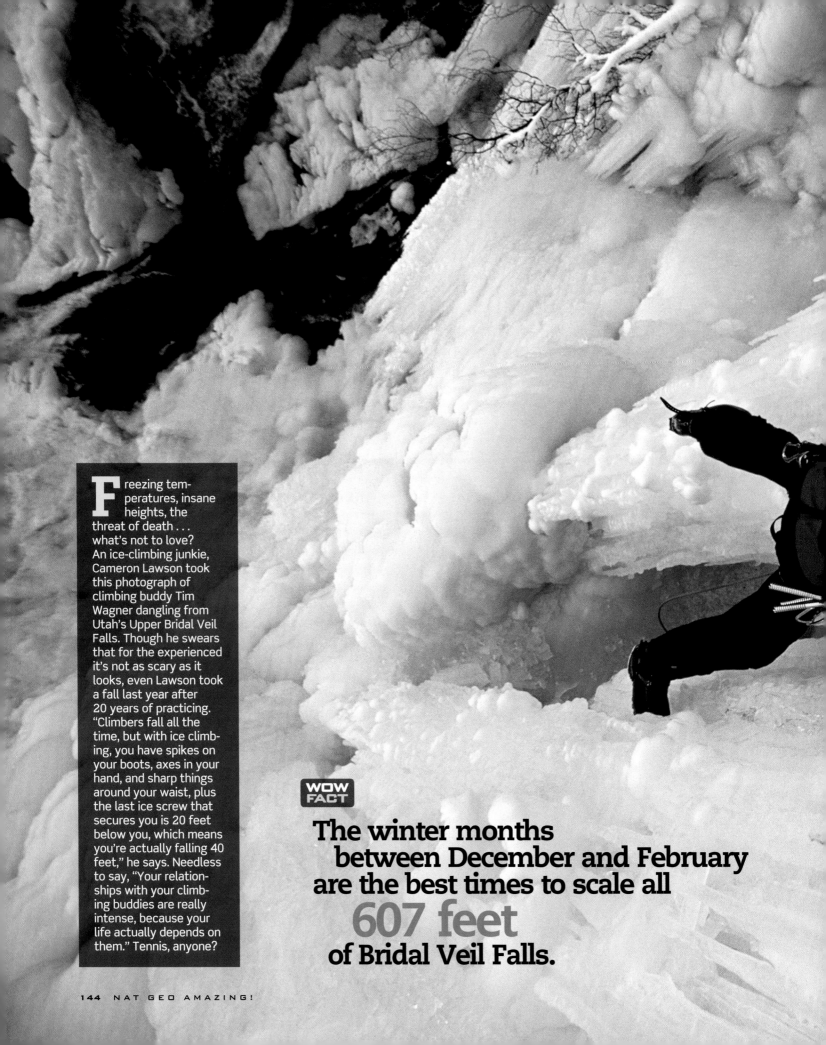

Freezing temperatures, insane heights, the threat of death . . . what's not to love? An ice-climbing junkie, Cameron Lawson took this photograph of climbing buddy Tim Wagner dangling from Utah's Upper Bridal Veil Falls. Though he swears that for the experienced it's not as scary as it looks, even Lawson took a fall last year after 20 years of practicing. "Climbers fall all the time, but with ice climbing, you have spikes on your boots, axes in your hand, and sharp things around your waist, plus the last ice screw that secures you is 20 feet below you, which means you're actually falling 40 feet," he says. Needless to say, "Your relationships with your climbing buddies are really intense, because your life actually depends on them." Tennis, anyone?

WOW FACT

The winter months between December and February are the best times to scale all **607 feet** of Bridal Veil Falls.

Picky, Picky

73

Bye Bye Bunny

T here's nothing cute about this bunny. Because Bryn, the pygmy rabbit pictured here, was one of the last of her kind.

Bryn was one of only two surviving rabbits genetically distinct to northwestern America's Columbia Basin. Wiped out by the conversion of sagebrush habitat to agriculture, the pygmy was one of 1,050 species currently listed under the controversial Endangered Species Act, which seeks to protect dying breeds from extinction. Photographer Joel Sartore met Bryn at the Oregon Zoo when she was only months from death; nearly blind, missing half an ear, her fur falling out in clumps. It was "a solemn occasion," he says.

Sartore photographs endangered animals against a uniform black or white background to help plead the case for them all. "I see the extinction process happening in my hometown of Lincoln, Nebraska, to the Salt Creek tiger beetle"—also on the endangered list—"and it's hard to get people to halt construction to save a bug. But it's not impossible. Maybe someone won't care about a bug, but a cute animal might move them. My photographs are making a dramatic plea to get folks to stop and take a look at what we are losing."

Endangered Species

572
SANTA CATALINA
ISLAND FOX

2,000
MEXICAN SPOTTED OWL

300
MOUNT GRAHAM
RED SQUIRREL

300
WOLVERINE

3,500
POLAR BEAR

2,100
HAWAIIAN GOOSE

1,000
DELHI SANDS
FLOWER-LOVING FLY

12,210
RED COCKADED
WOODPECKER

4,300
PALOS VERDES
BLUE BUTTERFLY

3,000
PYNE'S GROUND PLUM

75

STARS AND STRIPES FOREVER

From the Archives, 1917, Chicago, Illinois

symbol of patriotism, the American flag is embodied here by naval recruits at the Great Lakes Training Station in Chicago in 1917. But this particular flag didn't represent all of the country's citizens: The soldiers you see in the photo are white, but the base, which during World War II supplied about a million men to the Navy, was a segregated facility, with African Americans training at a base within the base, largely for noncombat roles. It wasn't until 1944 that 13 African Americans were allowed to enroll in regular officer training/candidate school, going on to be the first commissioned ensigns. In 1992, Rear Adm. Mack Gaston became the first African-American commander of the base; two years later, the base admitted its first women, finally and completely embracing what so proudly we hail.

WOW FACT

IN MINNESOTA, BUYING A U.S. FLAG NOT MADE IN THE U.S.A. IS A MISDEMEANOR PUNISHABLE BY A $1,000 FINE OR **90 DAYS IN JAIL.**

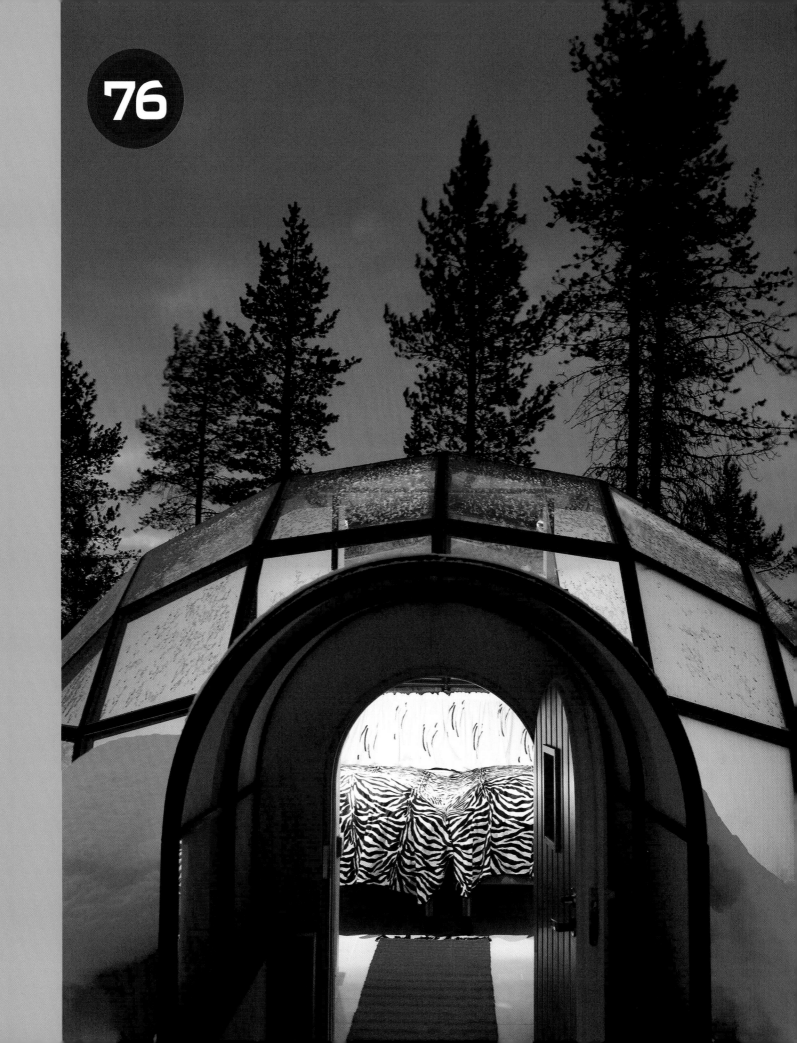

THE INCREDIBLE STORY OF THE LUXURY IGLOO....

...AND FOUR OTHER VERY SWEET STAYS

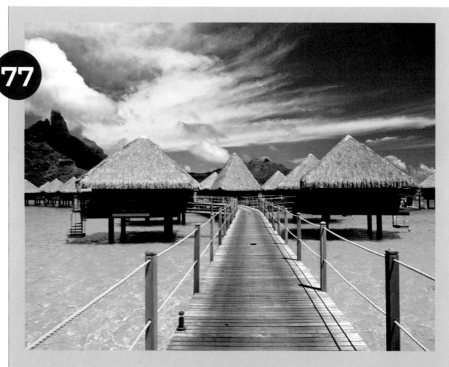

77

OCEAN VIEW
Le Meridien, Bora-Bora, French Polynesia

Getting sand between your toes is nice. But staying in your own personal aquarium is even nicer. At the Meridien hotel located on this French Polynesian island, guests can choose to live in bungalows that not only are built over the sea but also have a glass-bottomed floor. The hotel is also active in trying to save the hawksbill turtle with its own turtle sanctuary, which means that should residents get tired of merely watching them from above, they can join them in the water for a tandem dip.

◀ IN SOME OF THE IGLOOS THE TEMPERATURE HOVERS AROUND **25 DEGREES** FAHRENHEIT.

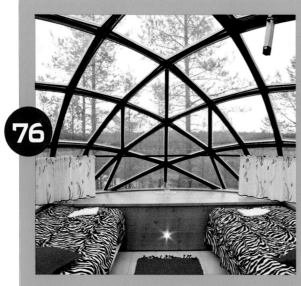

76

IGLOO'D
Hotel and Igloo Village Kakslauttanen, Saariselkä, Finland

Forget fuzzy slippers and lush bathrobes. This Lapland hotel provides wool socks and cold-weather sleeping bags to its guests, as well it should: Some of the rooms are igloos in which the temperature hovers around 25°F. Hot chocolate may warm guests' bones, but it is offered in what the resort calls the World's Largest Snow Restaurant, a claim few hotels are likely to challenge. Adventurous travelers can't push their luck toward spring, since these particular rooms experience a total meltdown in April, dissolving back whence they came until being rebuilt in December.

AN ANCIENT ▶ RETREAT
Gamirasu Cave Hotel, Ayvalik, Turkey

78

Most of us are lucky even to visit 4,000-year-old sites, let alone linger there. At this hotel, guests can call their own a suite that may be that old, while another is estimated to be 2,500 years old. A restored 1,000-year-old Byzantine monastic retreat, the Gamirasu is composed of these ancient cave dwellings as well as newer structures built of volcanic ash called tufa, which is naturally insulating, so rooms maintain constant and comfortable temperatures. Not to mention the fact that with walls this thick, there's little chance of being bothered by one's neighbors.

UP WHERE ▶ WE BELONG

Green Magic Nature Resort, Vythiri, India

At this ten-room resort, getting away from it all is taken to new heights—literally. In addition to lodging located on terra firma, the hotel offers rooms in two treetop villas sitting 86 feet aboveground, with uncovered windows looking out at the indigenous monkeys and birds that make their homes in the rain forest canopy. One tree house is accessed by a water-powered elevator, and the other is approached via a suspension bridge. Although the setting is rustic and the hotel eco-friendly, there is running water and, for those who want to savor their air time, room service.

79

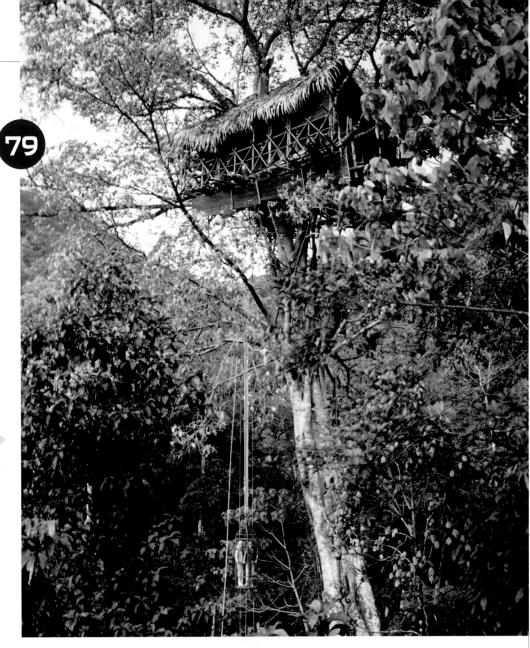

ONE TREE HOUSE ▶ IS ACCESSED BY A WATER-POWERED ELEVATOR, WHILE THE OTHER IS BY A SUSPENSION BRIDGE.

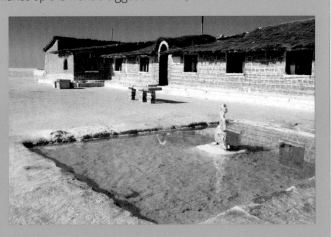

A SALTY STAY **80**

Tayka Hotel De Sal, Togua, Bolivia

As far as foundations go, this hotel is built on one of rock—rock salt, that is. Tayka sits on Salar de Uyuni, a dried-up prehistoric lake that makes up the world's biggest salt flat, in the foothills of the Thunupa volcano. Builders used the salt from the 4,633-square-mile flat to make the bricks that form the inn, cementing them with a paste (also made of salt) that hardens when it dries. When inclement weather begins to dissolve the eco-friendly structure, which overlooks the surrounding desert, the owners simply mix more salt paste and repair the damage. Assuming they avoid licking the walls, the 47 guests are treated to an otherwise happy and normal hotel stay in these rustic accommodations, complete with heated rooms and running water.

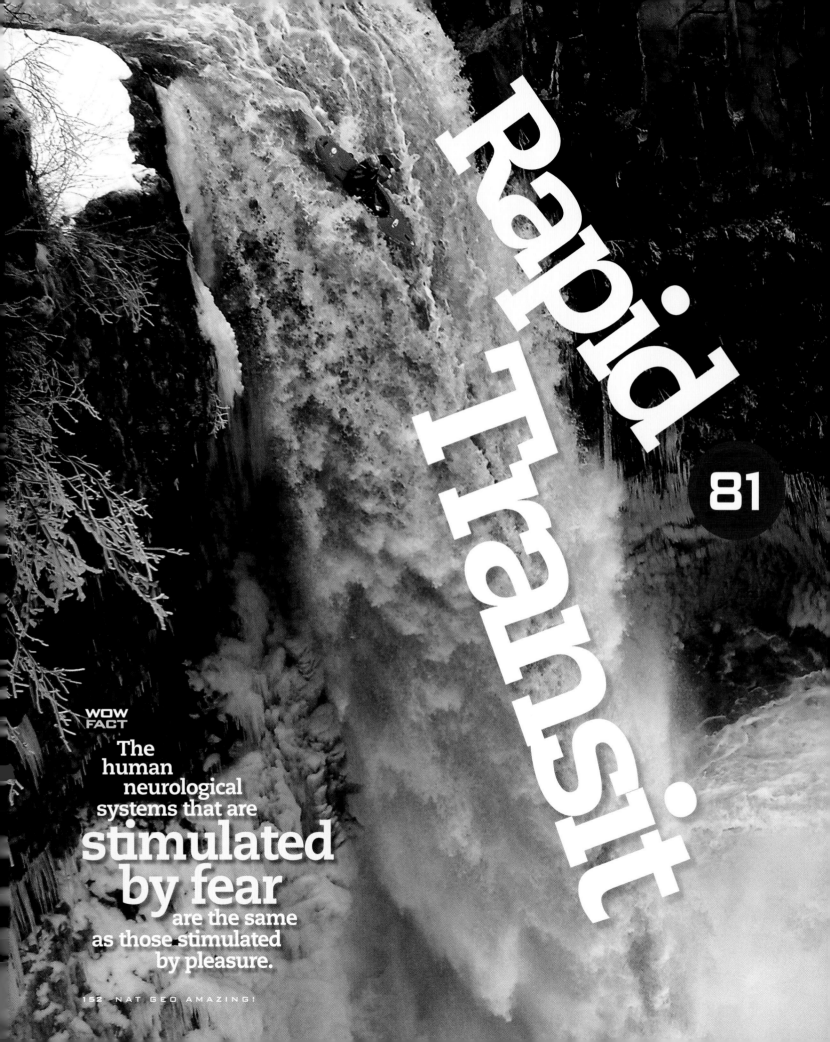

Rapid Transit

81

WOW FACT

The human neurological systems that are **stimulated by fear** are the same as those stimulated by pleasure.

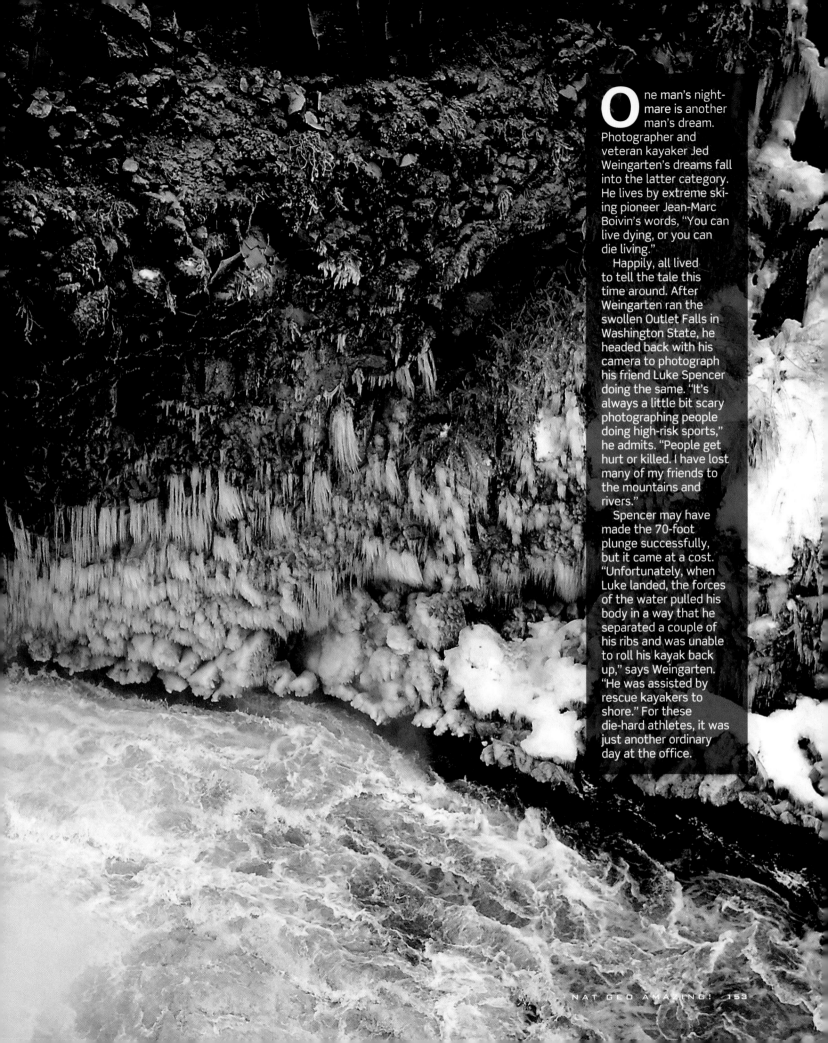

One man's nightmare is another man's dream. Photographer and veteran kayaker Jed Weingarten's dreams fall into the latter category. He lives by extreme skiing pioneer Jean-Marc Boivin's words, "You can live dying, or you can die living."

Happily, all lived to tell the tale this time around. After Weingarten ran the swollen Outlet Falls in Washington State, he headed back with his camera to photograph his friend Luke Spencer doing the same. "It's always a little bit scary photographing people doing high-risk sports," he admits. "People get hurt or killed. I have lost many of my friends to the mountains and rivers."

Spencer may have made the 70-foot plunge successfully, but it came at a cost. "Unfortunately, when Luke landed, the forces of the water pulled his body in a way that he separated a couple of his ribs and was unable to roll his kayak back up," says Weingarten. "He was assisted by rescue kayakers to shore." For these die-hard athletes, it was just another ordinary day at the office.

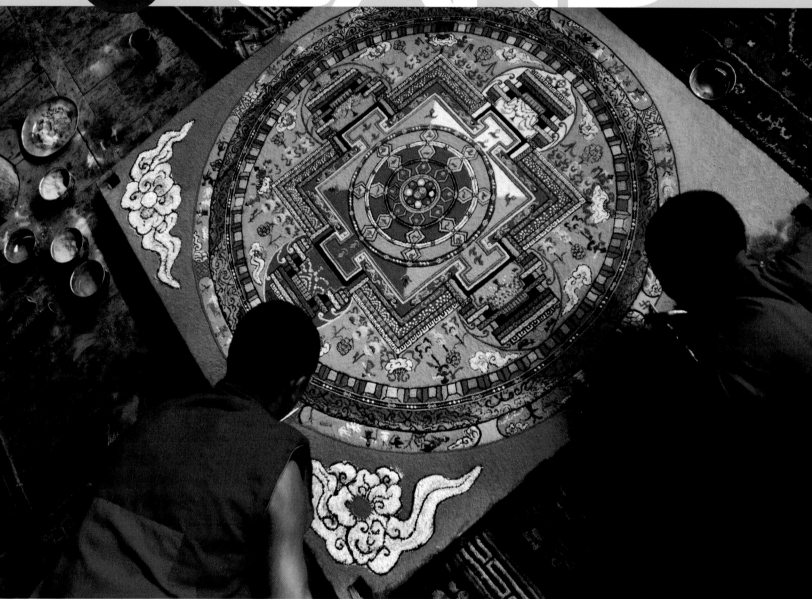

As artistic media go, sand is certainly one of the least permanent—a trait that has been embraced by both Eastern monks and Western artists.

The idea that effort should result in something tangible is a uniquely Western belief. For Tibetan Buddhists, who instead believe in a state of grace that would better be defined as effortless effort, there is no "point" to things as Western minds would describe it. Witness the making of a mandala, an intricate drawing in sand that is often used as a guide to meditation. Created as a kind of

sacred space in which deities reside, the mandala is the ultimate contradiction: a concrete symbol, however briefly, of the impermanence of life. After weeks or even months of work, the mandala is finally completed only when it is ultimately scattered to the wind.

As photographed here by Ami Vitale, Indian Ladakhi Buddhist monks construct a mandala out of sand, dust, and precious stones to celebrate a festival. Like all good parties, this one too must come to an end, one marked by the destruction of the breathtaking beauty that had been created—

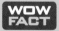

WOW FACT

"MANDALA" FROM SANSKRIT, TRANSLATES ROUGHLY AS "COMPLETION."

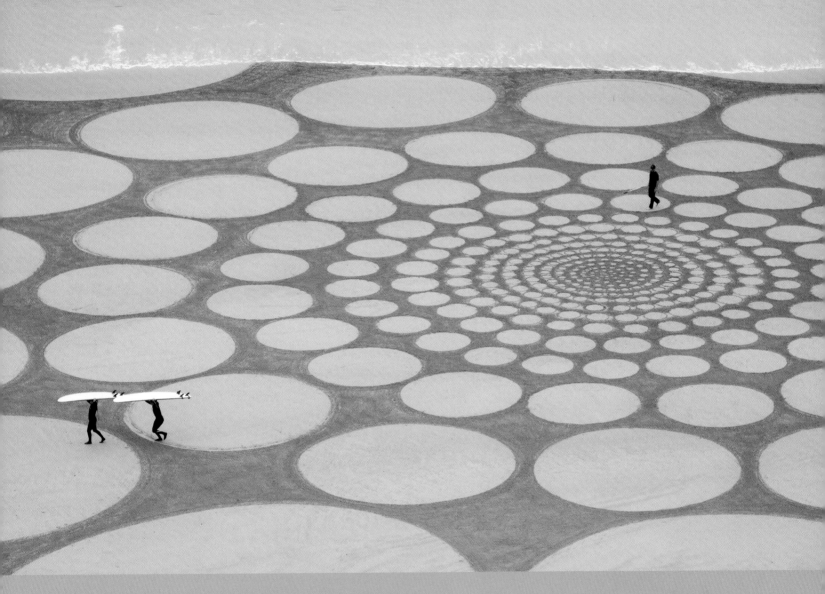

a reminder of the trite-seeming truth "Here today, gone tomorrow."

Most Western artists long to leave their mark on the world. Jim Denevan, who draws in the sand, celebrates when his work is washed away. "That makes me totally happy, watching the tide come in," says the northern California artist, who has been using beaches as his canvas for almost two decades. "If my drawing remained, it would be in the way of the next new idea."

Denevan found his calling when his mother developed Alzheimer's disease, finding that taking a stick and forming patterns in the sand served as a kind of therapy. The image captured here—Denevan is the lone figure walking toward the inner ring—took him seven hours to complete, an unaccustomed luxury. "I usually only have 3 to 5 hours before the tide comes up," he says. "But I'm at peace with the idea that it only exists for a small amount of time." Denevan can also lay claim to the world's largest piece of artwork: a nine-mile drawing he completed over a dry lake bed in Nevada, far from the menacing tides.

After three weeks, it rained.

83 EAT PREY BLOOD

The first response—how extraordinary it is that Michael Nichols got as close as he did to a lion feasting on his prey—is exactly what the National Geographic photographer intends. But only so he can tell the real story. Because if you look closely, you'll notice that the lion is eating an elephant. That is also extraordinary. And very, very wrong.

"Rarely do lions go after elephants, because when they try, they get their butts kicked," explains Nichols. But in Zakouma National Park in Chad, where this took place, poachers have murdered so many elephants that hundreds are left as orphans, disoriented and defenseless. "Nowhere else do elephants make up part of a lion's diet, because a lion wouldn't dare. I also took a picture here of 800 elephants grouped together, which at first looks amazing, but then you realize they are grouped together like this because they are so afraid." (As for the photographer's fear taking the picture here, he says that lions are not interested in getting near a jeep, such as the one he was in, especially when they are eating.)

During his visit to the park, Nichols also witnessed the devastation that poachers are causing to the lions when he and the park ranger found a group of cubs, orphaned when a poacher had murdered the lioness by poisoning the water hole. The cubs were now doomed to death as well, since if they were rescued by humans they would grow into defenseless adults, and the park does not have the ability to care for them. "Thousands of animals die from poachers poisoning the water intentionally in order to sell the bodies," says Nichols. "It shows you how dark it can get." How does he handle bearing witness to such atrocities? "You convince yourself that the work you are doing is important. You want people to look at a cool picture and then hit them with the message that if we want to have wildlife on this Earth, we have to help these countries."

TO ENSURE HIS GENETIC DOMINANCE, IF A NEW MALE LION ENTERS A PRIDE, HE WILL KILL ALL THE CUBS.

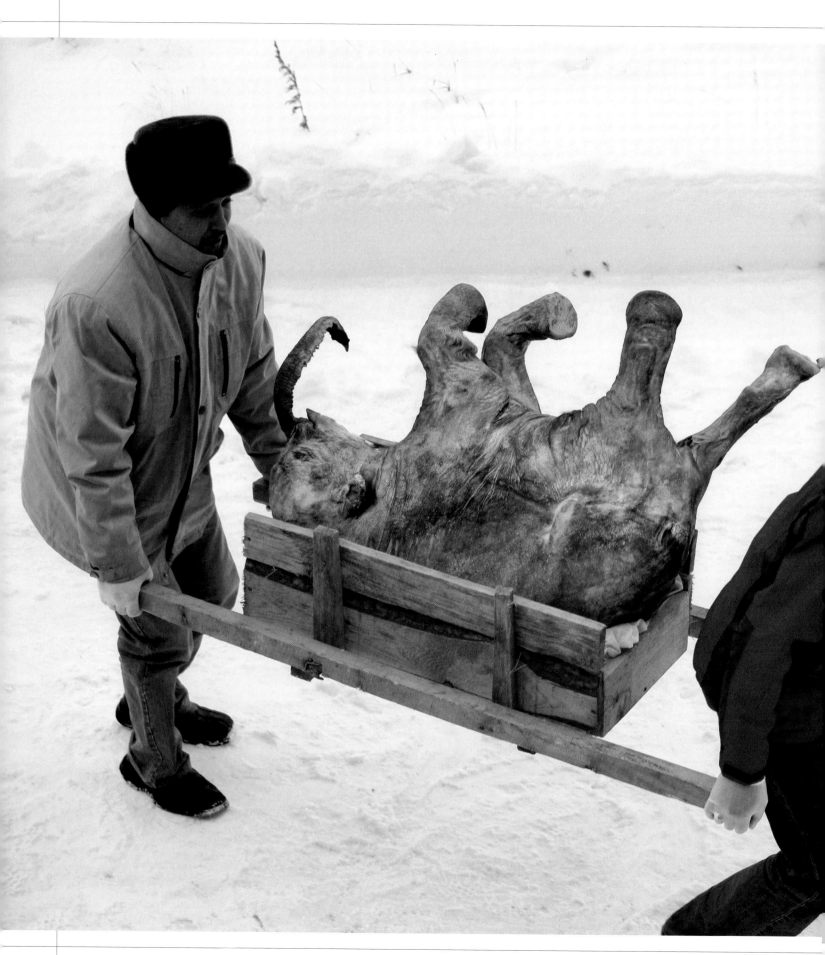

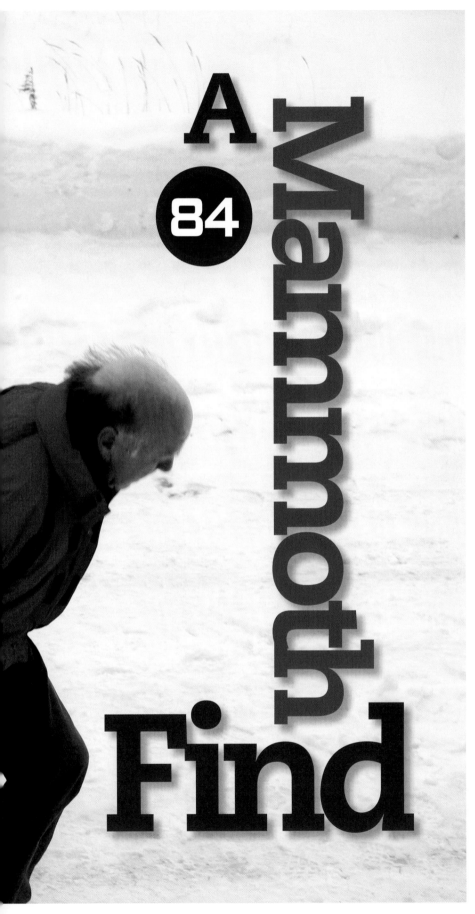

A 84 Mammoth Find

Elephants may never forget, but woolly mammoths can last forever. Or at least 40,000 years, in the case of Lyuba, a specimen who was discovered in almost perfect condition by a reindeer herder in Siberia.

Mammoths, an extinct group of elephants whose ancestors migrated from Africa about 3.5 million years ago, are among those creatures that bridge legend and reality. In stories told by the Nenets, indigenous Siberians, the mammoth wanders the underworld herded by gods. Not infrequently, they surface in actuality, as summer's thaw brings hundreds of their tusks, teeth, and bones to the topsoil after tens of thousands of years in deep freeze.

But before Lyuba, named in honor of the wife of the herder who discovered her, scientists had only incomplete specimens to work with. Now there was a mammoth that was missing only part of her right ear and tail (gnawed off by dogs only after she was found), her hair, and her toenails. For Dan Fisher, a paleontologist at the University of Michigan, the chance to study Lyuba was unprecedented. "When I saw her," he says, "my first thought was, 'Oh my goodness, she's perfect—even her eyelashes are there!' It looked like she'd just drifted off to sleep. Suddenly, what I'd been struggling to visualize for so long was lying right there for me to touch."

Carbon dating revealed that Lyuba had died roughly 40,000 years ago, about 25,000 years before mammoths disappeared from North America, Europe, and most of northern Asia, and about 35,000 years before the last of the woolly mammoths became extinct. CT scans confirmed that her internal organs were largely intact, and that the end of her trunk, throat, mouth and windpipe were filled with sediment, leading Fisher to believe she had asphyxiated in the mud.

Once Fisher was able to perform a necropsy on her, further light was shed on Lyuba's short life: Judging from her premolars and tusks, she had been born in the late spring and was only a month old when she died. Because her abdomen still contained its lining and a layer of fat, suggesting an abundance of nutrients, Fisher could see that the mother had kept her infant well fed. As for the reason she stayed preserved for so long? She had been pickled by bacteria after she died, protecting her body from rot, allowing her to be gently herded through the underworld to the one above in almost the condition in which she departed.

WOW FACT

Mammoth ancestors migrated from Africa 3.5 million years ago.

85

Underground

AGENT

Mark Jenkins, a National Geographic contributing writer, explored one of Tennessee's 9,200 ancient caves with veteran cavers Kristen Bobo and Marion "The Goat" Smith. What he discovered was a magical, underground world that tested his very limits.

We are hundreds of feet beneath the hills of Tennessee in Jaguar Cave. The darkness is so thick you can hold your hand an inch from your face and you won't see it. This is an ancient, undiscovered darkness, a darkness that has been here since the dawn of time.

Jaguar Cave is a maze of mad plumbing dogsledding down through a thick layer of limestone beneath the farms and wooded ridges in the north-central part of the state. People have been exploring this cave since prehistoric times, but the system is so vast that unknown conduits and million-year-old piping are still being discovered by cavers all the time. Smith, who has ventured into more caves than any person in America, has decided that our goal is to go beyond where any human has probed.

We have entered the system through a secret hole high in the forest, rappelling down 32 feet, then following the course of an underground river. We have seen a cave cricket and a cave fish. And we have examined prehistoric jaguar prints left by two animals as long ago as 35,000 years when they became trapped here. (Even more remarkable, 274 ancient human footprints have been discovered in a part of the cave called Aborigine Avenue, which is now closed to explorers. Dated at 4,500 years old, they are the oldest human cave prints in North America.)

But now we are deep inside the stygian column of earth, crawling, climbing, pulling, and pushing our way through. When we find ourselves at a blocked passage, solidly plugged by a pile of boulders and dirt when the ceiling collapsed, I volunteer to dig so we can push on.

I lie down on my belly and shimmy to the end of a hole beneath the breakdown where the ceiling has collapsed. Flat on my stomach, the ceiling pressing down on my neck, walls forcing in on the sides, I hold a shovel stretched out in front of me and furiously start to jab at the dirt wall. Chunks of earth begin to fall all around me as I dig like a berserk badger. Several times I fill a drag tray with dirt, pushing it beneath me and then backward with frog kicks, where it is emptied by my fellow cavers. But soon the hole is too narrow, and I dispense with it, using my hands as scoops to clear the way.

After 30 minutes, I've moved perhaps five feet forward. My arms are aching, and I'm soaked in sweat. I'm about to back out when my shovel breaks through. I feverishly round out the hole and cram my head through. There is a low, triangle-shaped crawlway straight ahead of me. Surging with adrenaline, I try dragging myself into this new passage.

Then my chest gets stuck.

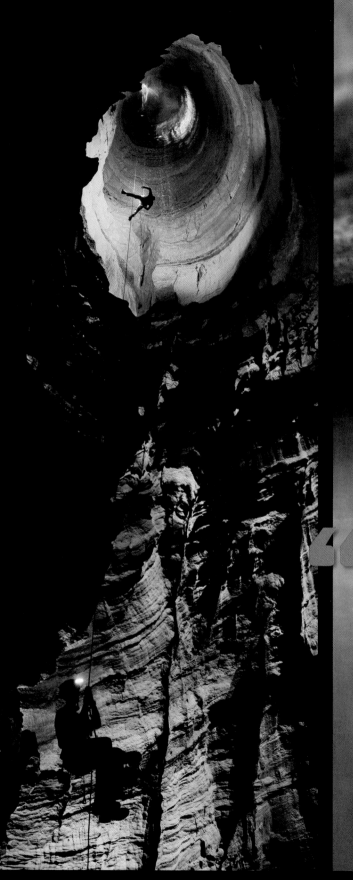

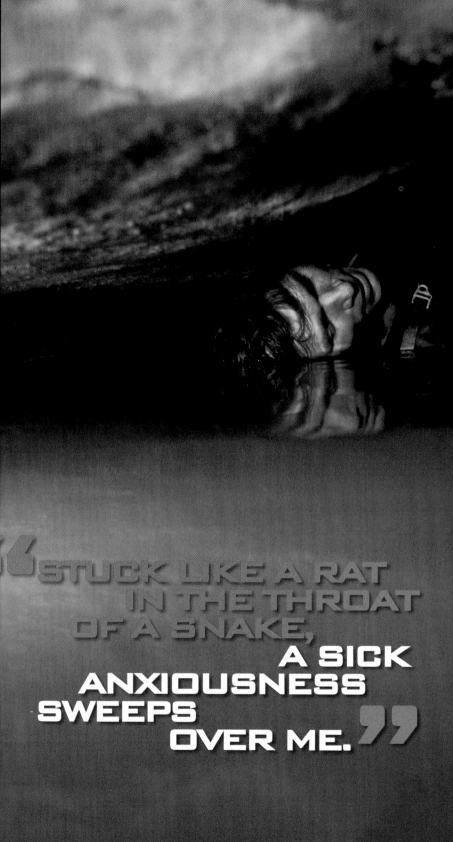

"STUCK LIKE A RAT IN THE THROAT OF A SNAKE, **A SICK ANXIOUSNESS SWEEPS OVER ME.**"

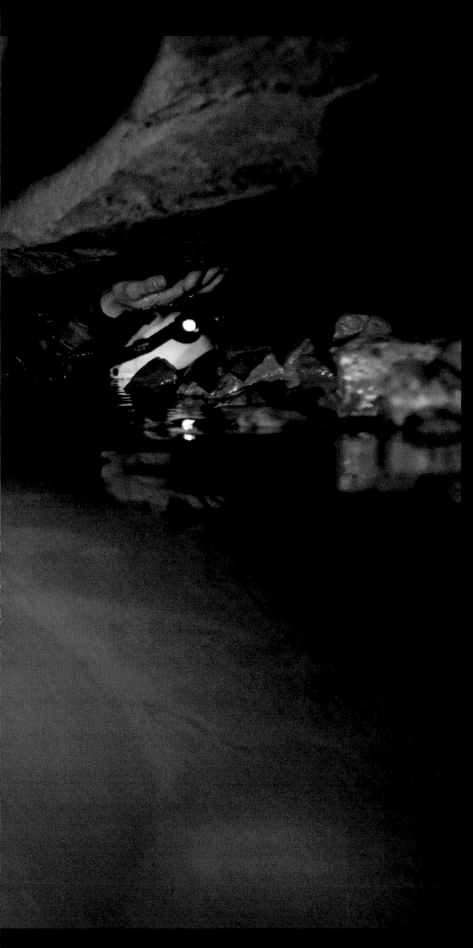

I have been so hyperfocused on digging I have staved off dark, horrifying feelings of claustrophobia, but now, stuck like a rat in the throat of a snake, a sick anxiousness sweeps over me. I violently kick my legs, but to no avail. I'm swimming in dirt. I realize that by not using the drag tray to remove the dirt, I've buried myself.

I try to calm my racing thoughts, but my mind is too preoccupied with the millions of tons of rock above me. I've been told that caves seldom collapse, and yet here I am, trapped at the bottom of a breakdown, in a cave that obviously did collapse. I try to slow my frantic breathing because I've also been told that hyperventilating expands one's lungs and only tightens the squeeze, which is exactly what's happening to me. Suddenly I'm thrashing shamelessly, kicking and clawing and writhing. In my frenzy, I manage to knock off my headlamp, and then everything goes black.

I have no choice but to lie here, try to calm my mind, and let my body relax and go limp. My clothes are so slick with sweat I can slide inside of them. With enormous effort, I inch my chest forward inside my jacket and suddenly slip into the far antechamber.

Crawling forward, I am soon stopped by another wall of dirt. I think it is another dead end until the beam of my headlamp spots a pinhole above me. Putting my face to the hole, I can feel the air moving. I dig fiendishly, awash with the overwhelming, visceral urge to push through and see what is on the other side. I hit rock immediately but manage to pull out several football-size pieces of debris. Throwing my arms up through the hole, I twist and turn and groan and curse, tearing the skin on my chest and stomach before popping into an enormous chamber.

I am ecstatic, perhaps as much for getting through what we would eventually call the Colonoscopy as for reaching a place no human has ever been before. An hour later, with considerably more digging, the whole team makes it through, and we begin to explore. To the trained caver's eye, discoveries are everywhere: A pile of ancient bat bones. The skeleton of a prehistoric rodent. Stalactites of an unusual tubular form. An intact crinoid fossil, a seabed animal with feathery arms used for feeding.

A tiny hole beckons at the far end of the new cavern and Bobo, being the smallest of us, pushes herself through the opening first. We hear her screaming with delight. She has discovered helictites, pure white, spiderlike formations never before found in Jaguar Cave.

The pain of the scrapes and bruises that cover us vanishes with our discoveries. As Bobo says when we are back on safe ground, "Cavers are too obsessed to worry about such trivial things. We all just want to go right back underground. We call it cave fever. You can see it in our eyes—a certain glow." Adds Smith, with the smile of a giddy boy, "Guess you figured out that caving ain't for the weak of spirit."

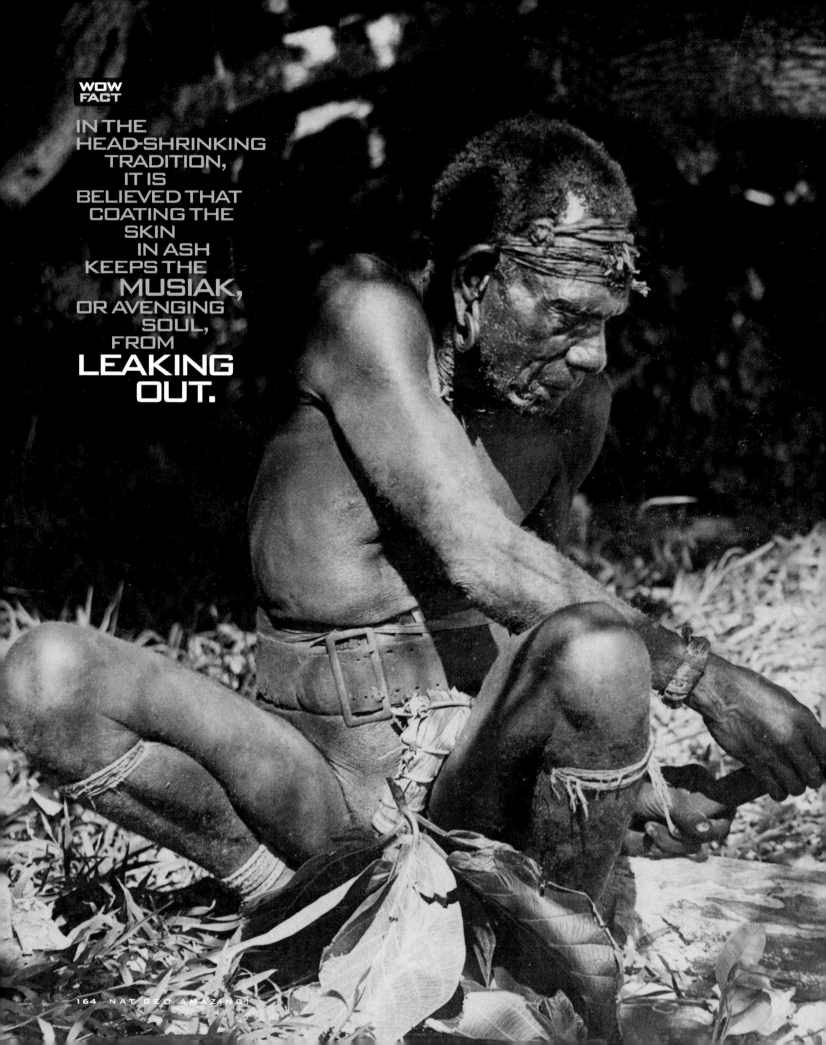

IN THE
HEAD-SHRINKING
TRADITION,
IT IS
BELIEVED THAT
COATING THE
SKIN
IN ASH
KEEPS THE
MUSIAK,
OR AVENGING
SOUL,
FROM
**LEAKING
OUT.**

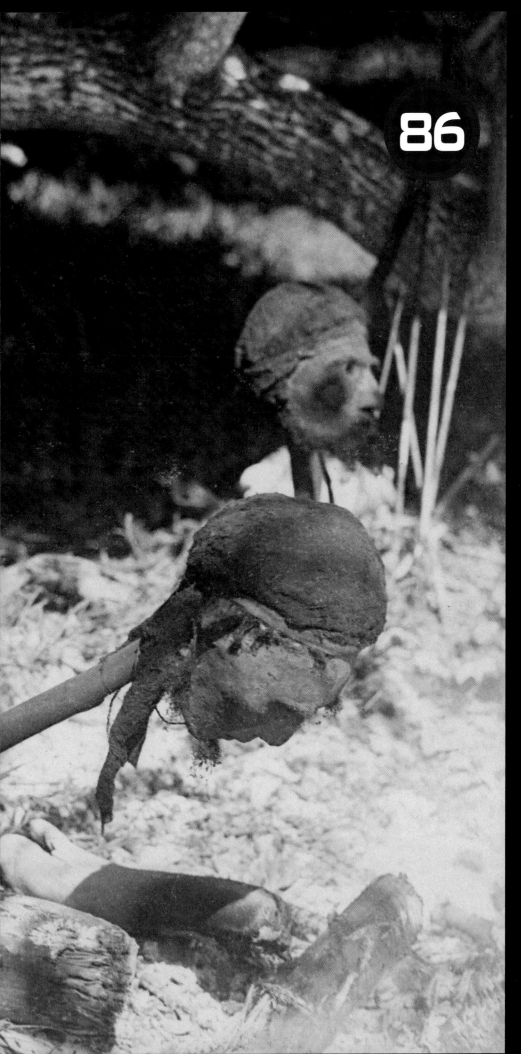

86

HEAD GAMES

Not your typical
memorial ser-
vice, for sure:
As photographed
circa 1919, a man on
the Vanuatu island of
Tomman performed
part of a weeks-long
ritual to honor the dead
by preserving the head.

First, the head was
soaked in a brine of fer-
mented herbs to harden
the skin; after that, it
was held over a fire to
render the fat and dry
the tissue. Next, a paste
made from, among other
things, dirt, soil, plant
fibers, and spiderwebs
was applied. Last, the
head was dried over a
slow-burning fire.

The instinct to pre-
serve is not a thing
of the past: Today
Alcor Life Extension
Foundation, which spe-
cializes in cryonic pres-
ervation, deep-freezes
bodies for $120,000, for
those who believe sci-
ence will catch up with
what ailed them. Saving
only a head is a relative
bargain, at just $50,000,
no need to keep the
home fires burning.

87 Autistic

Empathy in action is the life's work of Temple Grandin, best-selling author, professor, and revolutionary. As an autistic woman, Grandin realized several decades ago that her emotional life helps her understand the way that animals feel. "I'm a total visual thinker, and animals are sensory based as well," she explains. "You have to get away from language to understand how an animal thinks, how it stores memories of sounds, smells, and sights. When you are sensory based, those things are very specific."

Weathering a childhood and young adult life in which she had to battle others' misconceptions because of her autism, Grandin began to study animals (she has a Ph.D. in animal science). By understanding innately what scares and excites animals (because she reacts similarly to stimuli), Grandin realized that she could help animals raised for food die without cruelty. Now Grandin has become the person who has most dramatically changed the cattle industry as we know it.

When Grandin entered the field in the 1970s, how animals were treated before they made it onto our plates was not talked about like it is now; Whole Foods didn't exist, and if you ate organic, you probably lived on or near a farm. Grandin, meanwhile, took it upon herself to develop equipment to make the slaughtering of animals kinder and more efficient. It was a lonely battle for the scientist. But she was stubborn, and she understood how to get her point across. "The way I sold this equipment was I told the owners, 'You can take two men off, so that's $50,000, and you can cut your workman's comp down by two-thirds.' And they heard *that*."

She also demanded, when hired by fast food companies like McDonald's, Wendy's and Burger King, that executives get out from behind their desks and witness the slaughterhouses themselves. "It was interesting to watch their eyes open," Grandin says. "Something that had always been delegated to other people was now, suddenly, very real to them. When they saw it going decently, it was OK, but when they saw things going badly, they were really motivated to make changes."

Although she says that many of the facilities they toured needed only to have some changes in lighting and flooring to diminish the animals' panic—"We simply cut up a lot of pipes to lay them down and make floors less slippery for the animals"—Grandin can now claim having designed the facilities in which half the cattle in the United States are handled.

She's hardly resting on those laurels, as she continues to push for animal welfare. "I want to be clear where others are vague," she says, "so for instance, someone will write, 'Handle the pigs properly,' while I see a picture. I want to write, 'All the pigs in the

stockyard must be able to lie down without lying down on top of each other.'"

Grandin herself is buoyed by the changes that have been made. "When I started out, the thing that kept me going was there were only one or two ranchers who were doing things right," she says. And she has made peace with working within an industry that is, by its very nature, about death. "I can remember, after designing a conveyer system, standing up on a catwalk watching the animals go through it and getting upset," she says. "But then I told myself the animals wouldn't have been bred otherwise, they wouldn't have been born. But they *are* born, and they *are* here, so it's our responsibility to give them a decent life."

These days, Grandin has few struggles professionally: She is viewed as the expert on the industry and on animals in general. She is in high demand as a teacher and lecturer and has written several best-selling books about her life and about animal science. But she reserves at least a month a year to get back into the field with livestock. "I want to keep my real idea," she says. "It's important." She is also a vigilant activist for awareness of autism, a trait she says she wouldn't change if she could.

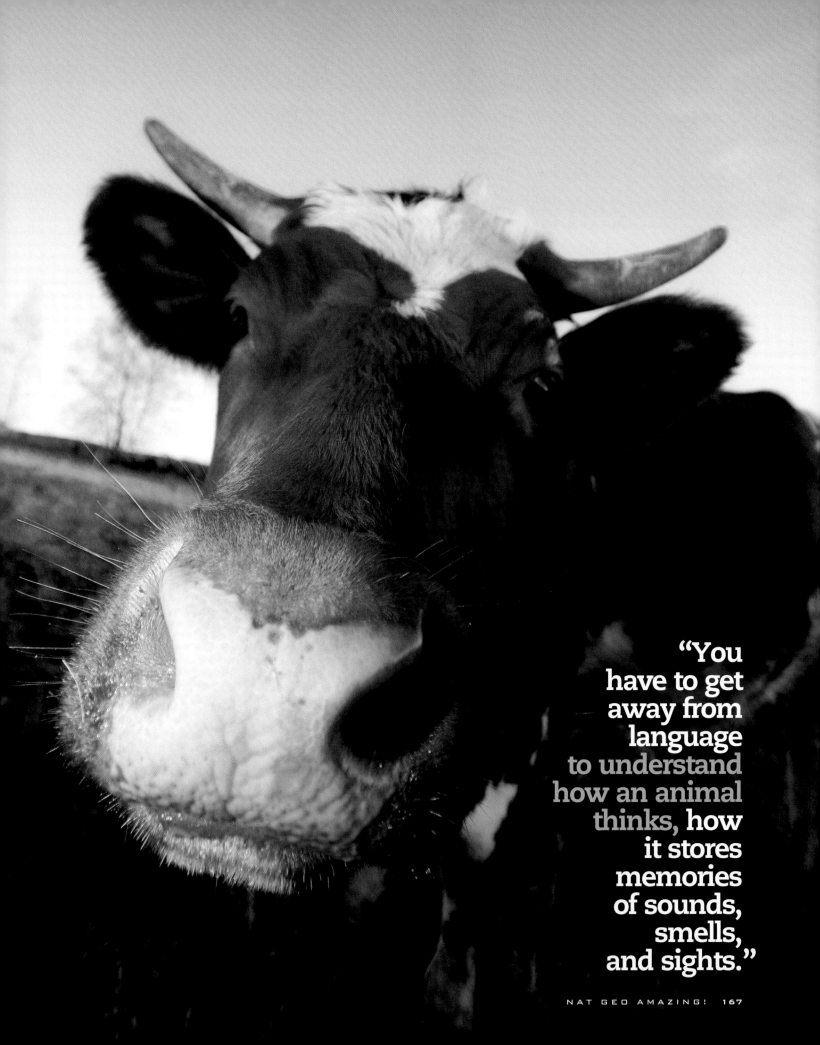

"You have to get away from language to understand how an animal thinks, how it stores memories of sounds, smells, and sights."

CHASING
OZ

t looks like this man is running the wrong way. But for a select few, the eye of the storm is exactly where they want to be.

Engineer Tim Samaras, photographed here by Carsten Peter, is a tornado chaser. Samaras spends months each year searching for the perfect tornado, a meteorological phenomenon still only partially understood by scientists. Driving a van outfitted with six probes designed to measure a tornado's wind speed and direction, barometric pressure, humidity, and temperature, Samaras hopes to plant his teammates—Peter, Pat Porter, and the rest of a team from National Geographic—in the path of the funnel. For his part, Peter wants to be the first photographer to film the inside of a tornado.

Approximately 1,000 of these destructive rotating columns of air tear through the United States every year, more than any other country in the world. Strong tornadoes can create winds that blow up to 205 miles an hour, their damage paths extending as far as 1 mile wide and 50 miles long. About 40 percent of these are those that touch down in the central Plains states from March through July, when cool, dry air from the Rocky Mountains mingles with warm, damp undercurrents from the Gulf of Mexico.

Samaras and Peter aren't alone in their tornado obsession. A thriving tourist industry devoted to eyewitnessing the storms has grown up in "Tornado Alley," a belt that runs between South Dakota and Texas. Those who want to thrill at the howling

WOW FACT

TORNADOES USUALLY SPIN IN OPPOSITE DIRECTIONS ABOVE AND BELOW THE EQUATOR.

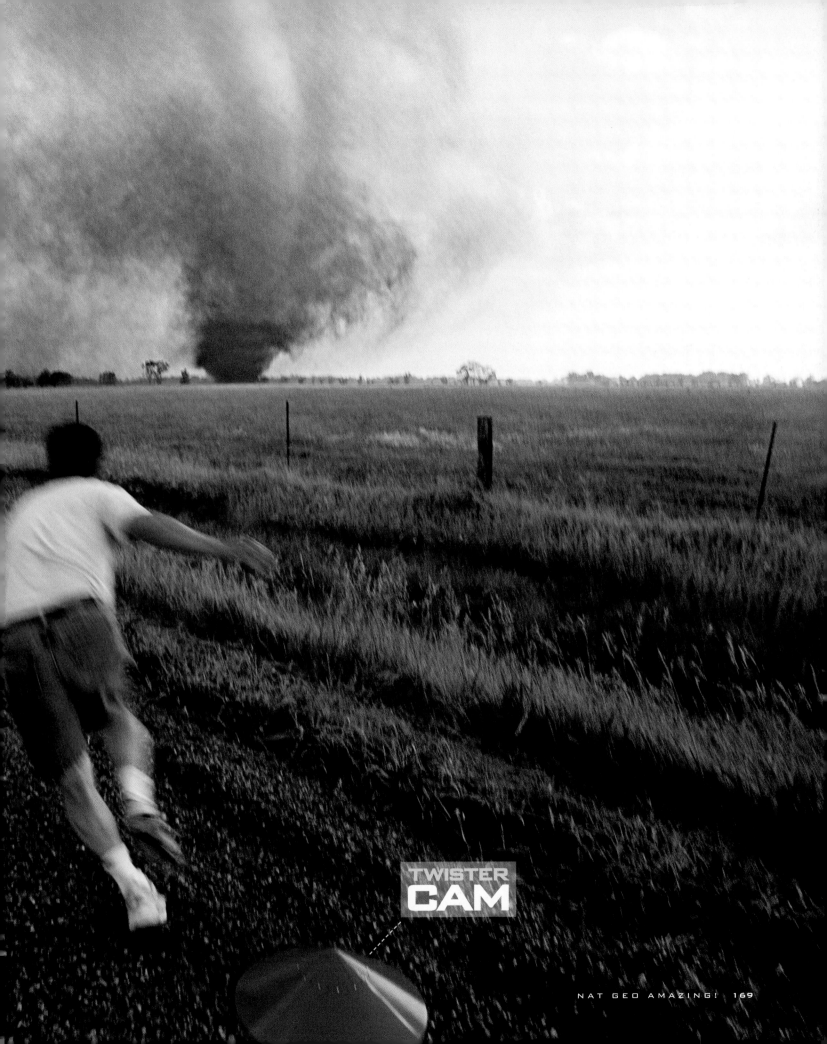

TWISTER
CAM

winds can book a vacation with companies, such as Storm Chasing Adventure Tours, that bring gawkers to places where the extreme storms are most frequent. Says Stephen Hondanish, a lightning specialist with the National Weather Service whom the team met during their expedition, "Everyone can read weather maps now. The information is shared. We don't hide it. So we all know where to go." But as Anton Seimon, a geographer and storm chaser who traveled with the National Geographic team, says, "The tornado has become the black hole of meteorology. We really don't know how it works."

For Samaras's team, chasing tornadoes has become their own fraught wild-goose chase, with two seasons spent enduring bad weather that was not quite bad enough to qualify for their purposes, prompting Samaras to say, "We should hire ourselves out as storm-prevention people. Everywhere we go, the storms fizzle out." Then, the third spring season, they are finally in the right place at the right time—in this case, Manchester, South Dakota, where a half-mile-wide twister set down on the town of just six people, raising roofs, rearranging walls, displacing sheds, but luckily killing no one. One couple sought refuge in their bathtub; a neighbor was pulled by the winds right through the wall of his trailer home. Resident Rex Geyer lost his two-story farmhouse in a flash. "There was nothing left, no trees, no house, no nothing," he says. "Just the foundation picked clean."

For Carsten Peter, the moment he had waited for was as dramatic as he had hoped, but equally unsettling. "It's an eerie situation," he says. "First, this beautiful, perfect structure comes towards you and then there's this smooth, rushing noise, and then everything is eaten up—everything. Power poles are sucked up out of the ground, all the steel wires are ripped off the metal fences, and the fences are blown down flat, leaving nothing but a pristine meadow. It's really crazy."

VIEW FROM

Twister Cam:
Tim Samaras's camera isn't meant to stay grounded. Protected by an outer shell of six-millimeter-thick steel, the twister cam can ride the wind. Placed in the path of a tornado, the camera records hundreds of images just 33 milliseconds apart, capturing detailed pictures of what was once an unfathomable act of nature.

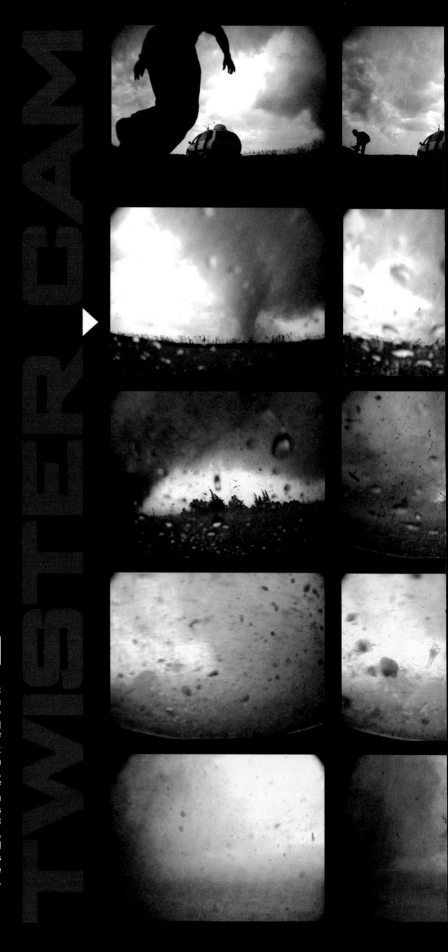

TWISTER CAM

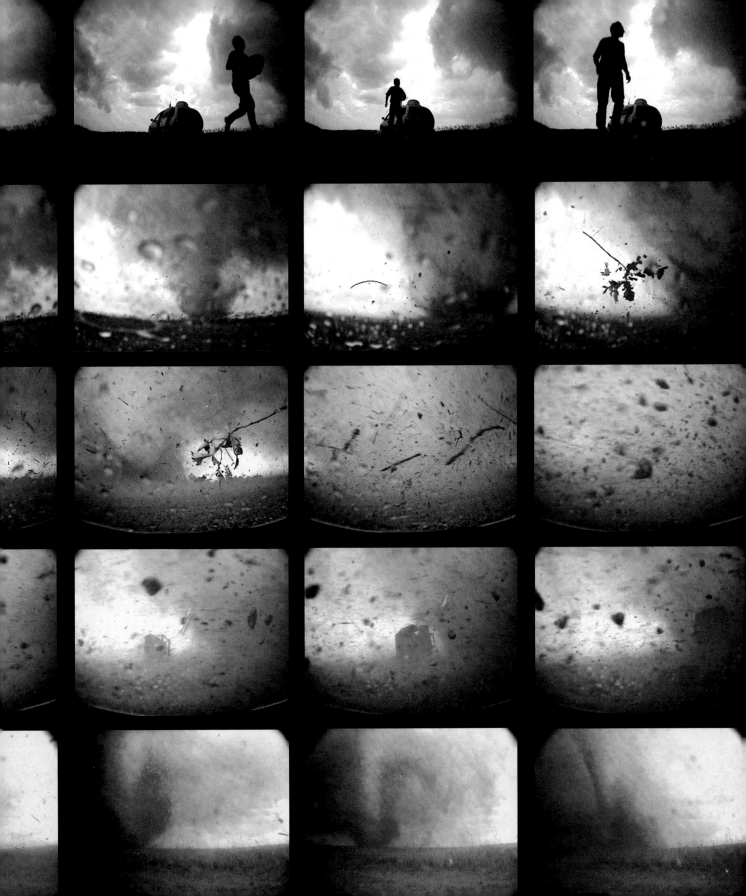

Through the Lens of a Blind Photographer

The concept of a blind photographer may sound like an oxymoron, but the works taken by Bruce Hall show a true artistry that many sighted people strive to match. Born legally blind, Hall cannot see more than three inches in front of his face, but his lack of eyesight has not stopped him from becoming an award-winning professional photographer.

Hall was nine years old before he saw a star in the sky for the first time. In a life-changing moment, he looked to the heavens one night through a friend's telescope and was able to see more than the moon. A whole new world opened up to Hall when he realized he could see the world if it was magnified through a lens; even better, if he could capture the world in still images, he could then study them to see what he had missed when they were right in front of him.

Hall's first and longest lasting passion is underwater photography. He dives near his home in southern California and on reefs where he has memorized the landscapes. But Hall's most time-consuming project—"almost an obsession," he says—is capturing images of his profoundly autistic twin sons. "It came out of trying to figure out how to communicate with them but also how to get happy at the same time, because this can be deeply sad," says the photographer, who is planning on editing the more than 20,000 images and publishing them in a book.

The photographer says he doesn't think that his impairment makes his photographs, which have appeared in many shows, better or worse than those of his colleagues with 20/20 vision. He says they're "just different. A lot of photographers look for line and big shape and color, but that's all I see. I see the big shapes and big forms, and then I wonder what the details are."

Like all artists, Hall finds salvation in being able to make sense of the world around him, although his need to do so begins with the very basics. And he even appreciates the odd perk—"When people say the visibility is bad on a certain day I say, 'That suits me just fine!'" he jokes.

89

Puppies Behind Bars

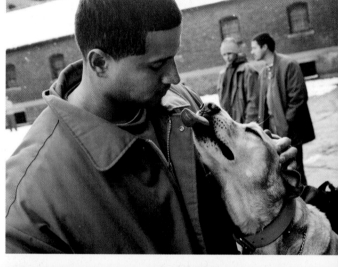

The worst part about Sgt. Allen Hill's return from the war in Iraq in November 2007 is that sometimes it feels like he hasn't come home at all. That's because as a sufferer of acute post-traumatic stress and traumatic brain injury, he has flashbacks that can occur at any time—too often, he says. He describes the episodes as "taking me 3,000 miles away," to where he was a gunner attacked by roadside bombers. Bringing him back home again? A female yellow Labrador named Frankie, who has learned to sense when he disassociates and who, simply by kissing him, "brings me back to America."

Frankie was only one year old when she arrived to live with Sergeant Hill, his wife, Gina, and their two young children, but she was already an old hand at changing people's lives for the better. Her first owner was Roberto, a New York State prison inmate who had served more than a decade as part of his sentence for taking a life. Roberto raised Frankie from a pup and trained her as part of Puppies Behind Bars, a program in which prisoners are paired with puppies that they are trained to turn into service dogs.

Gloria Gilbert Stoga started the program in 1997 as a way of giving back; since its founding, prisoners have begun to train dogs to be explosives detection canines for law enforcement officials and service dogs for veterans, the first in response to all who served in the aftermath of 9/11, and the latter as a response to those who have dedicated themselves to the wars in Afghanistan and Iraq. Of her inspiration, "It was simply, 'What can I do to say thank you?'" says Stoga, who once worked for New York's mayor Rudolph Giuliani. Now, the organization trains around 90 dogs a year; inmates are housed together with the dogs only once the prison and organization determine they are up to the task.

"Interestingly, the soldiers say almost exactly what

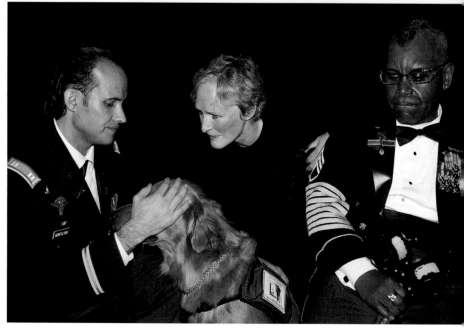

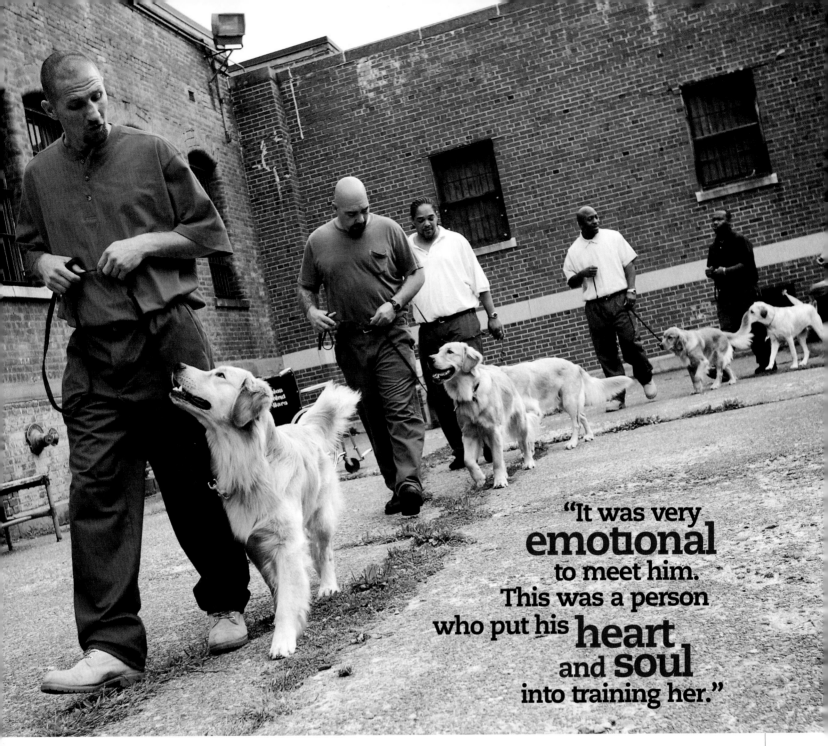

"It was very **emotional** to meet him. This was a person who put his **heart** and **soul** into training her."

the prisoners say about how this changes them," says Stoga, who has gotten public shout-outs from Oprah Winfrey and Glenn Close. "They say, 'I can tell the dog what I did in war, which I can't tell anyone else.' And the inmates say, 'I can tell the dog about my childhood and my crime, and he won't judge me.' The dogs make the inmates feel human again, and they do the same for soldiers who have been dehumanized by these wars."

For Sergeant Hill, having Frankie by his side—and she is always by his side, even when he is in the shower—means a reason to keep living. "Even on my worst days, I have to get up and take care of her," he says. Frankie wakes him up, reminds him when it's time to take his medication, alerts his wife when he is about to have a seizure, licks his face when he is having flashbacks, and makes him feel safe out in

the world. Perhaps most important, "In a week, I'll now have one or two days that work out really well for me," he says of his progress. "The rest of the week is still a big pile of trash. But Frankie is there for me every step of the way, tail wagging."

Sergeant Hill was able to express his thanks when he was given the opportunity to meet Roberto and reunite him with the puppy he had raised for a year. "It was very emotional to meet him," he says. "This was a person who put his heart and soul into training her. I take very seriously that the work he put into her won't be taken in vain. When we went to meet him again, Frankie recognized him right off. I let her off the leash to go see him, and she bounded a few yards off and then turned around and looked back at me. And when I said, 'Go ahead,' she ran and jumped into his arms."

91

BLAZING TRAILS

SEAN PENN'S
TRAILER

oet Robert Frost wondered whether the world would end in fire or ice. In southern California, that question has too often seemed nearly answered as forest fires have ravaged the area, destroying wildlife and homes and evacuating residents. As captured here by National Geographic photographer Mark Thiessen, actor Sean Penn's trailer is consumed by fires in 2007; only four years earlier, fires had leveled the four-million-dollar home he had built on the same site in Malibu.

As fires in America's forests and rangelands continue to grow at alarming rates, annual federal spending on firefighting has leaped from one billion dollars in 1998 to more than three billion dollars, and it continues to rise. The three most important ingredients in creating a fire are weather, terrain, and fuel; southern California is particularly at risk for intense fires thanks to its highly flammable and indigenous trees. Within California's high-frequency fire zones, analysts speculate that one or more acres out of every hundred will burn each year.

But it is far too easy to lose sight of the devastation in the overwhelming numbers of acres burned, shelter lost, and people uprooted. Individuals become parts of censuses; the sharp edges of personal tragedies soften when publicly consumed. All the more important, then, that Thiessen, with his haunting image, reminds us of one person's loss; that the person is a famous actor somehow makes it all the more poignant a reminder of the futility of our efforts when faced with nature's wrath.

WOW FACT

ON AVERAGE, MORE THAN 100,000 WILDFIRES CLEAR

4 MILLION TO 5 MILLION ACRES OF LAND IN THE U.S. EVERY YEAR

92 HANGOVER CURES FROM AROUND THE WORLD

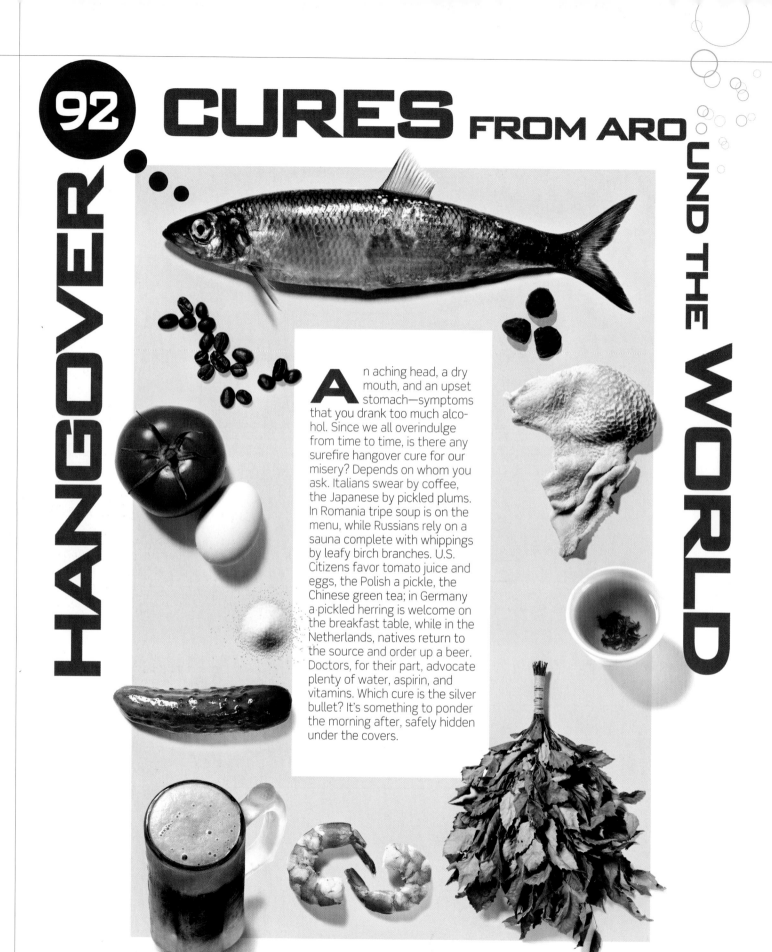

An aching head, a dry mouth, and an upset stomach—symptoms that you drank too much alcohol. Since we all overindulge from time to time, is there any surefire hangover cure for our misery? Depends on whom you ask. Italians swear by coffee, the Japanese by pickled plums. In Romania tripe soup is on the menu, while Russians rely on a sauna complete with whippings by leafy birch branches. U.S. Citizens favor tomato juice and eggs, the Polish a pickle, the Chinese green tea; in Germany a pickled herring is welcome on the breakfast table, while in the Netherlands, natives return to the source and order up a beer. Doctors, for their part, advocate plenty of water, aspirin, and vitamins. Which cure is the silver bullet? It's something to ponder the morning after, safely hidden under the covers.

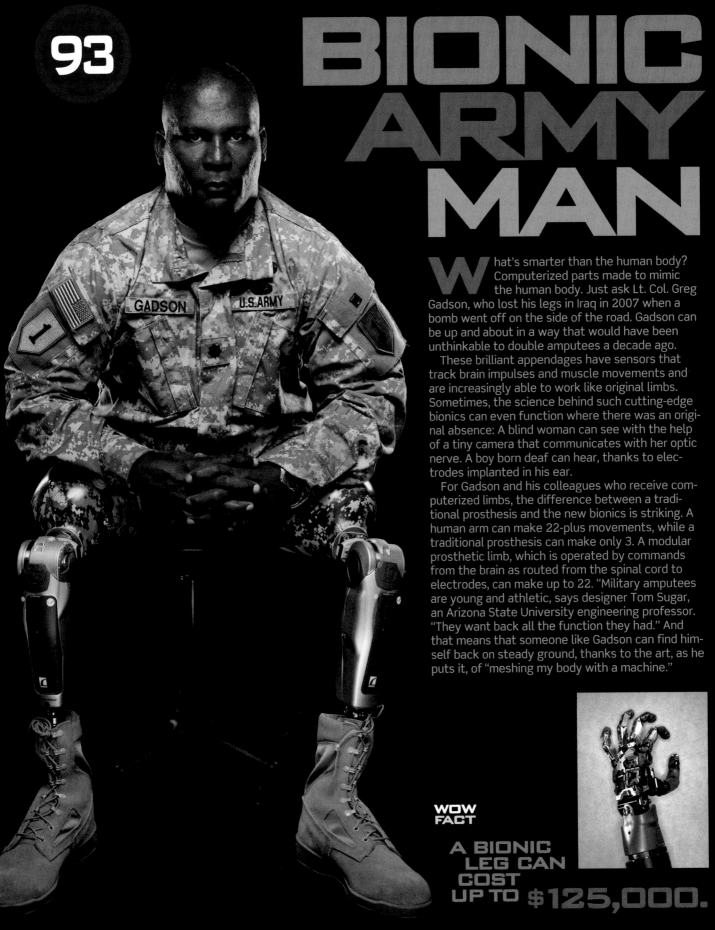

93

BIONIC ARMY MAN

What's smarter than the human body? Computerized parts made to mimic the human body. Just ask Lt. Col. Greg Gadson, who lost his legs in Iraq in 2007 when a bomb went off on the side of the road. Gadson can be up and about in a way that would have been unthinkable to double amputees a decade ago.

These brilliant appendages have sensors that track brain impulses and muscle movements and are increasingly able to work like original limbs. Sometimes, the science behind such cutting-edge bionics can even function where there was an original absence: A blind woman can see with the help of a tiny camera that communicates with her optic nerve. A boy born deaf can hear, thanks to electrodes implanted in his ear.

For Gadson and his colleagues who receive computerized limbs, the difference between a traditional prosthesis and the new bionics is striking. A human arm can make 22-plus movements, while a traditional prosthesis can make only 3. A modular prosthetic limb, which is operated by commands from the brain as routed from the spinal cord to electrodes, can make up to 22. "Military amputees are young and athletic, says designer Tom Sugar, an Arizona State University engineering professor. "They want back all the function they had." And that means that someone like Gadson can find himself back on steady ground, thanks to the art, as he puts it, of "meshing my body with a machine."

WOW FACT

A BIONIC LEG CAN COST UP TO $125,000.

THE INCREDIBLE STORY OF THE BOND-LIKE SUBMERSIBLE CAR...

...AND FOUR OTHER WILD FUTURE RIDES

95

BIONIC DOLPHIN

It is possible, in certain areas of the world, to swim with the dolphins, but it has never before been possible to swim *in* a dolphin. That's now changed, thanks to California inventors Tom "Doc" Rowe, a glass sculptor, and Dennis "Dusty" Kaiser, a businessman. The pair designed an aquatic vessel that moves like a real dolphin, capable of swimming near the surface, diving, jumping as high as six feet into the air, and completing a 360-degree barrel roll. The moves are all hand controlled by the passenger, with two pedals for turning left and right and making the nose go up and down. The dolphin can go at speeds of up to 40 mph and is available for sale in multiple colors at a starting price of about $48,000. Just the thing for the water lover for whom a Jet Ski is *so* yesterday.

▲ THE DOLPHIN CAN GO AT SPEEDS OF UP TO 40 MPH AND IS AVAILABLE FOR SALE IN MULTIPLE COLORS.

94

SUB COMPACT

James Bond seems to have it all: adventure, sophistication . . . and in *The Spy Who Loved Me*, even a car turned submarine. Inspired by that Lotus Esprit, the Swiss company Rinspeed has designed the sQuba, built at a cost of $1.5 million and holding the record for being the first fully submersible car. After the driver dons breathing gear and heads for the deep, this sporty-looking, open-topped automobile floats until a door is opened to allow the water in to help it sink. On land, the car goes about 77 mph, while it slows to about 3 mph on the surface. Once submerged, the car-boat, which is battery powered so it has no emissions, can be driven to a depth of 33 feet at about 1.8 mph, rendering the choice of "sink or swim" irrelevant.

96

CLEARLY COOL

Rinspeed, which designed the underwater sQuba car, has more transparent goals with its eXasis, the shell of which is made entirely of a see-through, yellow-tinged plastic. Almost every part of the car—which was designed to celebrate the company's 30th anniversary—is visible, from the engine in the back to the seats for the passenger and driver, who sit in fore and aft tandem seats. Transparent touch panels on the dashboard control different functions of the car, from headlights to turn signals, and it is, of course, as eco-friendly as possible, running on bioethanol fuel so it emits fewer pollutants in the air than an average vehicle. The invention, which can go up to 210 mph, is what is called a "concept car," meaning this is one trend you won't be able to test-drive.

97

◄ GOT WHEELS?

The concept of this go-kart on steroids—as stated by its designer, Toyota, when it debuted it at the World Expo in Japan in 2005—is "Expanding Human Abilities." The theme? "Inspire the individual." That's assuming the individual at the helm isn't afraid of heights. Known as the i-unit, this contraption is an electric-powered personal transporter meant to create a more comfortable way to get around than on a bike or skateboard, or even the old-fashioned way, on foot.

In low-speed mode, the unit is driven in an upright position with the intention of being able to provide face-to-face time with other (tall) pedestrians; in high-speed mode, it reclines for better handling, if not better views. The driver uses a simple hand control: push to go forward, twist to turn right or left, and pull or let go to stop. A personalized recognition system provides information and music, and the color of the gadgety vehicle, like a modern mood ring, can be customized according to a person's emotions and preferences.

Lest it seem like a waste of energy, rest assured: The unit, which weighs just under 400 pounds and is designed to look like a leaf, runs on a battery and is made of eco-friendly, plant-based materials.

THE UNIT IS DESIGNED TO RESEMBLE A LEAF, RUNS ON A BATTERY, AND IS MADE OF ECO-FRIENDLY, PLANT-BASED MATERIALS.

FLYING CARS **98**

With air travel becoming as fraught as it has and the highways clogged with traffic, it was only a matter of time before the Jetsons' cartoon reality became ours: a car that can fly. There are currently at least two competing companies: that of designer Paul Moller and British company Parajet, both of which have designed products they call Skycars.

Moller, whose prototype is pictured here, lays claim to what his company refers to as the world's first and only feasible personally affordable, personal takeoff and landing vehicle (or VTOL, for those in the know)—similar to what is seen in James Cameron's movie *Avatar*. Parajet's Skycar, on the other hand, is essentially a modern dune buggy with a paramotor and parafoil attached. After an expedition team successfully drove/flew it in February 2009 from France to Timbuktu, Parajet began offering the Skycar for sale, with an estimated price of about £50,000 ($81,7000) and a delivery date of late 2010. Its maximum speed on the road is 140 mph, with a maximum airspeed of 100 mph. That may not make it the fastest vehicle on land or in the sky, but will surely make it the most impressive.

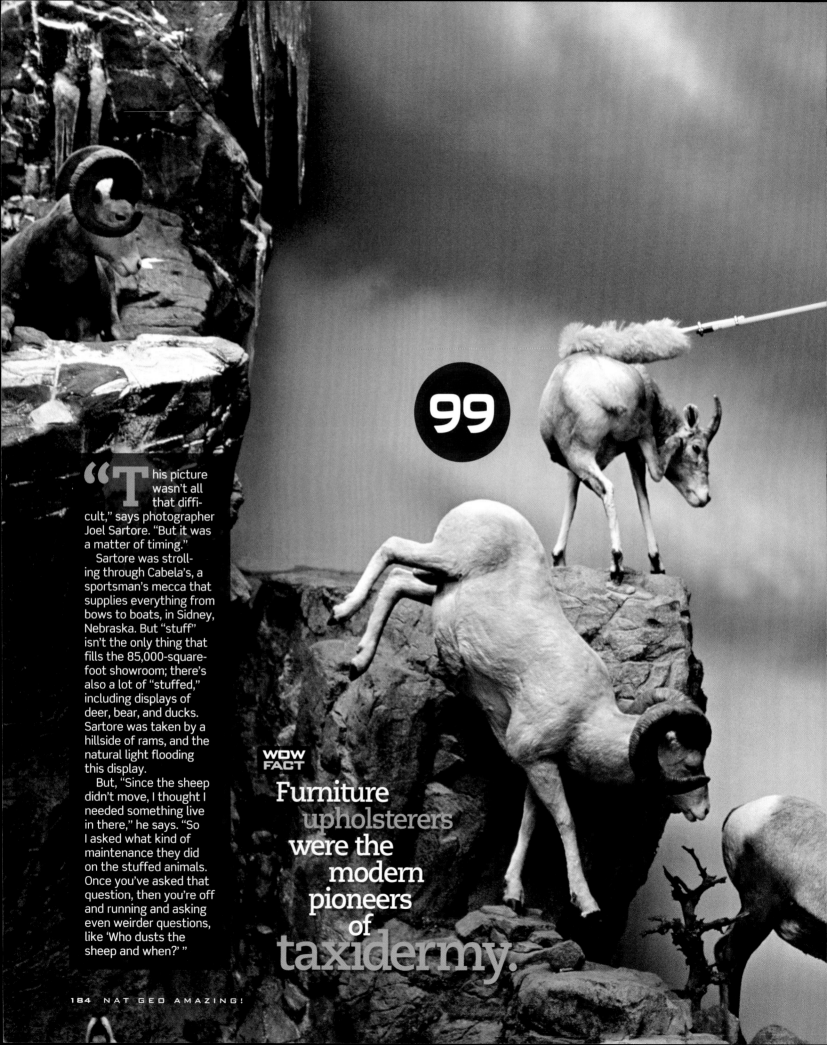

99

"This picture wasn't all that difficult," says photographer Joel Sartore. "But it was a matter of timing."

Sartore was strolling through Cabela's, a sportsman's mecca that supplies everything from bows to boats, in Sidney, Nebraska. But "stuff" isn't the only thing that fills the 85,000-square-foot showroom; there's also a lot of "stuffed," including displays of deer, bear, and ducks. Sartore was taken by a hillside of rams, and the natural light flooding this display.

But, "Since the sheep didn't move, I thought I needed something live in there," he says. "So I asked what kind of maintenance they did on the stuffed animals. Once you've asked that question, then you're off and running and asking even weirder questions, like 'Who dusts the sheep and when?'"

WOW FACT

Furniture upholsterers were the modern pioneers of taxidermy.

No Thanks.

I'm Stuffed.

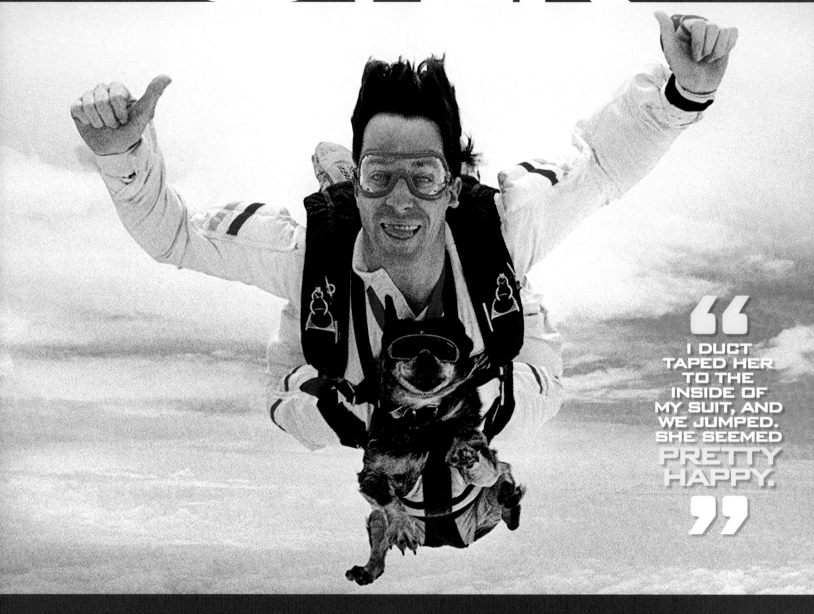

> "I DUCT TAPED HER TO THE INSIDE OF MY SUIT, AND WE JUMPED. SHE SEEMED **PRETTY HAPPY.**"

Every dog has his day, but few canines can claim days spent jumping out of airplanes and exploring reefs.

In a moment most matchmakers can only dream of, Hooch—half King Charles spaniel, half blue heeler, 100 percent explorer—met the eyes of Sean Herbert—aviation company owner, skydiving instructor, and scuba diver. In an Australian pound, a dynamic duo of explorers was born.

Hooch began her rise to heights of greatness by racing up the tarmac to a plane just as Herbert was getting on board to take off and then skydive out of it. "The person by the door grabbed the dog and said, 'Is this yours?' as we were taking off," Herbert remembers. "The pilot wasn't about to look after a puppy, so I duct taped her to the inside of my suit, and we jumped. She seemed pretty happy." Soon enough, Hooch had her own custom-designed harness and was skydiving weekly with her human partner.

But Hooch wanted to explore the depths as well. When she first saw her master in the water with his scuba gear on, she jumped overboard and began to duck dive down to him. So Herbert did what any

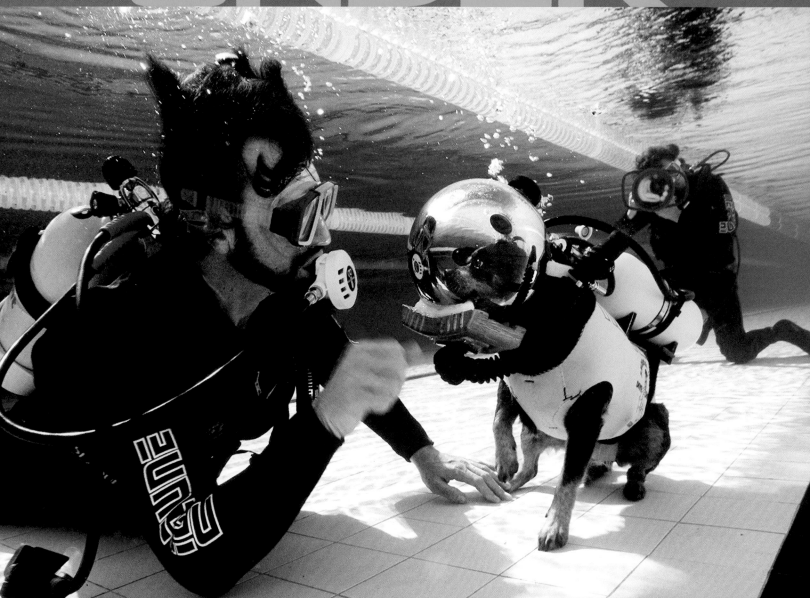

responsible owner would do: He contacted a wet-suit company to custom-make a dog-size outfit for Hooch. But what to do for the mask? Herbert headed to a lighting store and tried glass lampshades on his dog. "At first the store owner wasn't happy," Herbert says. "But when I explained what I was trying to do he was very helpful."

Engineers came in to attach the casing to oxygen, and soon the pair began sinking under the water together, first training in swimming pools, then small shallows, and finally reefs. "She would get to the bottom and walk away from me, exploring things around her," says Herbert. "She was very interested in what was going on."

Hooch was equally happy when riding on the back of Herbert's motorcycle and Jet Ski, never once suffering an injury. At the ripe old age of 15, Hooch finally succumbed from a genetic fault inherited from her King Charles lineage: As Herbert says of her cardiac arrest, "Their hearts grow too big for their bodies." Hooch's body may ultimately have failed her, but her adventurous spirit never flagged whether she was diving from the sky or flying in the sea.

WANT TO SEE MORE?

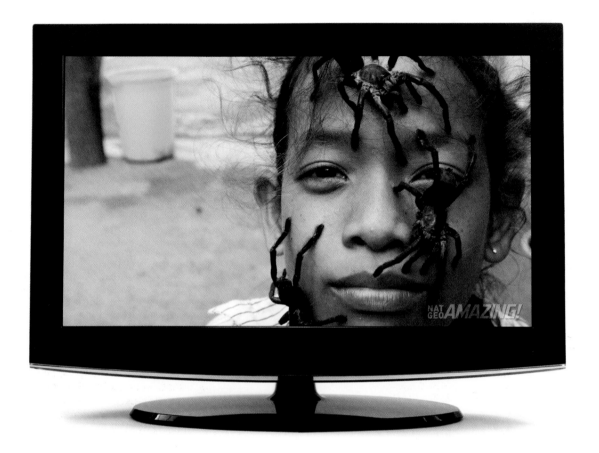

The book in your hands just skims the surface of all the amazing things going on at the National Geographic Society. For a deeper look at what we're up to, visit us on the Web and at the National Geographic Channel!

Now, *Nat Geo Amazing!*—a daring, new ten-part series airing on the National Geographic Channel—examines dozens of some of the most astonishing stories on Earth, be they curious animal behavior, sweeping natural phenomena, or death-defying human endeavors. Together with National Geographic filmmakers, scientists, engineers, animal experts, and explorers shed light on the lesser known, overlooked corners of the globe. Journey from the shores of Japan to the swamps of Costa Rica as we reveal the wacky, often whimsical, always wild wonders of the world. A bike stuntman in Scotland, Kung Fu monks in San Francisco, indoor skydiving, or a Japanese crystal ball juggler . . . our bizarre world will come to life before your eyes.

Nationalgeographic.com is the acclaimed Web site of the National Geographic Society and attracts 14 million unique visitors a month. Winner of two of the first digital media awards from ASME in 2010, *nationalgeographic.com* combines National Geographic's photography, video, and maps with in-depth information and interactive features about animals, nature, destinations and cultures. *Nationalgeographic.com*'s news service, National Geographic News, publishes daily stories about science and discoveries. The National Geographic Digital Media (NGDM) is the multimedia division of National Geographic Ventures. Holding many top industry awards, NGDM publishes *Nationalgeographic.com;* produces short-form video for broadband markets; and manages marketing and content partnerships across broadband, mobile, gaming, and other consumer digital platforms.

PHOTO CREDITS

Cover: Jim Smith/AFP/Getty Images; 2-3, Jaipal Singh/epa/CORBIS; 4 (UP), Sean Justice/CORBIS; 4 (LE CTR), Kenneth Garrett; 4 (RT CTR), Cameron Lawson; 4 (LO), NASA; 5 (UP LE), Mark Thiessen; 5 (UP RT), Carol Beckwith; 5 (LO), Paul Nicklen; 7, Joel W. Rogers/CORBIS; 8-9, Melissa Brandts; 9 (UP) & (LO), Thinkstock; 10-11, Carol Beckwith; 12, Tim Laman; 13, Brian Skerry; 14-15, Kjell B. Sandved; 14 (UP), Michael and Patricia Fogden/Minden Pictures; 16, Barbara Walton/CORBIS; 18 (UP), Martin K. Telewa/Reuters; 18 (LO), Barbara Walton/EPA/Landov; 18-19, Pawan Kumar/Reuters; 19 (UP), Bob Pennell/Mail Tribune; 19 (LO), Peter Greste/AFP/Getty Images; 20-21, Sindre Lundvold/Barcroft Media/Getty Images; 22-23, Pioneer Productions; 24 & 25, David Liittschwager & Susan Middleton; 26-27, Michael Nichols; 28-29, Emmanuel Kwitema/Reuters; 30-31, Robert B. Haas; 32, Philip Straub; 33, Robert Clark; 34-35, F.J. Kirschbaum; 36, Nicole Duplaix; 37, David Doubilet; 38-39, NASA; 40-41, Sean Justice/CORBIS; 42, Charlie Robertson; 43, Ingo Arndt/Minden Pictures; 44, Kenneth Geiger; 45, David Fisher; 46-47, Carsten Peter; 48-49, Philipp Horak/Anzenberger; 50-55, Paul Nicklen; 56-57, Steve McCurry; 58-59, George Steinmetz; 61, NGS Archives; 62-63, Michael Nichols; 64-65, Scott Aichner; 66-67, Szilard Koszticsak/epa/CORBIS; 68, Adrian Dennis/AFP/Getty Images; 69 (UP), Jess Hurd/reportdigital.co.uk; 69 (LO), Peter Macdiarmid/Getty Images; 70-71, Mattias Klum; 72-73, Marco Di Lauro/Getty Images; 74-77, Tom Nick Cocotos; 78-79, Horace Bristol/CORBIS; 80-81, All images, NASA; 82-83, Kenneth Garrett; 84-85, Edgar Mueller/Getty Images; 86-89, Brent Stirton/Getty Images; 90-91, Fritz Hoffmann; 92, Maggie Zackowitz; 93, Hans Hildenbrand; 94-95 (Dog), Jason Neely; 94 (Motorcycle), Thinkstock; 94 (Billboard), Photo 24; 94-95 (Snowboarder), Thinkstock; 95 (Space), NASA; 95 (Tower), Royalty-Free CORBIS; 96-97, David Doubilet; 98, John Warburton-Lee/Danita Delimont.com; 99, Gavin Hellier/age fotostock; 100, Kazuyoshi Nomachi/Photo Researchers, Inc.; 101 (UP), Valdrin Xhemaj/epa/Corbis; 101 (LO), Jodi Cobb & Stephen Marquardt; 102-103, Emmanuel Aguirre/Getty Images; 104-107, David Liittschwager; 108-109, Joseph H. Bailey; 110-111, Emory Kristof; 112, Drew Gardiner/Guinness World Records; 114 (LE), Drew Gardiner/Guinness World Records; 114 (RT), Niklas Halle'n / Barcroft Media/Fame Pictures; 114-115, John Wright/Guinness World Records; 115 (UP), Ranald Mackechnie/Guinness World Records; 115 (LO), Drew Gardner/Guinness World Records; 116-117, Martin Oeggerli; 118-119, Joel Sartore; 120, Fabrice Coffrini/AFP/Getty Images; 121, Kenneth Garrett; 122-123, Mark Thiessen; 124-129, Michael Nichols; 131, Matti Bernitz; 132, Robert Clark; 133, Bob Rohrbaugh, WildFX Cats; 134-135, Joe McNally; 136-137, Zhou Min/JHSB/ChinaFotoPress; 138-139, Andy Day/Actionplus/Icon; 140-141, Monica Szczupider; 142, Hulton-Deutsch Collection/CORBIS; 143, Penny De Los Santos; 144-145, Cameron Lawson; 146, Joel Sartore; 147, Mayhart Studio/NGS Archives; 148, Arctic-Images/CORBIS; 150 (LE), Andreas Hub/laif/Redux; 150 (RT), Jon Arnold Images Ltd/Alamy; 150-151, Courtesy Gamirasu Hotel; 151 (UP), SEPIA/Alamy; 151 (LO), Diego Giudice/Corbis; 152-153, Jed Weingarten; 154, Ami Vitale; 155, Aaron Fee; 156-157, Michael Nichols; 158-159, International Mammoth Committee; 160-163, Stephen L. Alvarez; 164-165, Martin Johnson; 166, Jonathan Sprague/Redux Pictures; 167, Kjell Ragnar Hermansen; 168-171, Timothy Samaras; 172-173, Bruce Hall; 174 (UP), Ian Wingfield; 174 (LO), Gabriela Maj/Getty Images; 175, Radhika Chalasani/Redux Pictures; 176-177, Mark Thiessen; 178, Rebecca Hale; 179, Mark Thiessen; 180, Joffet Emanuel/Sipa; 182 (LE), Joffet Emanuel/Sipa; 182 (RT), Martin Sykes/New Zealand Herald; 182-183, Rinspeed/Dingo, courtesy of Emotiv Systems; 183 (UP), AP Images/Shuji Kajiyama; 183 (LO), Barbara Ries courtesy of Dynamism, Inc (Watch TV); 184-185, Joel Sartore; 186, Jim Smith/AFP/Getty Images; 187, Jay Town/AFP/Getty Images; 188, Hywit Dimyadi/Shutterstock; Back Cover: (UP LE), NGS Archives; (UP RT), Carol Beckwith; (CTR), Melissa Brandts & Thinkstock; (LO LE), Fabrice Coffrini/AFP/Getty Images; (LO RT), David Doubilet.

ACKNOWLEDGMENTS

All great ideas typically have great minds behind them, and *Nat Geo Amazing!* is no exception. Many talented people with a knack for thinking outside the box all played a part in bringing this book, and its companion TV show, to life. It was a long journey that took more than four years to be realized, but here we are. Amazing.

In the beginning, the "Amazing Idea" originated in a brainstorming session by the people at National Geographic Kids Magazine. We were jamming on a product that would target the same people who love the National Geographic Channel and the National Geographic website. Why couldn't a print companion appeal to this "in-between" demographic? The idea caught fire, and we worked and worked on this new magazine, tirelessly creating prototype after prototype, focus group testing each one before we refined and regenerated each new breathtaking design. These crucial early stages of the project defined its modern vision and playful sensibility, and for that I want to thank the talented researchers, editors, photo editors, and designers who were propelled simply by their passion for this project. The team includes Eva Absher, Julie Agnone, Karine Aigner, Rachel Buchholz, Jülide Dengel, Jonathan Halling, Catherine Hughes, Nicole Lazarus, Margaret Krauss, Kelley Miller, Erin Monroney, Eleanor Shannahan, David Showers, Jay Sumner, Robin Terry, Sharon Thompson, and Jill Yaworski.

Along the way, our innovative magazine idea turned into an innovative TV show, one with the same cutting-edge, knock-your-socks-off content—all thanks to the intuition of intrepid producer Alison Barrat. She and her team, which is led by Michael Rosenfeld, Maryanne Culpepper, Mark Bauman and Martha Conboy, were a joy to collaborate with. The biggest shout out goes to Timothy Kelly, who originally saw the promise in our premise and quietly whispered "You can do it" the whole way through the process.

I also want to thank the leaders of the books team, John Q. Griffin, Nina Hoffman, and Barbara Brownell Grogan, for giving us the greenlight and making our print companion a reality. Hilarious editor extraordinaire Amy Briggs and tenacious photo editor Jane Menyawi worked tirelessly with design genius Jonathan Halling and me to format our original concept into book form; contributing writer and reporter Rebecca Ascher Walsh was invaluable in wrestling the text onto the page; illustrations specialist Robert Waymouth tracked down those hard-to-get photographs while assistants Jülide Dengel and Margaret Krauss herded all the stray cats, ensuring no details were left unchecked. It's been a true team effort all along this amazing journey.

INDEX

CREDITS

100 People, Places, and Things That Will Wow You

Melina Gerosa Bellows

Published by the National Geographic Society

John M. Fahey, Jr., President and Chief
 Executive Officer
Gilbert M. Grosvenor, Chairman of the Board
Tim T. Kelly, President, Global Media Group
John Q. Griffin, Executive Vice President;
 President, Publishing
Nina D. Hoffman, Executive Vice President;
 President, Book Publishing Group

Prepared by the Book Division

Barbara Brownell Grogan, Vice President
 and Editor in Chief
Marianne R. Koszorus, Director of Design
Lisa Thomas, Senior Editor
Carl Mehler, Director of Maps
R. Gary Colbert, Production Director
Jennifer A. Thornton, Managing Editor
Meredith C. Wilcox, Administrative Director, Illustrations

Staff for This Book

Amy Briggs, Editor
Jonathan Halling, Designer
Jane Menyawi, Illustrations Editor
Karine Aigner, Kelley Miller, Jay Sumner,
 Illustrations Editors, National Geographic Kids
Margaret Krauss, Researcher
Rebecca Ascher-Walsh, Contributing Writer
Judith Klein, Copy Editor
Lewis Bassford, Production Project Manager
Robert Waymouth, Illustrations Specialist
Jülide Dengel, Design Assistant

Manufacturing and Quality Management

Christopher A. Liedel, Chief Financial Officer
Phillip L. Schlosser, Vice President
Chris Brown, Technical Director
Nicole Elliott, Manager
Rachel Faulise, Manager

The National Geographic Society is one of the world's largest nonprofit scientific and educational organizations. Founded in 1888 to "increase and diffuse geographic knowledge," the Society works to inspire people to care about the planet. It reaches more than 325 million people worldwide each month through its official journal, *National Geographic,* and other magazines; National Geographic Channel; television documentaries; music; radio; films; books; DVDs; maps; exhibitions; school publishing programs; interactive media; and merchandise. National Geographic has funded more than 9,000 scientific research, conservation and exploration projects and supports an education program combating geographic illiteracy. For more information, visit nationalgeographic.com.

For more information, please call 1-800-NGS LINE (647-5463) or write to the following address:

National Geographic Society
1145 17th Street N.W.
Washington, D.C. 20036-4688 U.S.A.

Visit us online at www.nationalgeographic.com

For information about special discounts for bulk purchases, please contact National Geographic Books Special Sales: ngspecsales@ngs.org

For rights or permissions inquiries, please contact National Geographic Books Subsidiary Rights: ngbookrights@ngs.org

ISBN: 978-1-4262-0649-8

Acknowledgment is made to *National Geographic* in which the following stories in this collection were originally published (some differently titled or in slightly different form): "Elephants Under Siege"," Copyright © 2007 John Michael Fay; "Fateful Passage," Copyright © 2005 Robert Ballard; "Gorillas Under Attack," Copyright © 2008 Mark Jenkins; "Underground Agent," Copyright © 2009 Mark Jenkins.

"The Seal Who Loved Me" is excerpted with permission from *Polar Obsession,* National Geographic Focal Point, 2009, with thanks to its author, Paul Nicklen.

"A Wing and a Prayer," originally published in *National Geographic Traveler,* November/December 2009, appears in this collection with permission and our thanks.

Printed in the United States of America

10/CK-CML/1